庆祝中国共产党
成立100周年
暨第五届浙江工艺美术双年展
作品选集

Selected Works from the 5th Zhejiang
Arts and Crafts Biennial Exhibition
Celebrating the 100th Anniversary of the
Founding of the CPC

郑 蓉 主编

U0125289

浙江文艺出版社
Zhejiang Literature & Art Publishing House

ART HEART TO THE

庆祝中国共产
暨第五届浙江

Celebrate The 100 Anniversary of
Arts and Ci

主办单位

浙江省文学艺术界联合会
Zhejiang Provincial Federation
Literary and Art Circles

NIST PARTY OF CHINA

成立100周年
艺美术双年展

ding of The CPC & The 5th Zhejiang
nial Exhibition

映山红奖
YINGSHANHONG AWARD

承办单位
浙江省民间文艺家协会
Zhejiang Provincial
Folk Artists Association

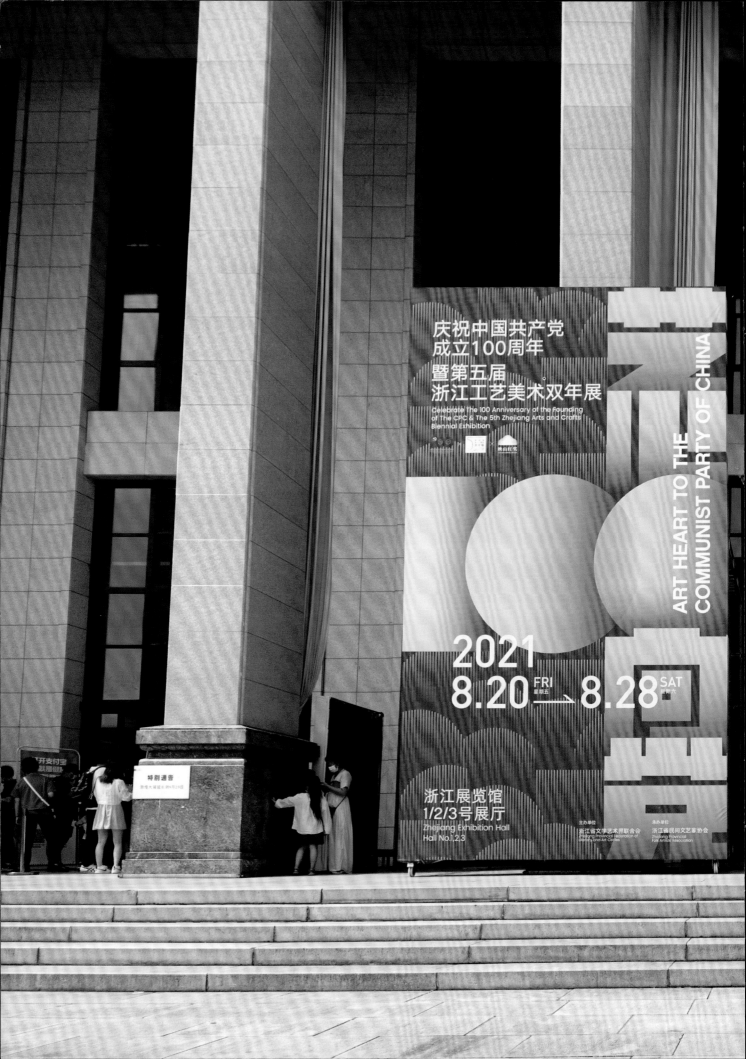

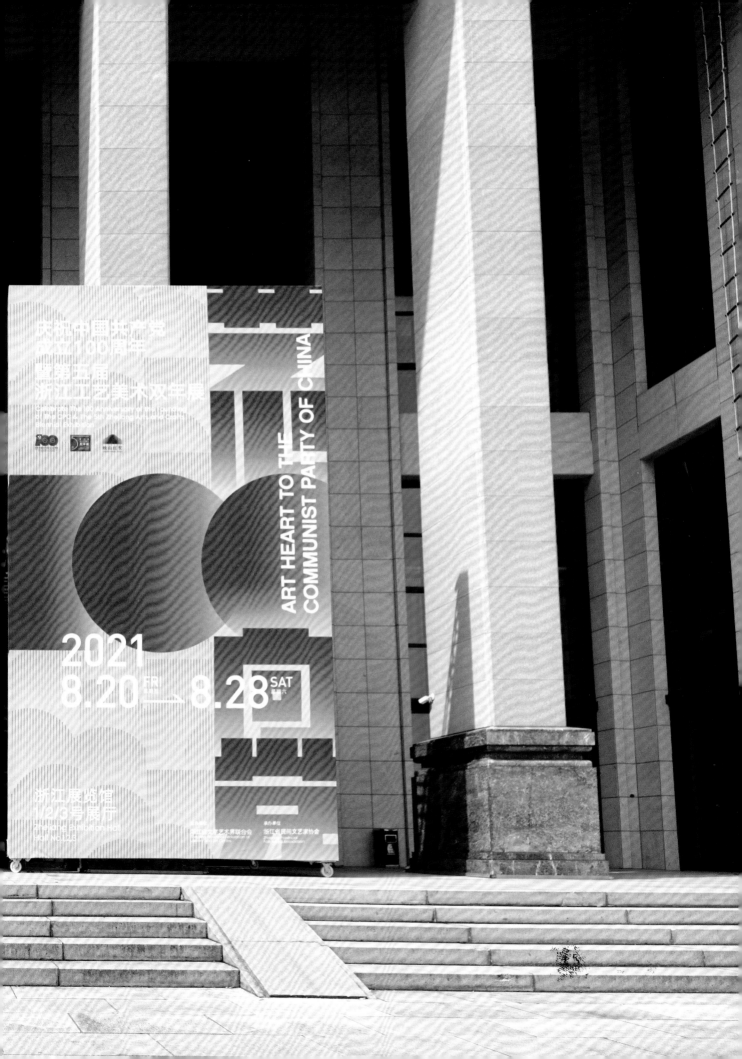

庆祝中国共产党成立100周年
暨第五届浙江工艺美术双年展

庆祝中国共产党成立100周年
The 100th Anniversary of the Founding of
The Communist Party of China

前言 Introduction

　　浙江地处江南，山川毓秀，文脉兴盛，物产丰茂。7000 年前河姆渡的黑陶器上刻画的生动拙朴的猪纹、稻穗纹，5300 年前的良渚文化神秘莫测的神人兽面纹，无不彰显出先民们惊人的创造力和审美趣味。在随后的岁月里，浙江人民又创造和发展了许多别具风韵的民间工艺，剪纸、木雕、石雕、青瓷、瓯塑、铜雕、刺绣、湖笔等等，不一而足。一器一物，方寸之间承载了先辈传承、家国情思、时代激荡。

　　浙江工艺美术双年展是浙江省文联和省民协联合举办的两年一届的全省性民间工艺大展，是鼓励创作、展示成果、加强交流的平台，至今已举办了四届，今年举办的是第五届。整个展览分成三个部分：第一部分是"红色礼赞"，表现红船"启航"后的辉煌征程，致敬红色荣光，赓续百年伟业；第二部分"山花烂漫"，展陈的是近两年来浙江省民间工艺家创作的精品力作，代表浙江民间工艺的赡美之境、独具匠心；第三部分是"富美生活"，每件展品都是美轮美奂的艺术品，也是实用益民的生活器具，厚重的生活和浓缩的文化在这里水乳交融。

　　这次双年展既是两年来浙江民间工艺界向人民交出的一份答卷，又是浙江民间工艺工作者们向党的百年华诞呈上的献礼，更是浙江民间工艺界在新时代新征程吹响的奋斗号角。民间工艺是"生产者的艺术"，集壮美和朴素于一身，散发着劳动人民内在的真挚、善良、直率、热情。在推进高质量发展建设共同富裕示范区的征程中，我们将始终植根于深厚的民间沃土，勇担使命，贡献民艺力量，力攀共美高峰。

目录 Contents

红色礼赞
The Red Praise

从建党的开天辟地，到新中国成立的改天换地，到改革开放的翻天覆地，再到党的十八大以来党和国家事业取得历史性成就、发生历史性变革，中国共产党始终坚守为中国人民谋幸福、为中华民族谋复兴的初心和使命。

浙江是中国共产党的诞生地之一，是改革开放先行地，也是习近平新时代中国特色社会主义思想的重要萌发地。习近平总书记讲：我们党的每一段革命历史，都是一部理想信念的生动教材。在建党百年之际，浙江民间工艺界积极遵循习近平总书记的重要讲话精神，以匠心、手艺讲好建党百年辉煌历程中的红色故事。

百年征程波澜壮阔，百年初心历久弥坚。百年华诞，艺心向党，祝愿我们的祖国永远繁荣昌盛。

Stone Carving Craft

石雕工艺

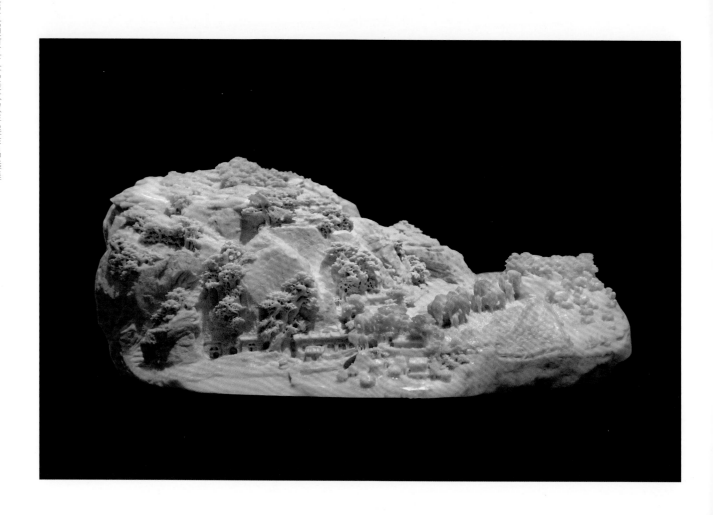

梁家河　石雕　85cm×35cm×35cm　周金甫　丽水

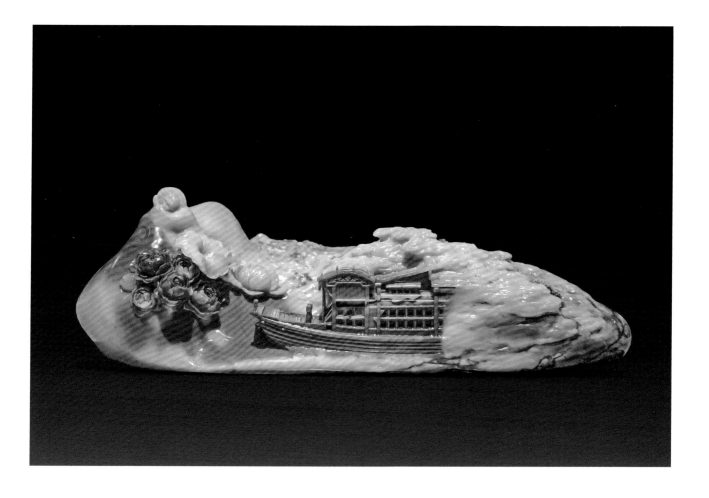

中国梦 石雕 53cm×23cm×18cm 陈小甫 丽水

庆祝中国共产党成立 100 周年暨第五届浙江工艺美术双年展作品选集

Selected Works from the 5th Zhejiang Arts and Crafts Biennial Exhibition Celebrating the 100th Anniversary of the Founding of the CPC

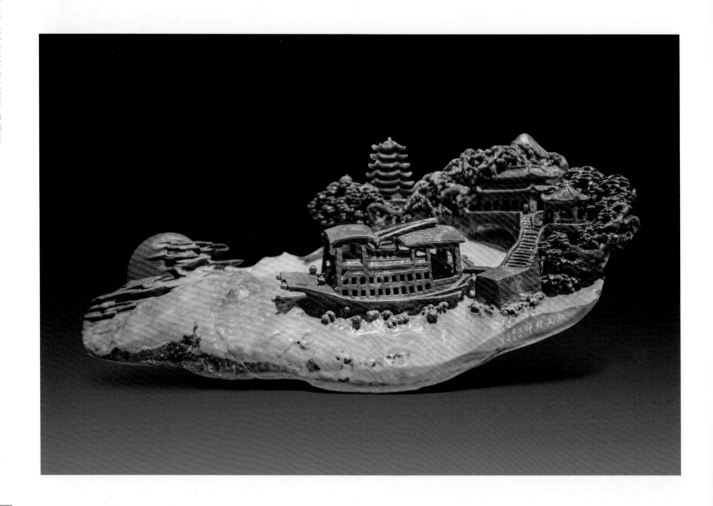

Stone Carving Craft

石雕工艺

红船精神　石雕　45cm×30cm×30cm　裘良军　丽水

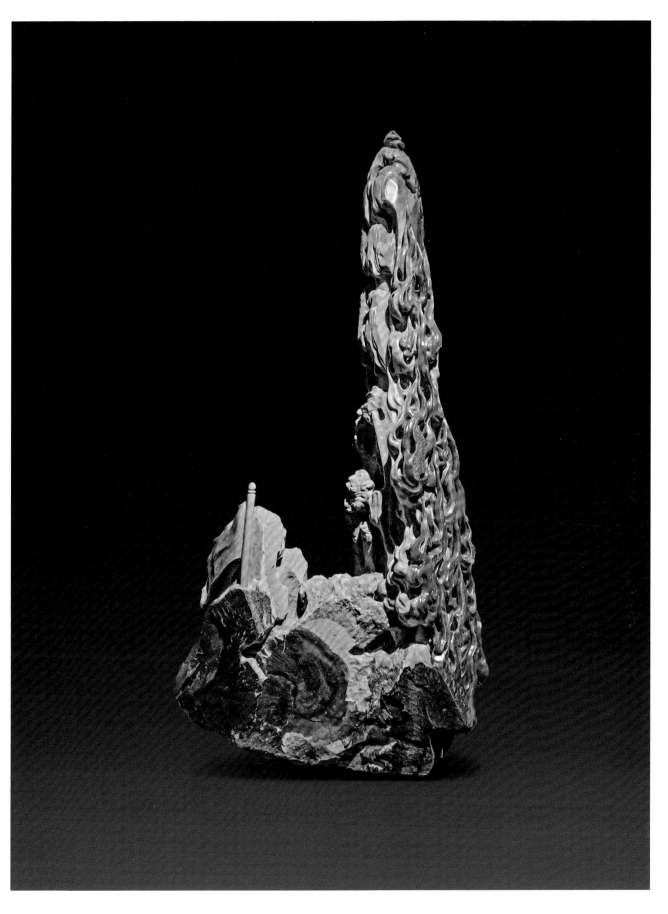

星火燎原　石雕　40cm×20cm×90cm　裘良军　丽水

Stone Carving Craft

石雕工艺

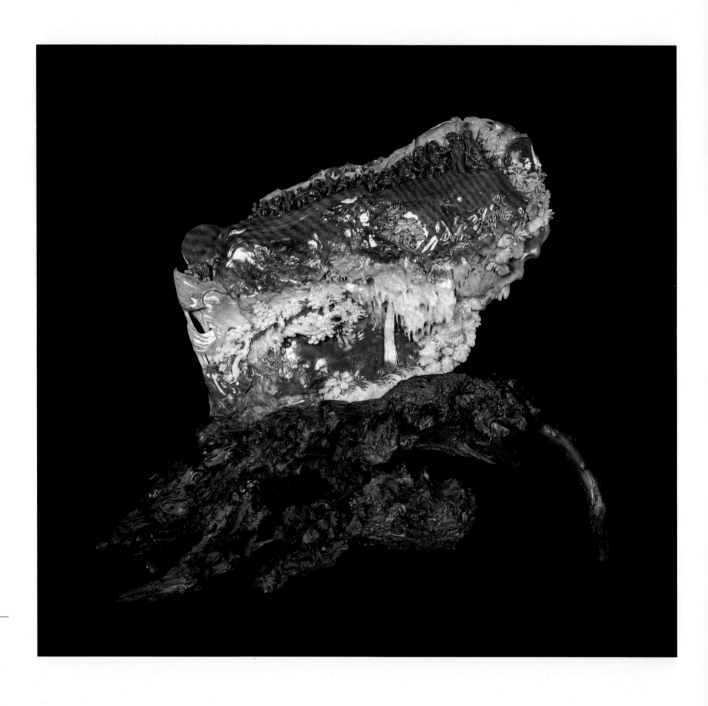

会师　石雕　31cm×7cm×25cm　凌东辉　杭州

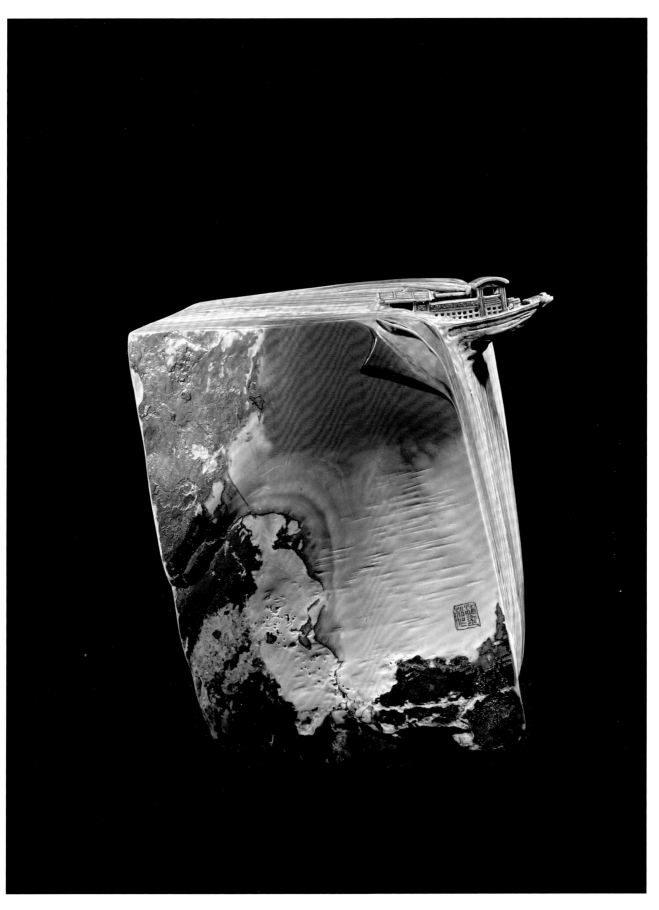

继往开来　石雕　29cm×30cm×10cm　潘金松　温州

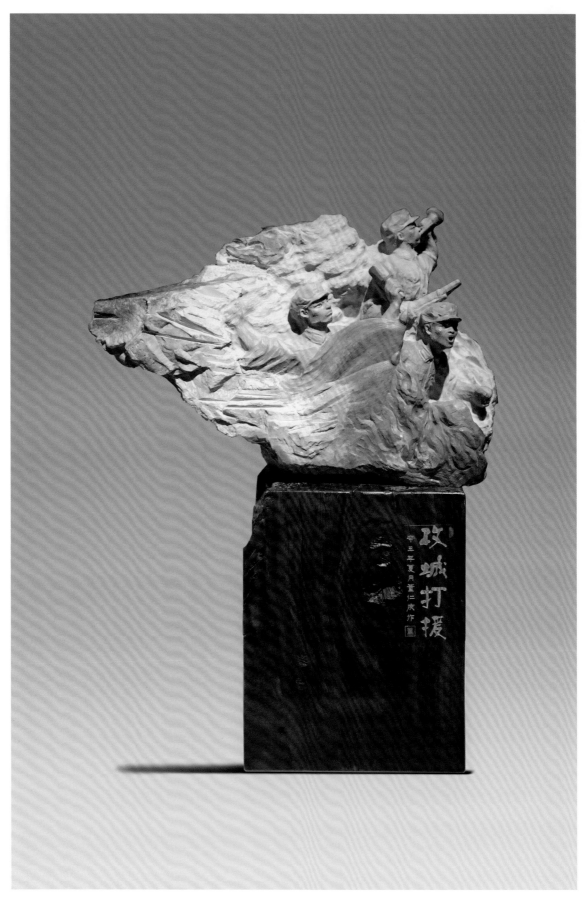

庆祝中国共产党成立 100 周年暨第五届浙江工艺美术双年展作品选集
Selected Works from the 5th Zhejiang Arts and Crafts Biennial Exhibition Celebrating the 100th Anniversary of the Founding of the CPC

Stone Carving Craft

石雕工艺

攻城打援　石雕　51cm×20cm×67cm　董仁庆　温州

庆祝中国共产党成立100周年暨第五届浙江工艺美术双年展作品选集

Selected Works Anthology for Zhejiang Crafts Selection of Arts and Crafts Celebrating the 100th Anniversary of the Communist Party of China

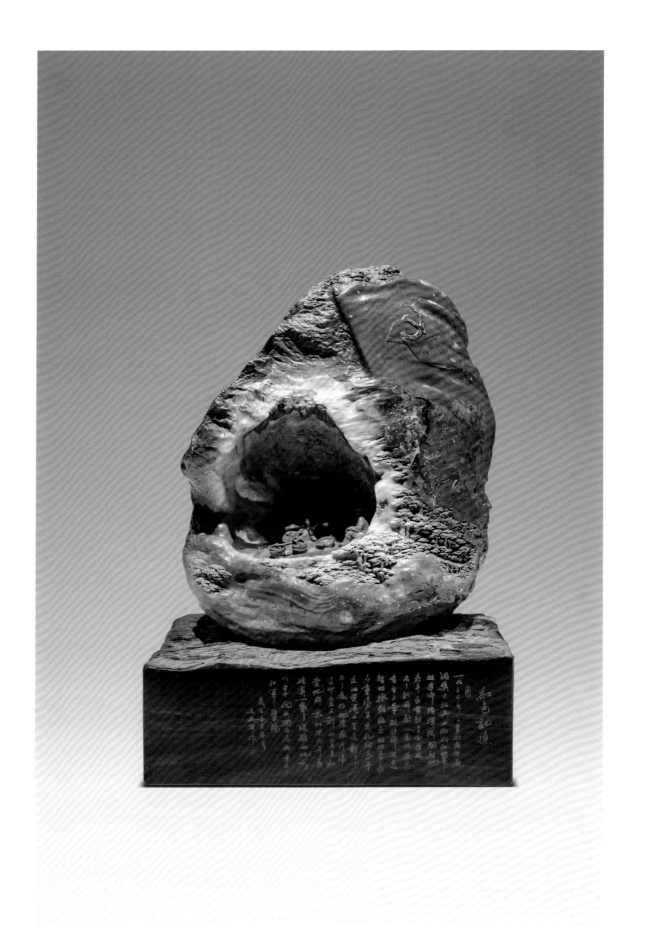

红色记忆 石雕　41cm×26cm×45cm　王尚可　温州

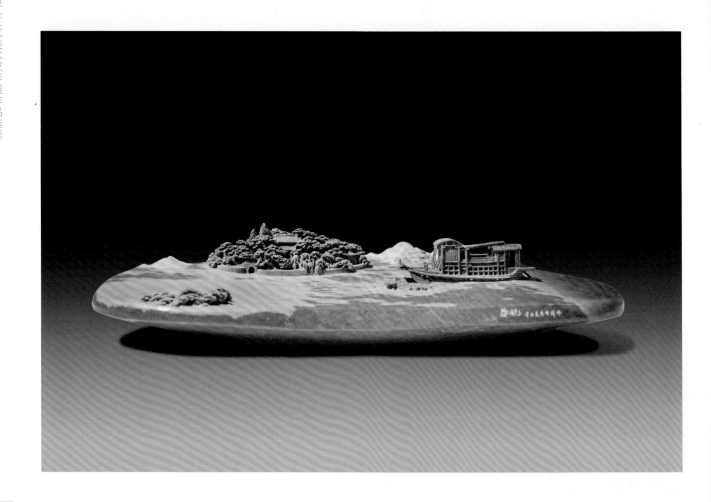

启航　石雕　65cm×30cm×15cm　黄雪峰　丽水

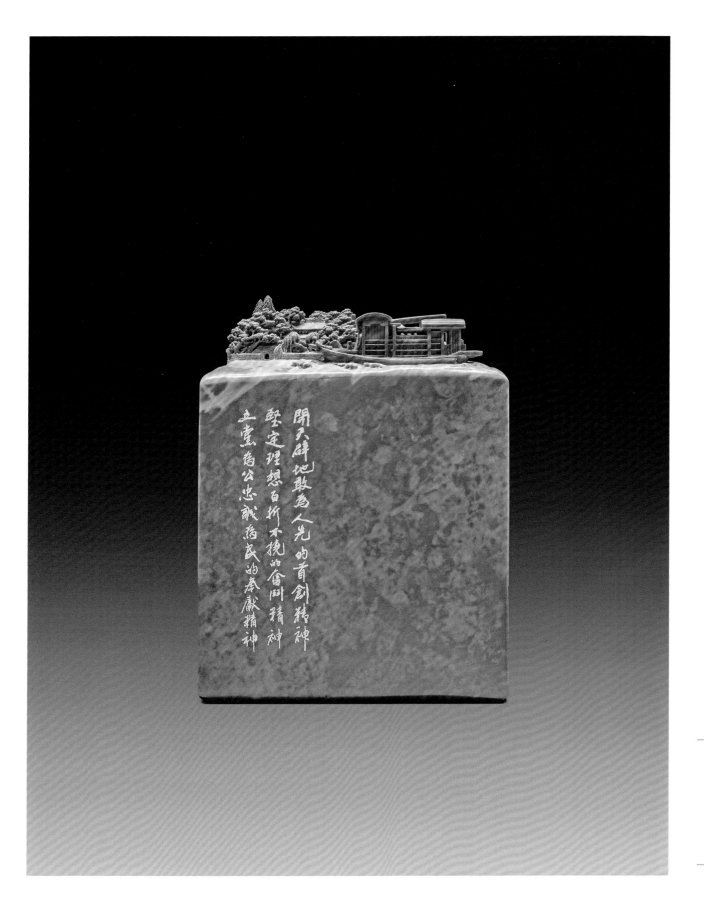

红船精神　石雕　18cm×18cm×28cm　黄雪峰　丽水

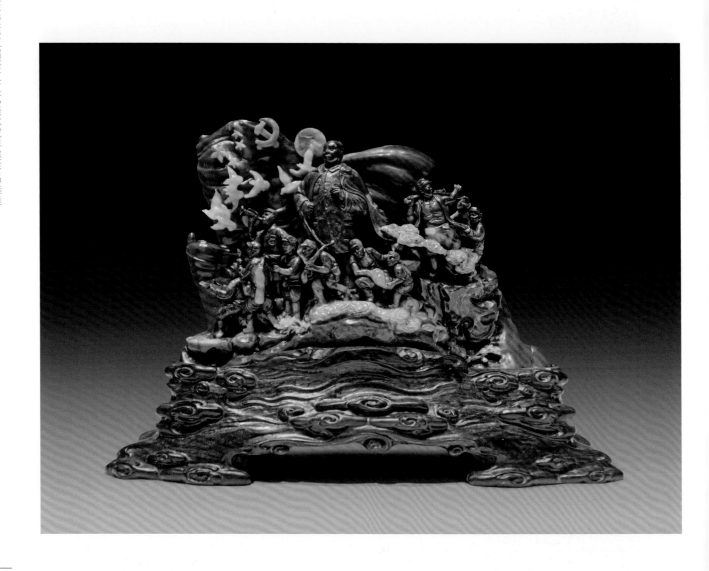

Stone Carving Craft

石雕工艺

长征 石雕 33cm×10cm×23cm 梅军华 杭州

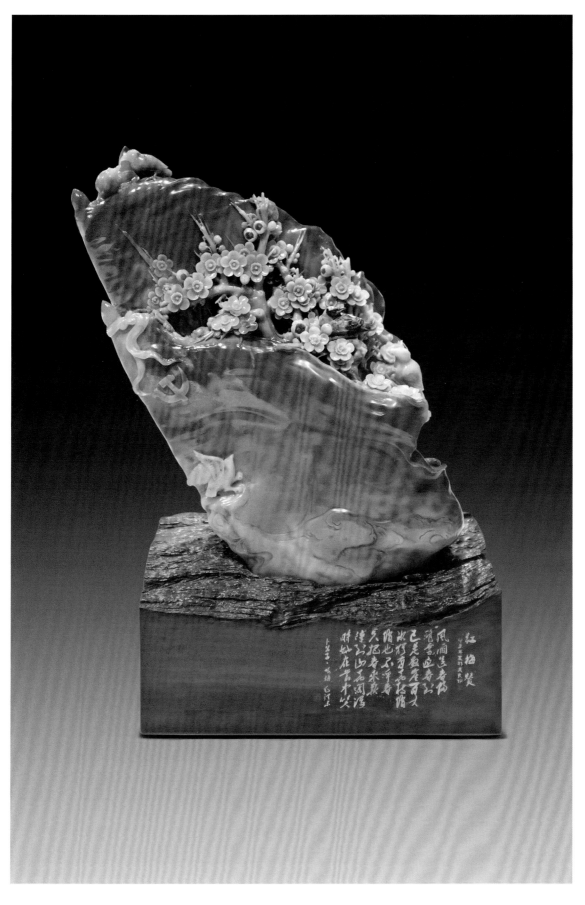

红梅赞　石雕　30cm×16cm×46cm　林志良　温州

庆祝中国共产党成立 100 周年暨第五届浙江工艺美术双年展作品选集

Selected Works from the 5th Zhejiang Arts and Crafts Biennial Exhibition Celebrating the 100th Anniversary of the Founding of the CPC

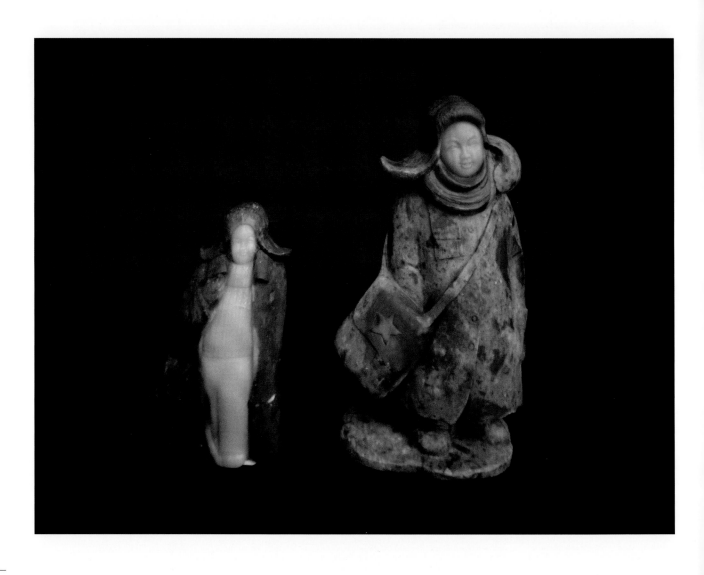

不忘初心　石雕　5cm×4cm×15cm、10cm×5cm×25cm　胡植柱　温州

幸福一家　石雕　33cm×20cm×32cm　郑道华　温州

庆祝中国共产党成立 100 周年暨第五届浙江工艺美术双年展作品选集

Selected Works from the 8th Zhejiang Arts and Crafts Biennial Exhibition Celebrating the 100th Anniversary of the Founding of the CPC

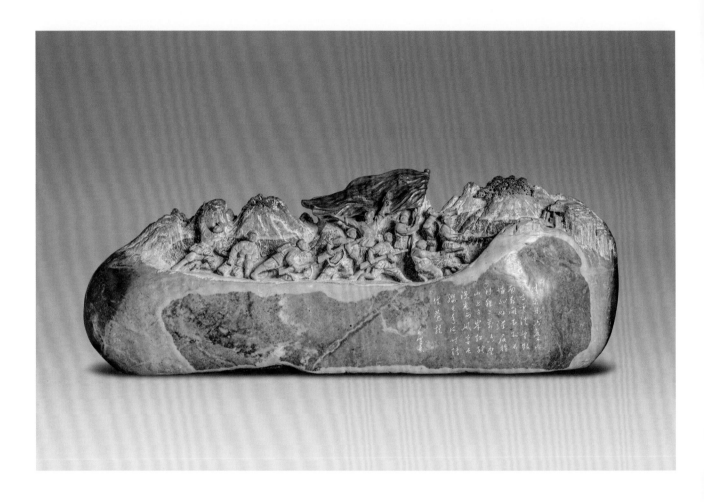

Stone Carving Craft

石雕工艺

光辉历程　石雕　90cm×25cm×38cm　郑放鸣　温州

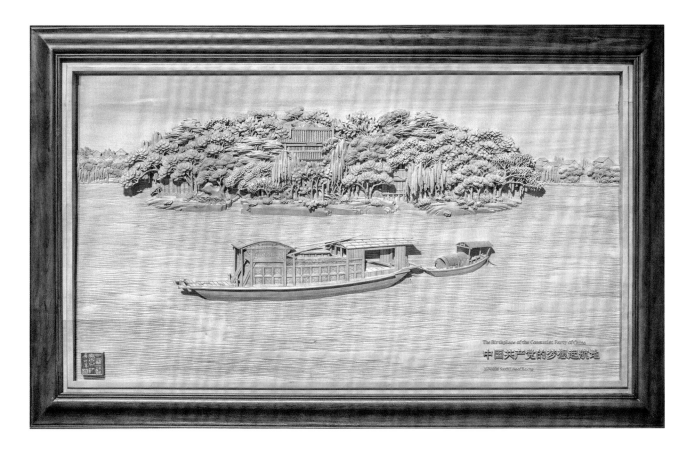

中国共产党的梦想起航地 木雕 100cm×160cm×7cm 吴初伟 金华

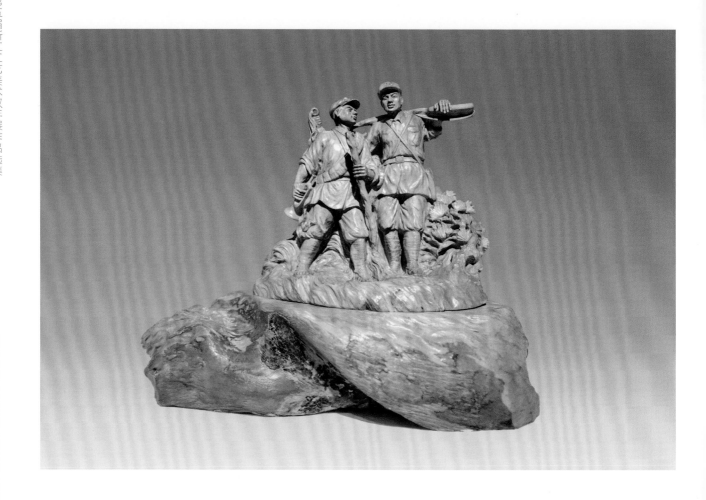

长征路上　木雕　50cm×40cm×30cm　虞金顺　温州

庆祝中国共产党成立 100 周年暨第五届浙江工艺美术双年展作品选集

Selected Works from the 5th Zhejiang Arts and Crafts Biennial Exhibition Celebrating the 100th Anniversary of the Founding of the CPC

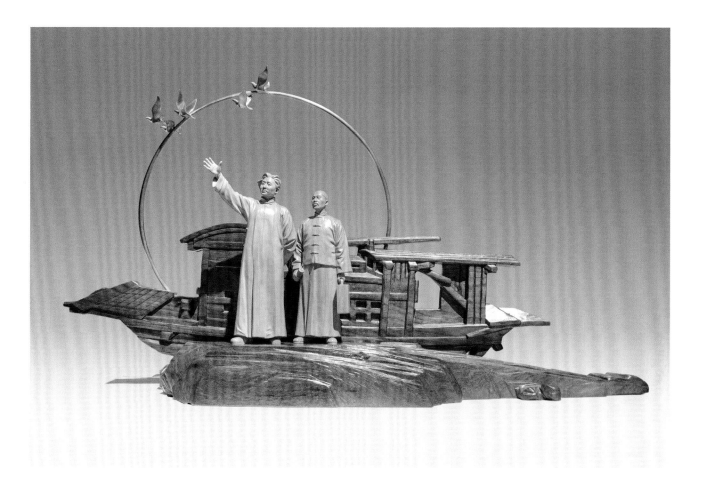

开天辟地　木雕　128cm×30cm×75cm　吴尧辉　温州

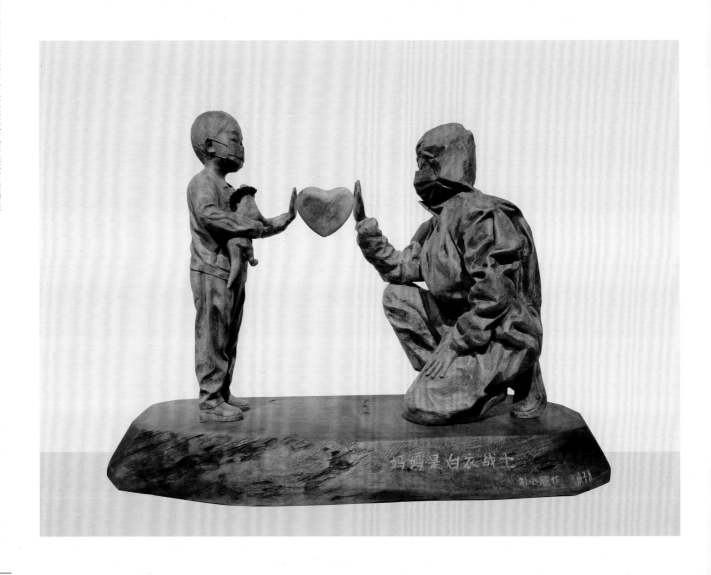

妈妈是白衣战士　木雕　57cm×22cm×41cm　刘小聪　杭州

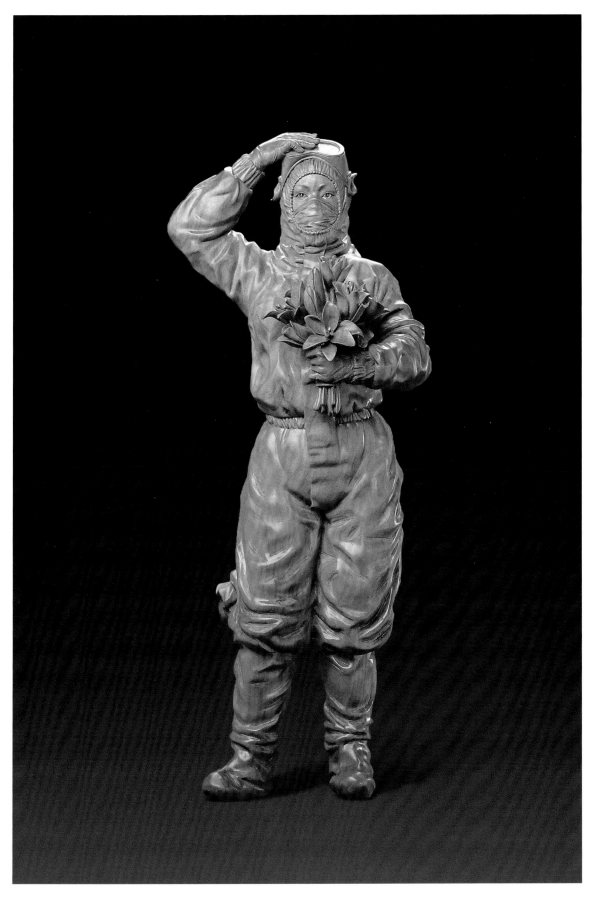

献给她的花束　木雕　31cm×28cm×102cm　叶小鹏　温州

庆祝中国共产党成立 100 周年暨第五届浙江工艺美术双年展作品选集

Selected Works from the 5th Zhejiang Arts and Crafts Biennial Exhibition Celebrating the 100th Anniversary of the Founding of the CPC

红色赓续 木雕 45cm×45cm×5cm×4 王向东 金华

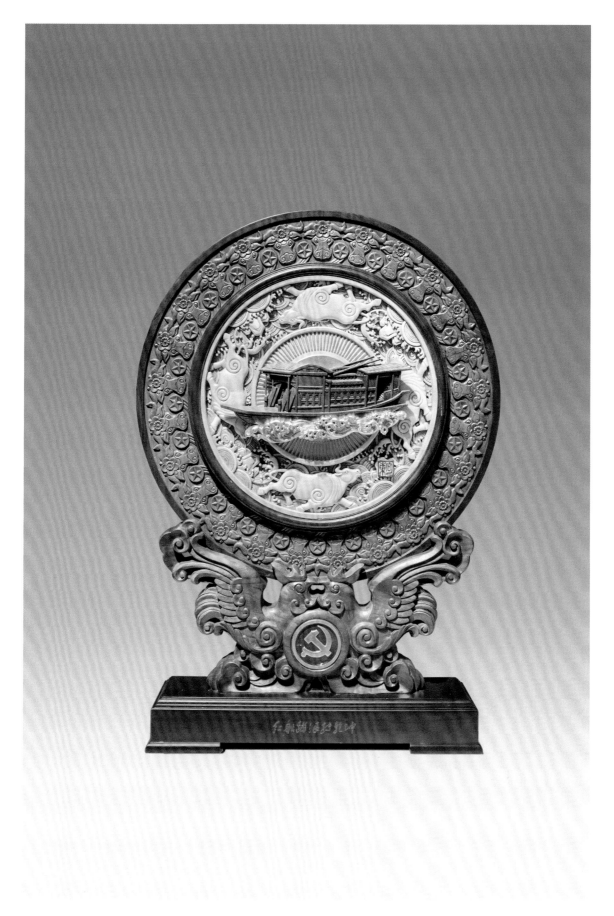

庆祝中国共产党成立 100 周年暨第五届浙江工艺美术双年展作品选集

Selected Works from the 5th Zhejiang Arts and Crafts Biennial Exhibition Celebrating the 100th Anniversary of the Founding of the CPC

红船踏浪转乾坤 木雕 60cm×14cm×85cm 王向东 金华

庆祝中国共产党成立 100 周年暨第五届浙江工艺美术双年展作品选集

Selected Works from the 5th Zhejiang Arts and Crafts Biennial Exhibition Celebrating the 100th Anniversary of the Founding of the CPC

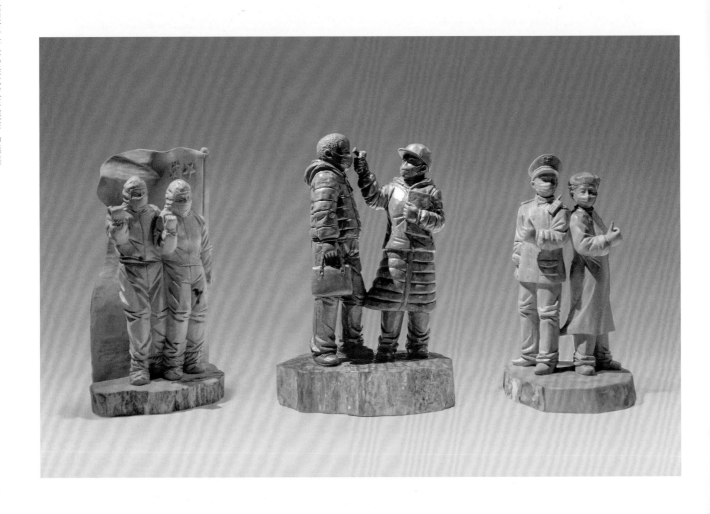

战疫 木雕 55cm×30cm×20cm 潘修科 温州

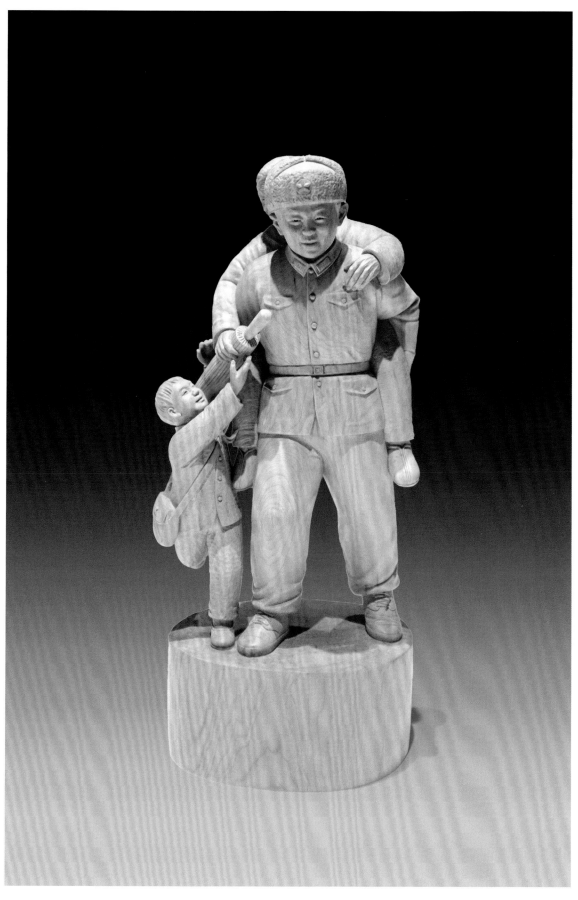

庆祝中国共产党成立 100 周年暨第五届浙江工艺美术双年展作品选集

Selected Works from the 5th Zhejiang Arts and Crafts Biennial Exhibition Celebrating the 100th Anniversary of the Founding of the CPC

时代楷模——雷锋　木雕　15cm×16cm×36cm　叶立丰　温州

追梦　木雕　53cm×16.5cm×36cm　牟湘波　温州

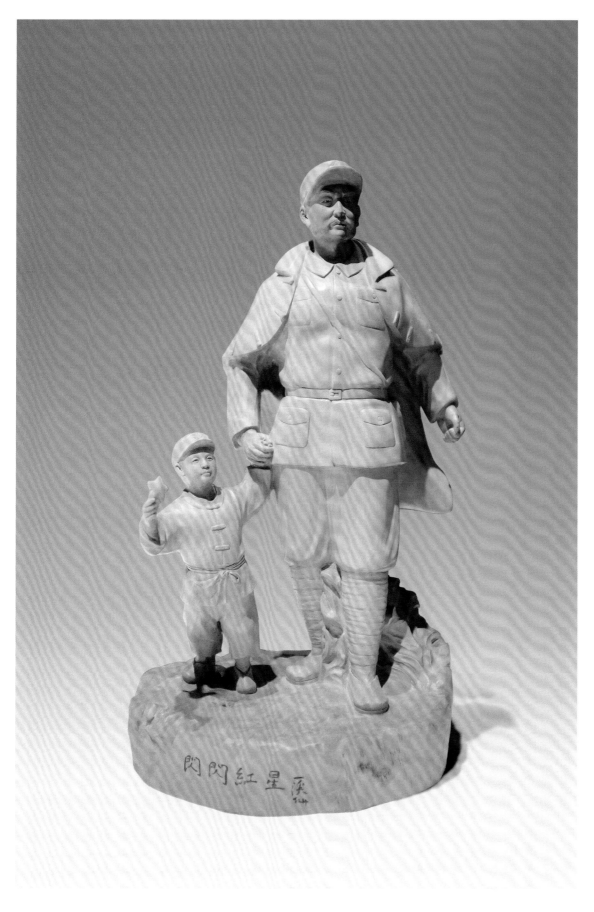

闪闪红星 木雕 48cm×24cm×18cm 叶芳林 温州

庆祝中国共产党成立 100 周年暨第五届浙江工艺美术双年展作品选集

Selected Works from the 5th Zhejiang Arts and Crafts Biennial Exhibition Celebrating the 100th Anniversary of the Founding of the CPC

敬礼　木雕　16cm×60cm×38cm　陈绵旦　杭州

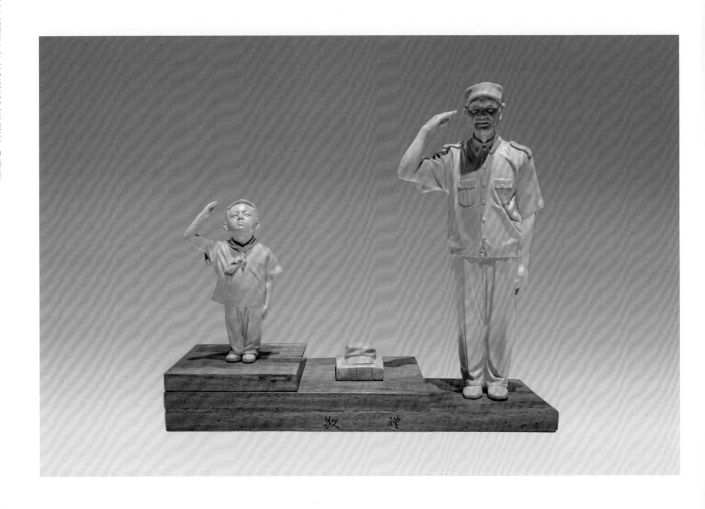

敬礼　木雕　16cm×60cm×38cm　陈绵旦　杭州

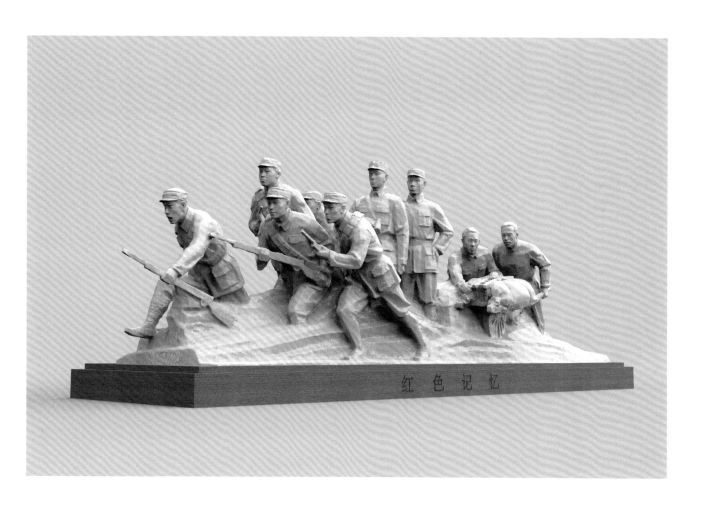

红色记忆 黄杨木雕 65cm×25cm×30cm 徐庆丰 杭州

庆祝中国共产党成立 100 周年暨第五届浙江工艺美术双年展作品选集

Selected Works from the 5th Zhejiang Arts and Crafts Biennial Exhibition Celebrating the 100th Anniversary of the Founding of the CPC

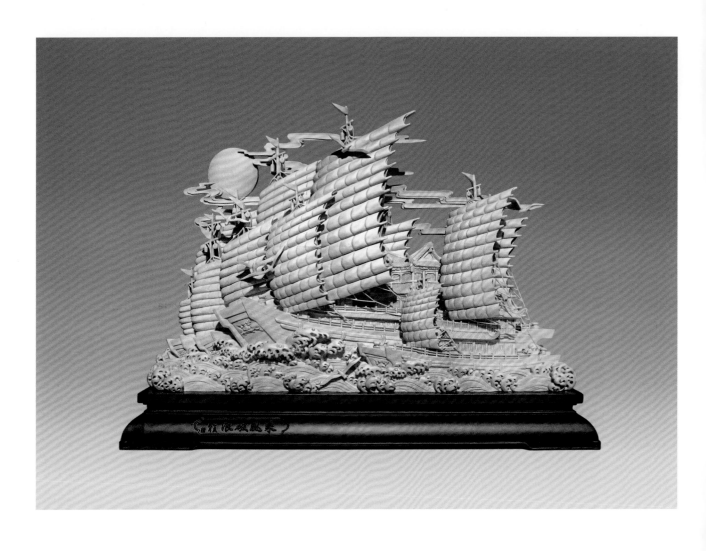

Wood And Bamboo Carving Craft

木竹雕刻工艺

乘风破浪　木雕　75cm×45cm×18cm　陆会勇　金华

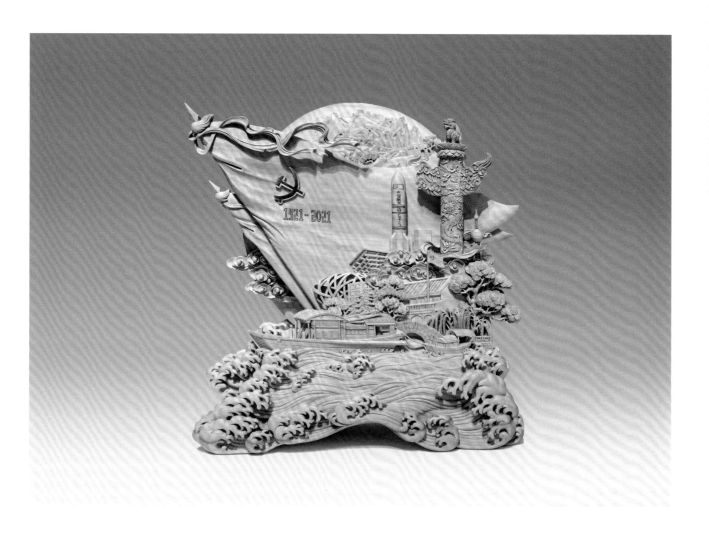

庆祝中国共产党成立 100 周年暨第五届浙江工艺美术双年展作品选集
Selected Works from the 5th Zhejiang Arts and Crafts Biennial Exhibition Celebrating the 100th Anniversary of the Founding of the CPC

Wood And Bamboo Carving Craft

木竹雕刻工艺

盛世中华　木雕　40cm×16cm×40cm　郭向峰、郭荣杰　金华

庆祝中国共产党成立 100 周年暨第五届浙江工艺美术双年展作品选集

Selected Works from the 5th Zhejiang Arts and Crafts Biennial Exhibition Celebrating the 100th Anniversary of the Founding of the CPC

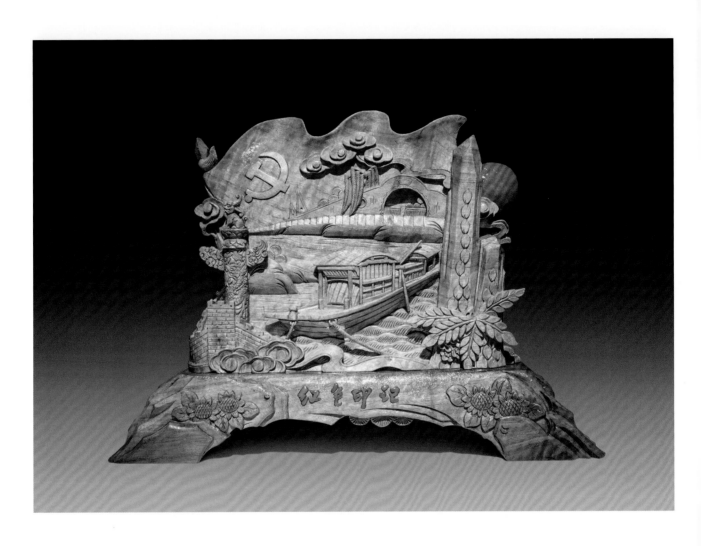

红色印记　木雕　60cm×10cm×40cm　倪孝平　杭州

Wood And Bamboo Carving Craft

木竹雕刻工艺

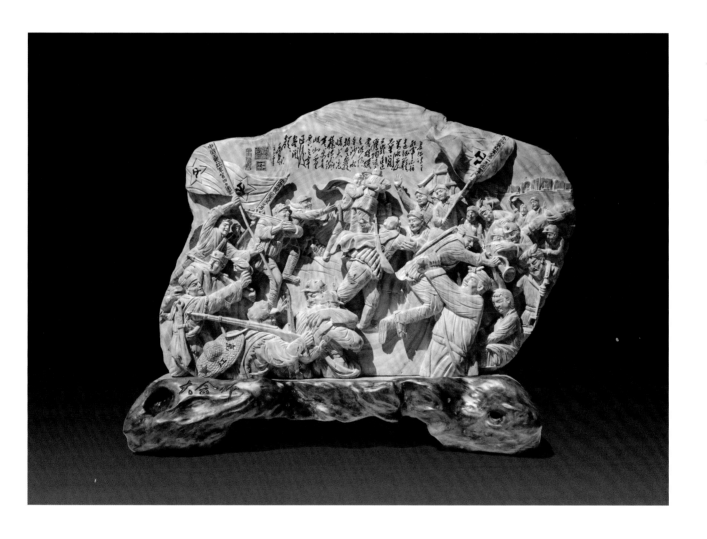

三军大会师　　木雕　80cm×100cm×12cm　胡兴财　衢州

庆祝中国共产党成立100周年暨第五届浙江工艺美术双年展作品选集

Selected Works from the 5th Zhejiang Arts and Crafts Biennial Exhibition Celebrating the 100th Anniversary of the Founding of the CPC

Ceramic Craft

陶瓷工艺

不忘初心·牢记使命　青瓷　30cm×30cm×37.5cm　徐朝兴　丽水

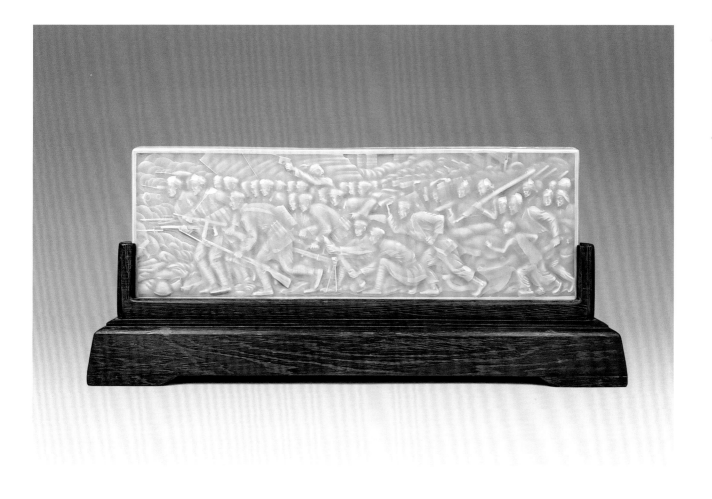

庆祝中国共产党成立 100 周年暨第五届浙江工艺美术双年展作品选集

Jinizhao Works from the 5th Zhejiang Arts and Crafts Biennial Exhibition Celebrating the 100th Anniversary of the Founding of the CPC

烽火记忆　青瓷　38cm×10cm×13cm　周晓峰　丽水

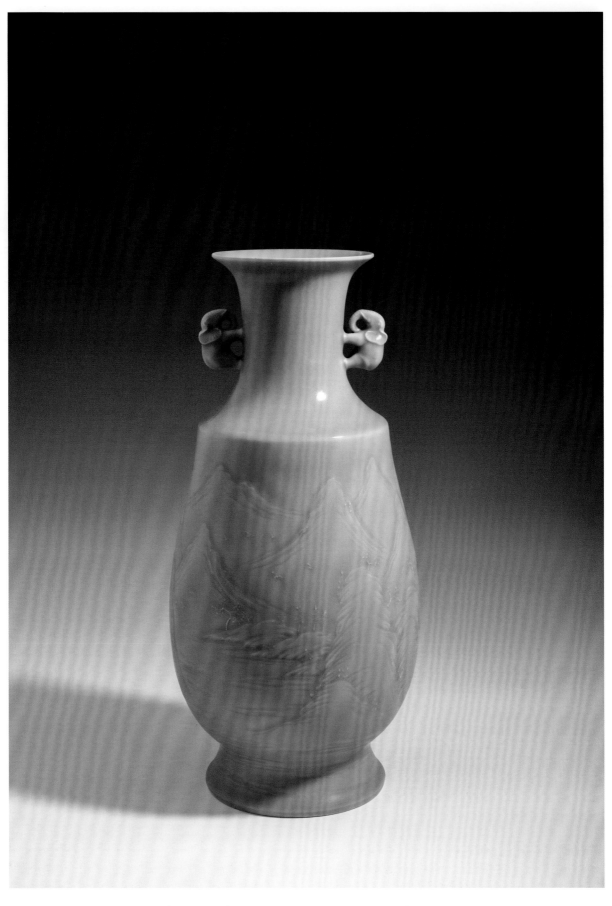

庆祝中国共产党成立 100 周年暨第五届浙江工艺美术双年展作品选集
Selected Works from the 5th Zhejiang Arts and Crafts Biennial Exhibition Celebrating the 100th Anniversary of the Founding of the CPC

Ceramic Craft

陶瓷工艺

百年记忆——启 青瓷 18cm×18cm×40cm 吴建春 丽水

同心向党 青瓷 60cm×50cm（展示尺寸） 叶芳 丽水

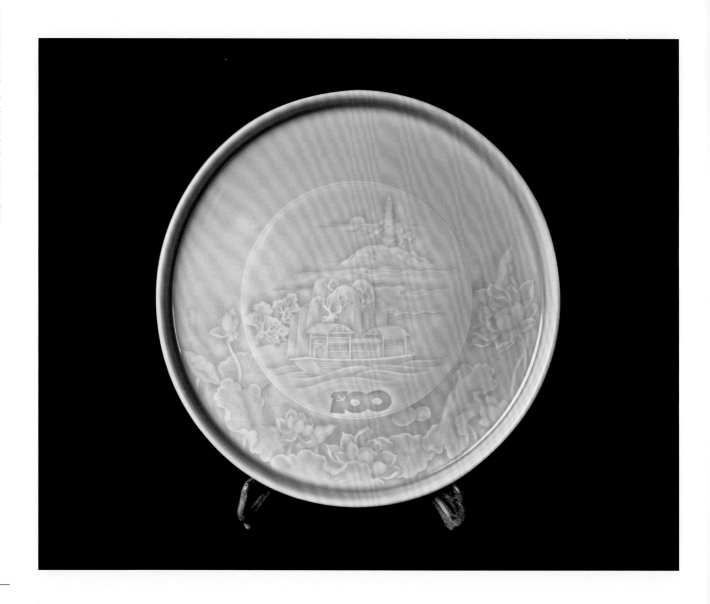

光辉的历程　青瓷　42cm×42cm　罗洪文　杭州

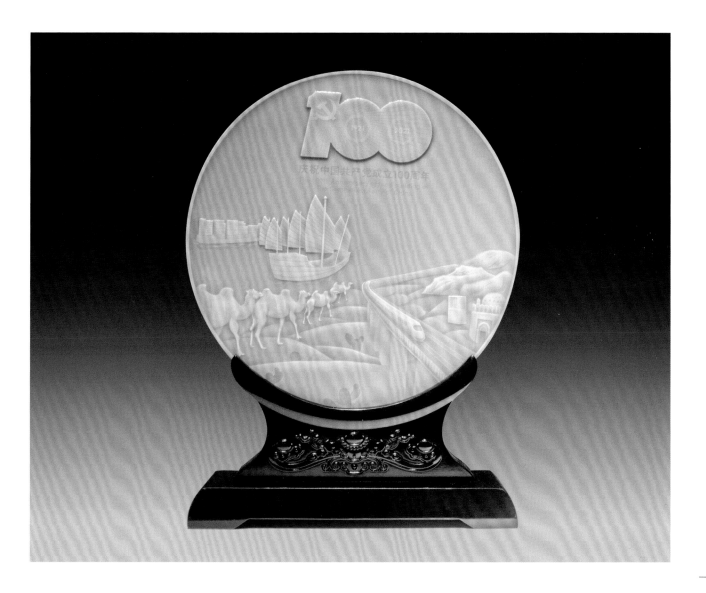

远眺前行 青瓷 41cm×41cm×65cm 李茂林 丽水

庆祝中国共产党成立 100 周年暨第五届浙江工艺美术双年展作品选集

Selected Works from the 5th Zhejiang Arts and Crafts Biennial Exhibition Celebrating the 100th Anniversary of the Founding of the CPC

Ceramic Craft

陶瓷工艺

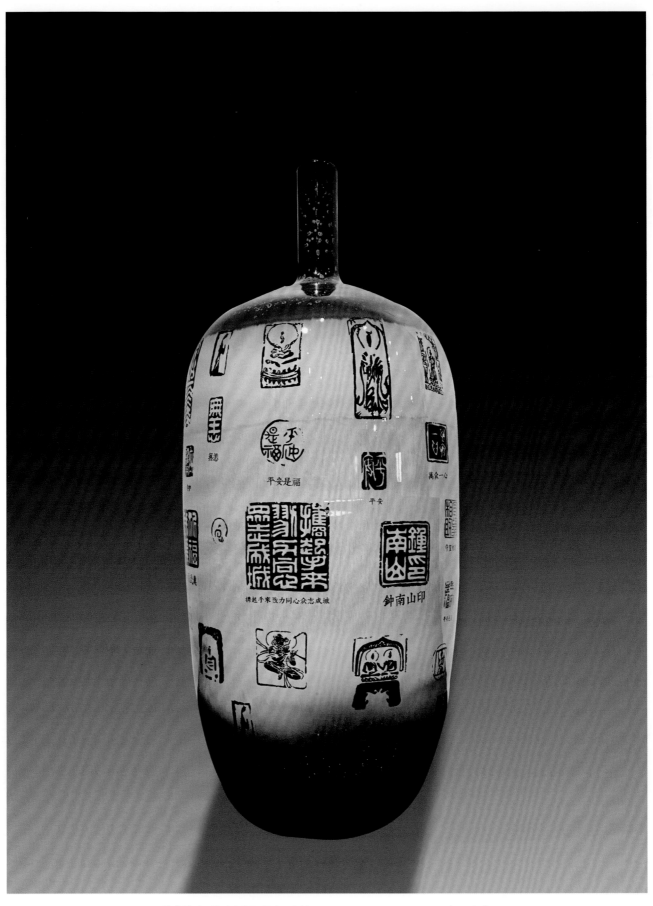

婺窑瓷印·抗疫祈福系列　陶瓷　22cm×22cm×47cm　顾童　金华

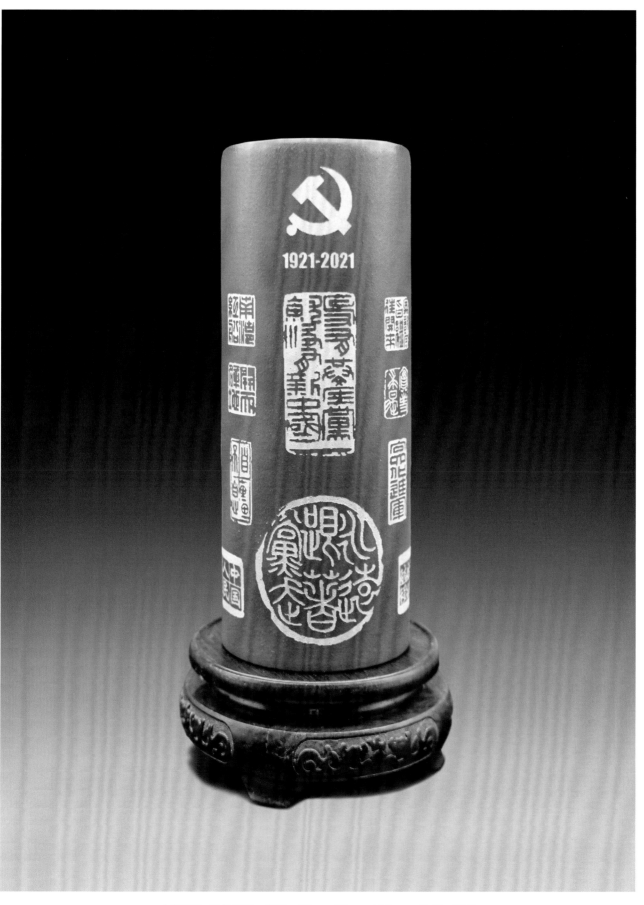

中流砥柱·赤色印记　紫砂　7.3cm×7.3cm×18.3cm　陈峰　湖州

庆祝中国共产党成立 100 周年暨第五届浙江工艺美术双年展作品选集

Selected Works from the 5th Zhejiang Arts and Crafts Biennial Exhibition Celebrating the 100th Anniversary of the Founding of the CPC

Ceramic Craft

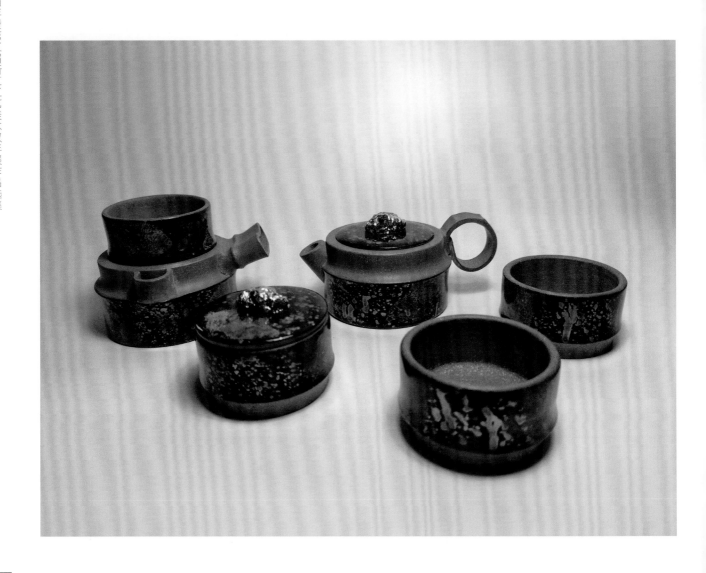

陶瓷工艺

百年星火　紫砂　50cm×60cm（展示尺寸）　杭鑫　湖州

庆祝中国共产党成立 100 周年暨第五届浙江工艺美术双年展作品选集

Side-Shot Works from the 5th Zhejiang Arts and Crafts Biennial Exhibition Celebrating the 100th Anniversary of the Founding of the CPC

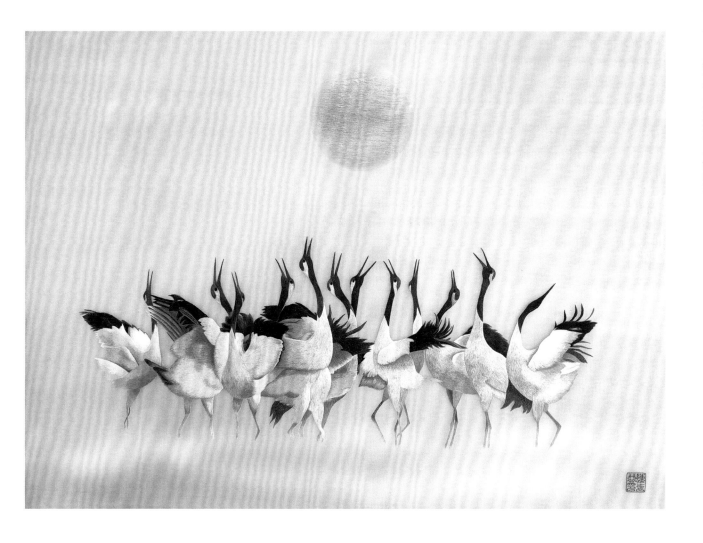

群仙迎朝阳　杭绣　105cm×144cm　陈水琴　杭州

庆祝中国共产党成立 100 周年暨第五届浙江工艺美术双年展作品选集

Selected Works from the 5th Zhejiang Arts and Crafts Biennial Exhibition Celebrating the 100th Anniversary of the Founding of the CPC

源 台绣　140cm×100cm　林霞　台州

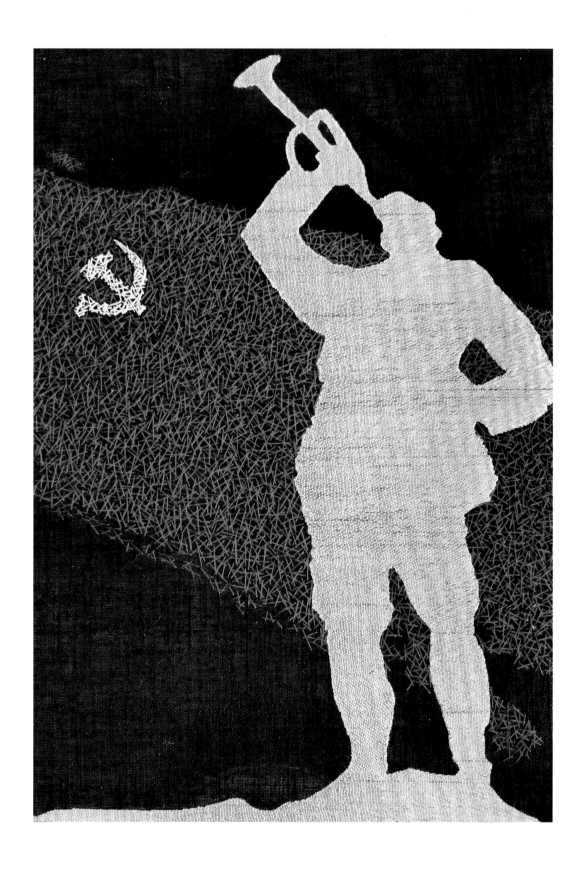

金色号手　杭绣　50cm×80cm　金家虹　杭州

庆祝中国共产党成立 100 周年暨第五届浙江工艺美术双年展作品选集

Selected Works from the 5th Zhejiang Arts and Crafts Biennial Exhibition Celebrating the 100th Anniversary of the Founding of the CPC

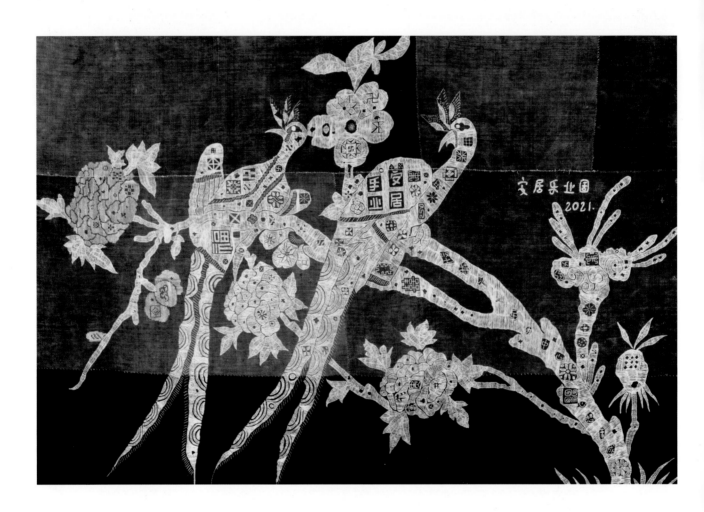

安居乐业图　刺绣　190cm×130cm　廖春妹、卢钇君　台州

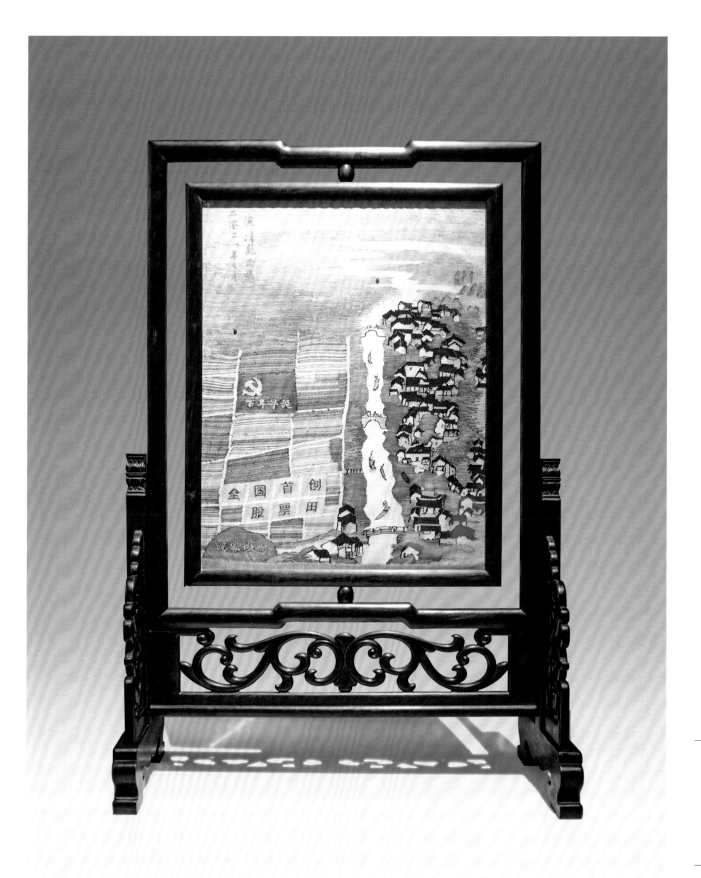

庆祝中国共产党成立 100 周年暨第五届浙江工艺美术双年展作品选集
Selected Works from the 5th Zhejiang Arts and Crafts Biennial Exhibition Celebrating the 100th Anniversary of the Founding of the CPC

刺绣工艺

Embroidery Craft

股票田　缂丝　73cm×46cm×4.1cm　柯翔祥　湖州

遥望 手工挂毯　85cm×85cm　郑丹　嘉兴

庆祝中国共产党成立100周年暨第五届浙江工艺美术双年展作品选集

Selected Works From the 5th Zhejiang Arts and Crafts Biennial Exhibition Celebrating the 100th Anniversary of the Founding of the CPC

Sculpture Craft

堆塑工艺

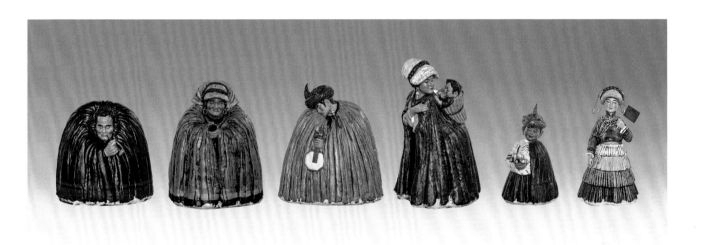

公路通到家门口　泥塑　200cm×60cm×40cm（展示尺寸）　宓风光　绍兴

Sculpture Craft

堆塑工艺

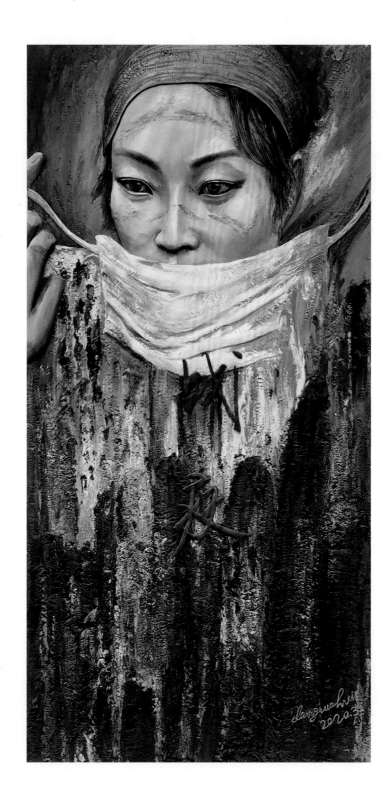

战疫 瓯塑 95cm×55cm 董若慧 温州

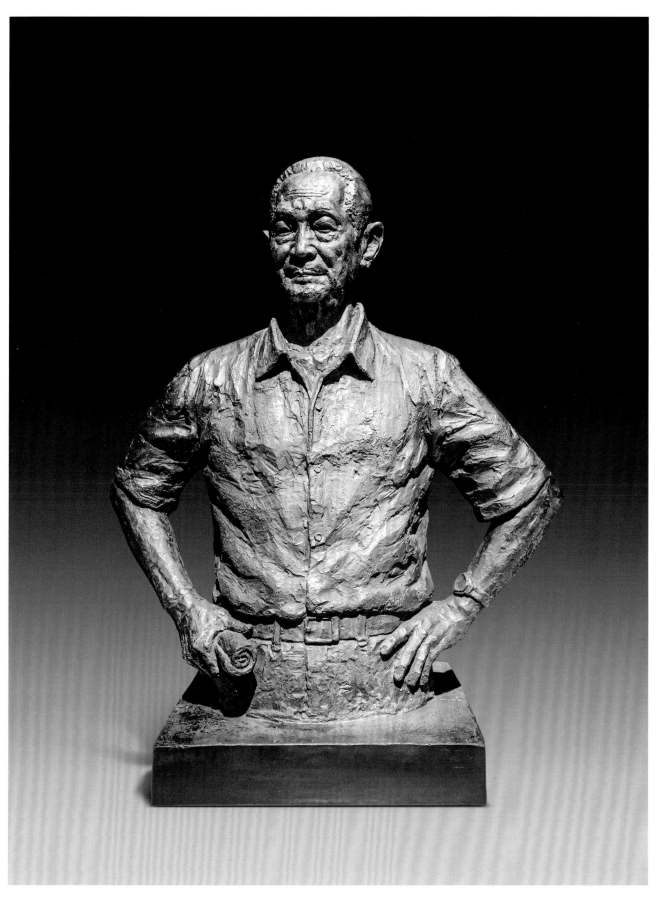

袁隆平半身像　泥塑　82cm×42cm×106cm　郑福海　宁波

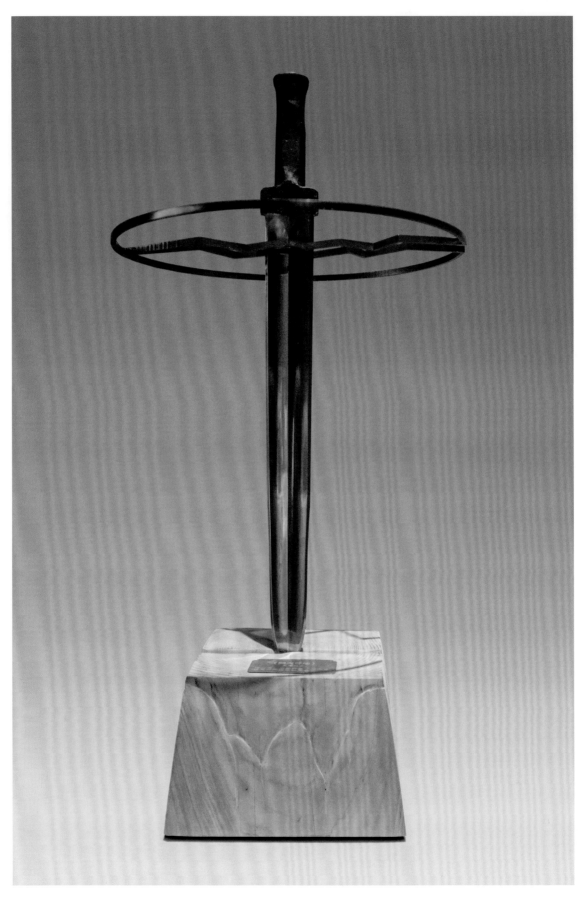

开天辟地 宝剑 50cm×85cm 查长伟 丽水

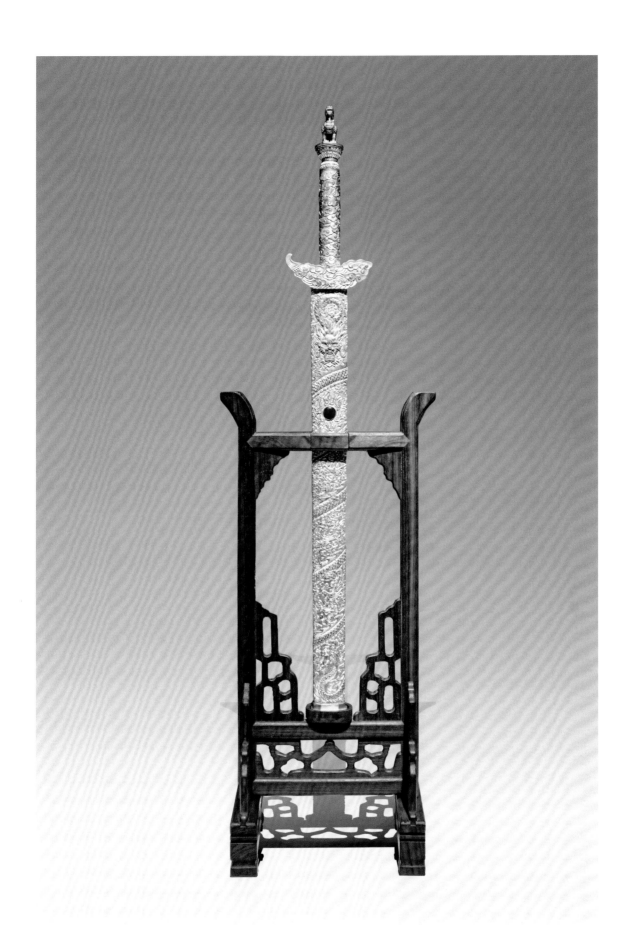

盛世之剑　宝剑　122cm×36cm　江龙　丽水

庆祝中国共产党成立 100 周年暨第五届浙江工艺美术双年展作品选集

Selected Works from the 5th Zhejiang Arts and Crafts Biennial Exhibition Celebrating the 100th Anniversary of the Founding of the CPC

伟大成就 金属工艺 80cm×80cm 谢善法 舟山

庆祝中国共产党成立 100 周年暨第五届浙江工艺美术双年展作品选集

Selected Works from the 5th Zhejiang Arts and Crafts Biennial Exhibition Celebrating the 100th Anniversary of the Founding of the CPC

绿水青山就是金山银山 扇艺 80cm×50cm×15cm×2 游晓婷 杭州

真理的味道　竹编　153cm×205cm　何福礼　金华

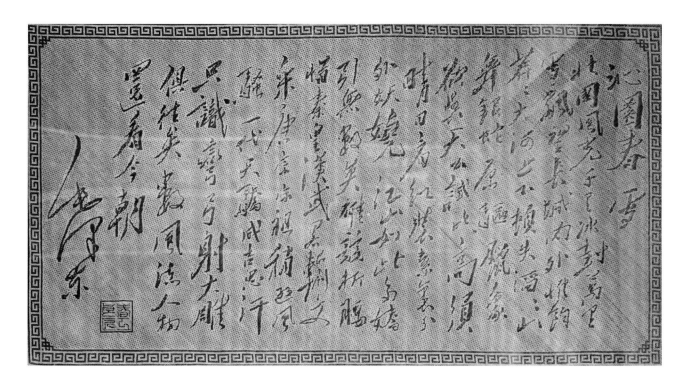

沁园春·雪　竹编　168.5cm×92cm　毛春良　衢州

庆祝中国共产党成立 100 周年暨第五届浙江工艺美术双年展作品选集

Selected Works from the 5th Zhejiang Arts and Crafts Biennial Exhibition Celebrating the 100th Anniversary of the Founding of the CPC

红船　竹编　65cm×18cm×21cm　钱鑫明　嘉兴

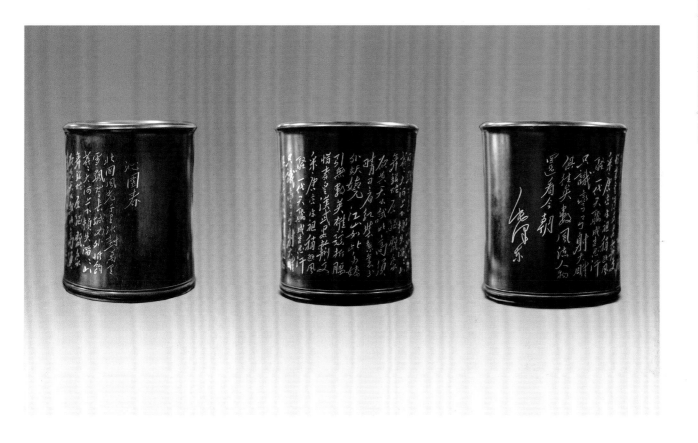

沁园春·雪　紫檀嵌银　12cm×11cm　徐凤鸣　杭州

百年风华卷　扇艺　110cm×30cm×80cm　孙亚青　杭州

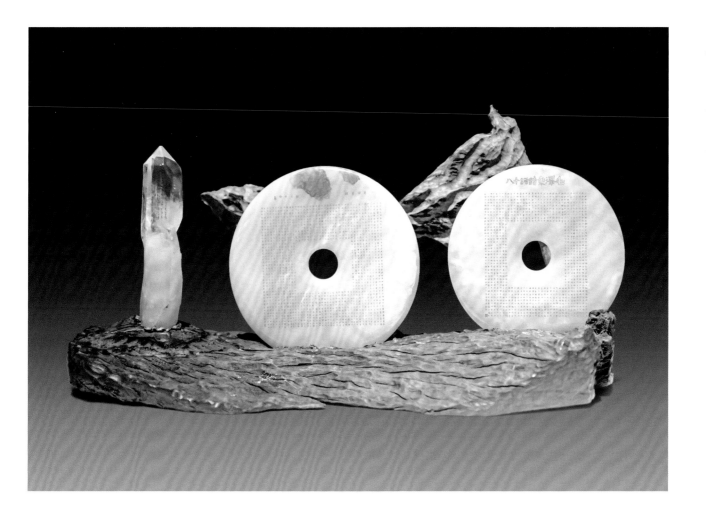

百年庆　微雕　60cm×40cm×25cm　胡慧达　绍兴

庆祝中国共产党成立 100 周年暨第五届浙江工艺美术双年展作品选集

Selected Works from the 5th Zhejiang Arts and Crafts Biennial Exhibition Celebrating the 100th Anniversary of the Founding of the CPC

综合工艺

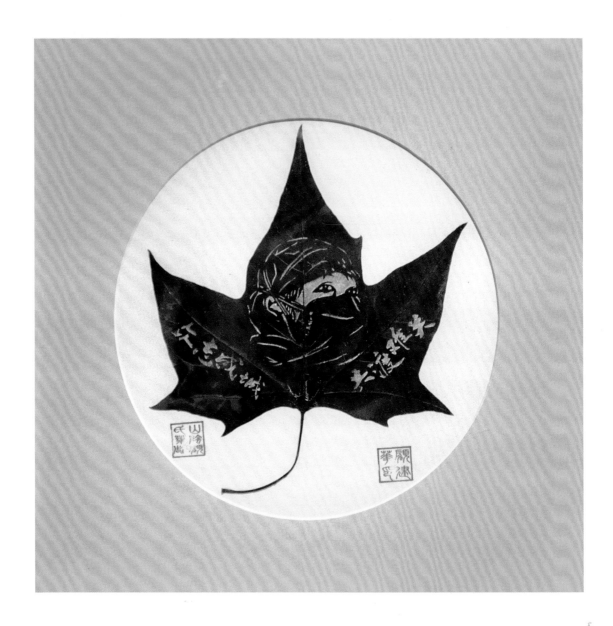

逆行者 叶雕 37.5cm×37.5cm 顾建华 绍兴

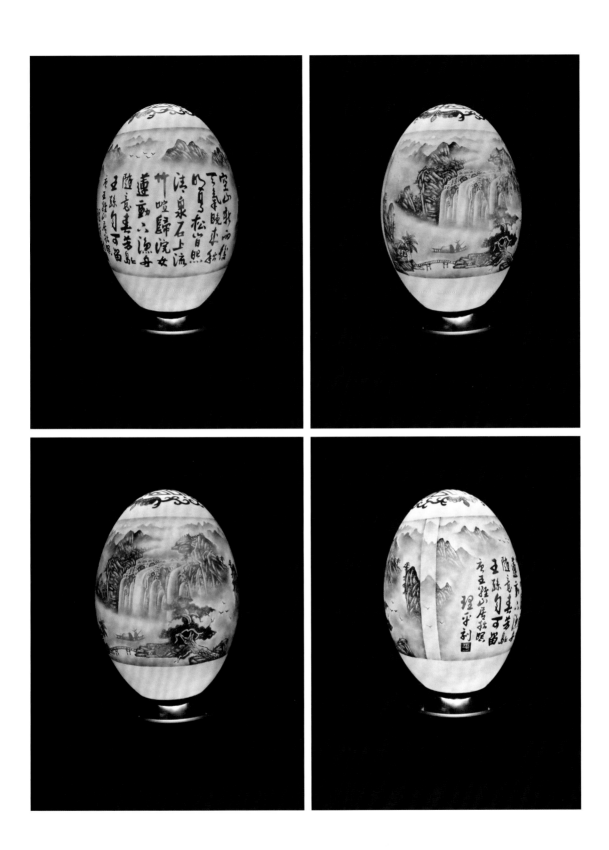

庆祝中国共产党成立100周年暨第五届浙江工艺美术双年展作品选集

Selected Works from the 5th Zhejiang Arts and Crafts Biennial Exhibition Celebrating the 100th Anniversary of the Founding of the CPC

山河无恙·人间皆安　蛋雕　10cm×8cm×18cm　戴理平　衢州

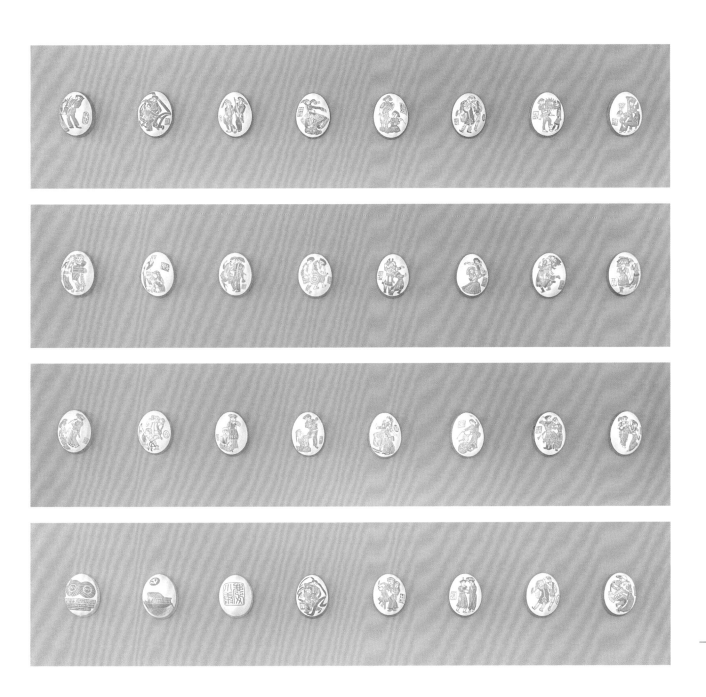

百年华诞庆小康　蛋雕　100cm×30cm×8　潘夏皓　衢州

不忘初心
牢记使命

红色起点　玻璃工艺　68cm×90cm×5cm　项之华　温州

红船·精神　漆艺　150cm×30cm×50cm　毛伟峰、谢比丽　宁波

庆祝中国共产党成立 100 周年暨第五届浙江工艺美术双年展作品选集

Selected Works from the 5th Zhejiang Arts and Crafts Biennial Exhibition Celebrating the 100th Anniversary of the Founding of the CPC

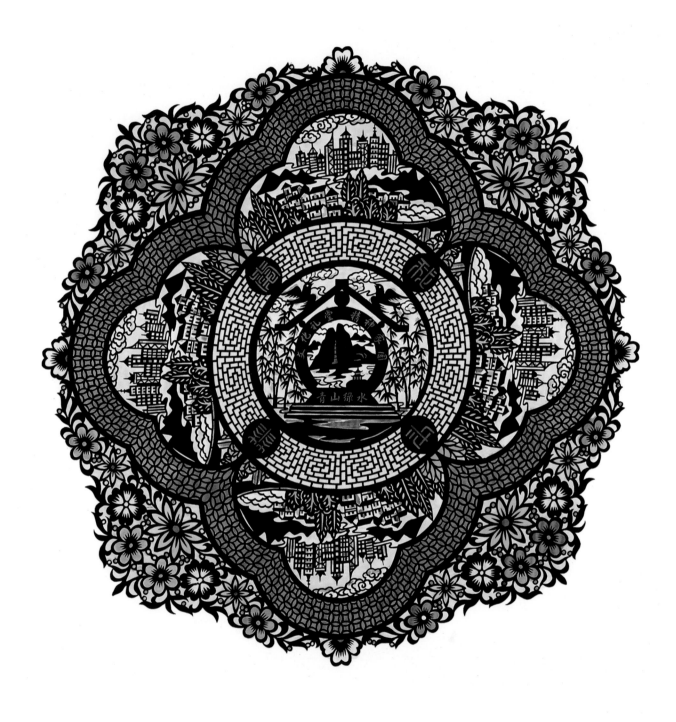

锦绣中华　剪纸　39cm×39cm　周唯好　温州

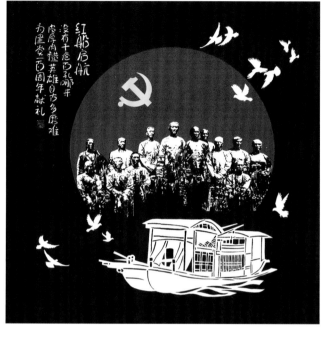

东方红·光辉历程 剪纸 90cm×90cm×4 张秀娟、杨雨潇 台州

庆祝中国共产党成立 100 周年暨第五届浙江工艺美术双年展作品选集

Selected Works from the 5th Zhejiang Arts and Crafts Biennial Exhibition Celebrating the 100th Anniversary of the Founding of the CPC

Chinese Paper Cutting Craft

剪纸工艺

新行当　剪纸　122cm×90cm（展示尺寸）　沈扬　台州

庆祝中国共产党成立100周年暨第五届浙江工艺美术双年展作品选集

Selected Works from the 8th Zhejiang Arts and Crafts Biennial Exhibition Celebrating the 100th Anniversary of the Founding of the CPC

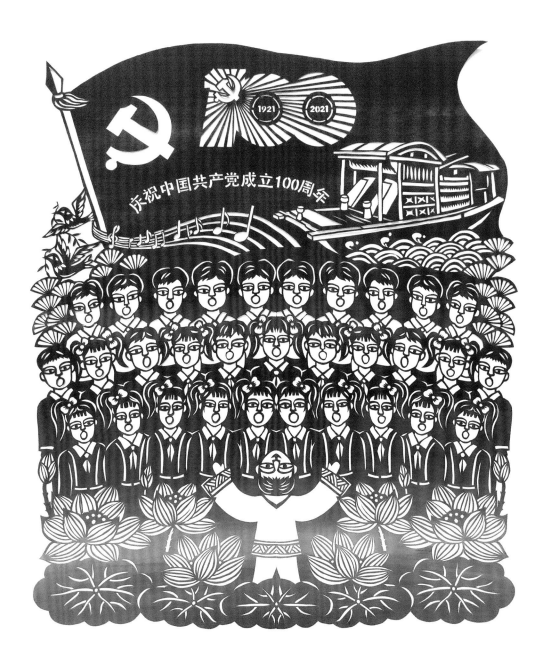

红歌嘹亮庆百年华诞　剪纸　80cm×80cm　李周杰　嘉兴

庆祝中国共产党成立 100 周年暨第五届浙江工艺美术双年展作品选集

Selected Works from the 5th Zhejiang Arts and Crafts Biennial Exhibition Celebrating the 100th Anniversary of the Founding of the CPC

Chinese Paper Cutting Craft

剪纸工艺

英姿秀拔　细纹刻纸　50cm×38cm　周是一　温州

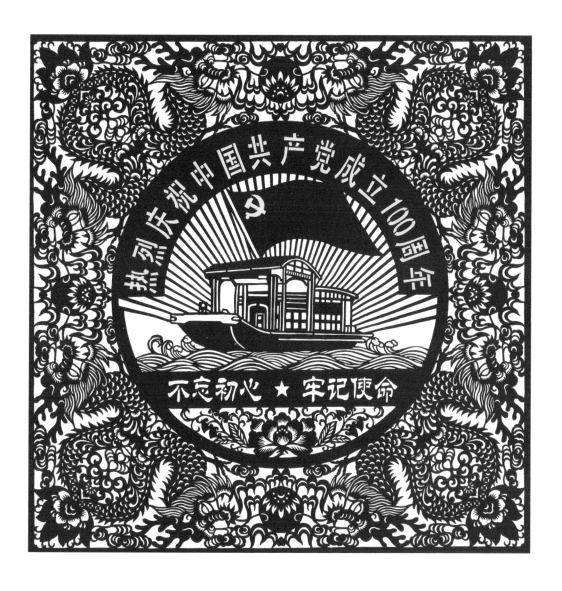

百年辉煌·红船首航　剪纸　80cm×80cm　杨计兵　台州

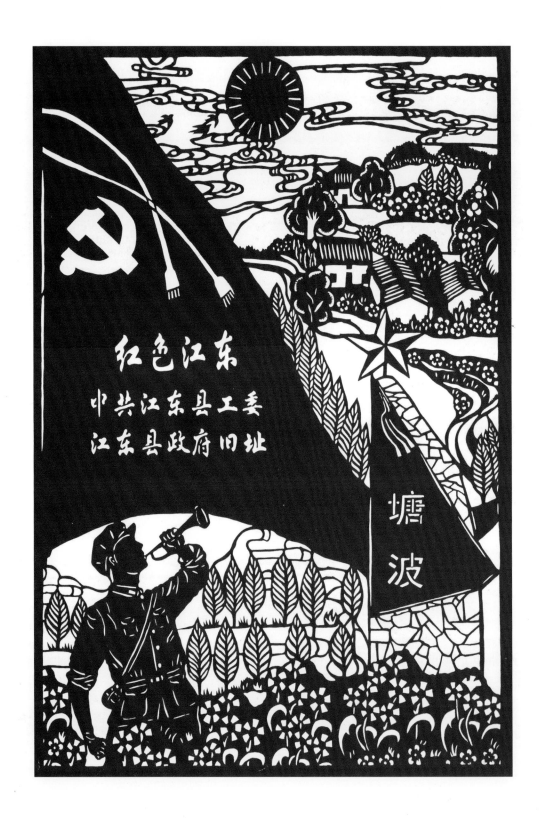

红色塘波　剪纸　60cm×40cm　朱瑞芳　金华

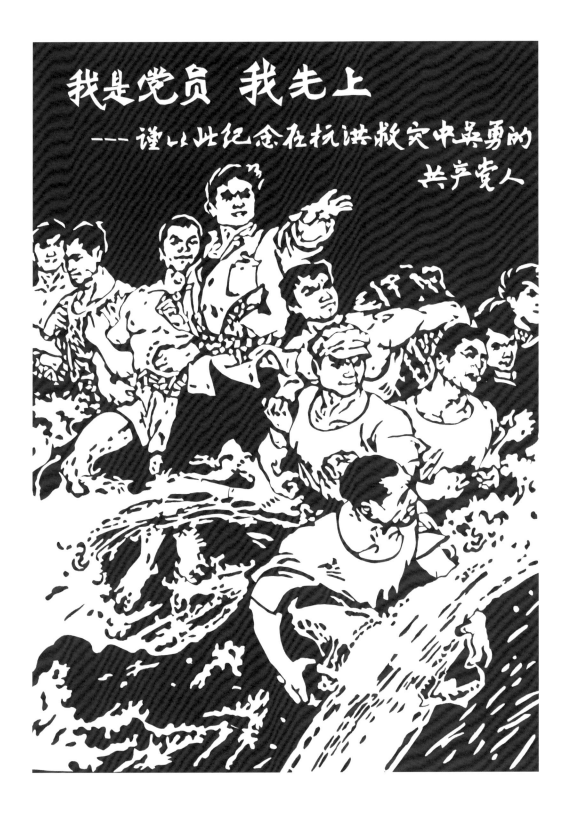

我是党员 我先上　剪纸　80cm×60cm　徐玲琴　嘉兴

庆祝中国共产党成立100周年暨第五届浙江工艺美术双年展作品选集

Selected Works from the 5th Zhejiang Arts and Crafts Biennial Exhibition Celebrating the 100th Anniversary of the Founding of the CPC

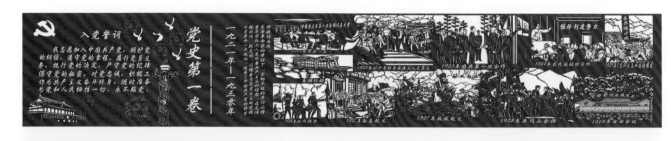

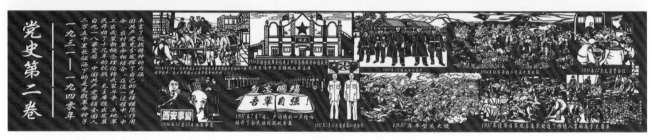

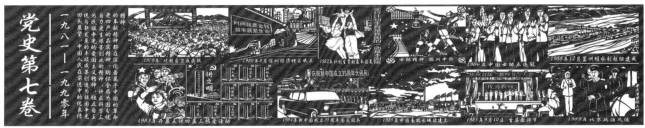

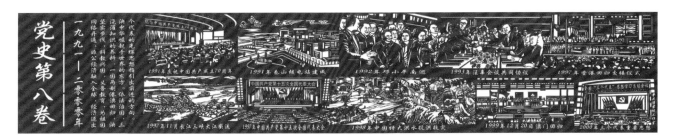

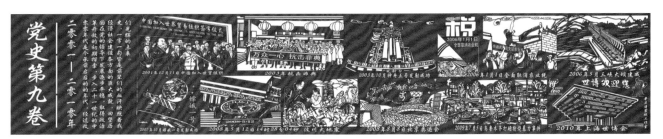

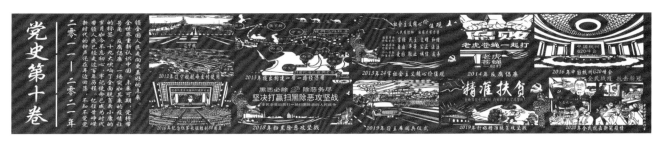

建党 100 周年剪纸长卷　剪纸　400cm×70cm×10　鲁立清　杭州

山花烂漫
The Flowers Blossom

山花无数笑春风，临水精视迥不同。

唤作映山风味短，看来恰惟映溪红。

两年一届的映山红奖评选，以推出更多民间文艺精品为宗旨，鼓励和引导广大民间文艺工作者深入基层，弘扬浙江优秀传统文化和地域文化。

领历史之潮流，开一代之先锋。映山红奖所代表和昭示的是时代审美，是创作方向，是奋进指引，是融合在浙江儿女心中的永不褪色的文化基因。以此为标杆，不断铸就浙江民艺新辉煌，不断从高原向高峰昂首迈进。

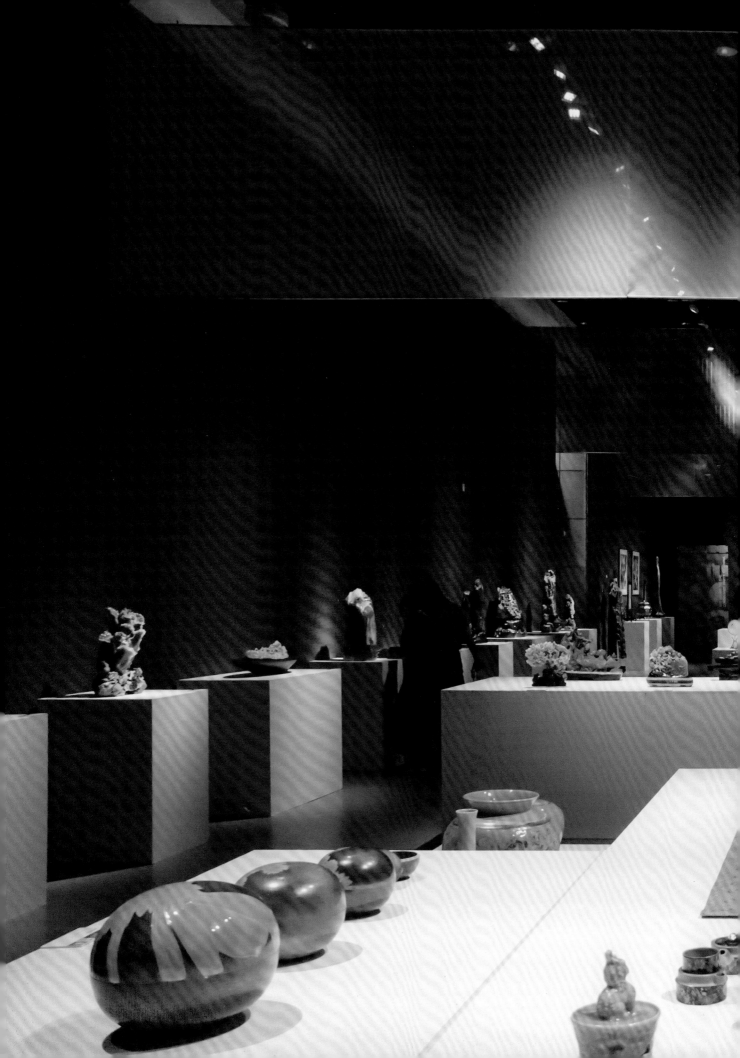

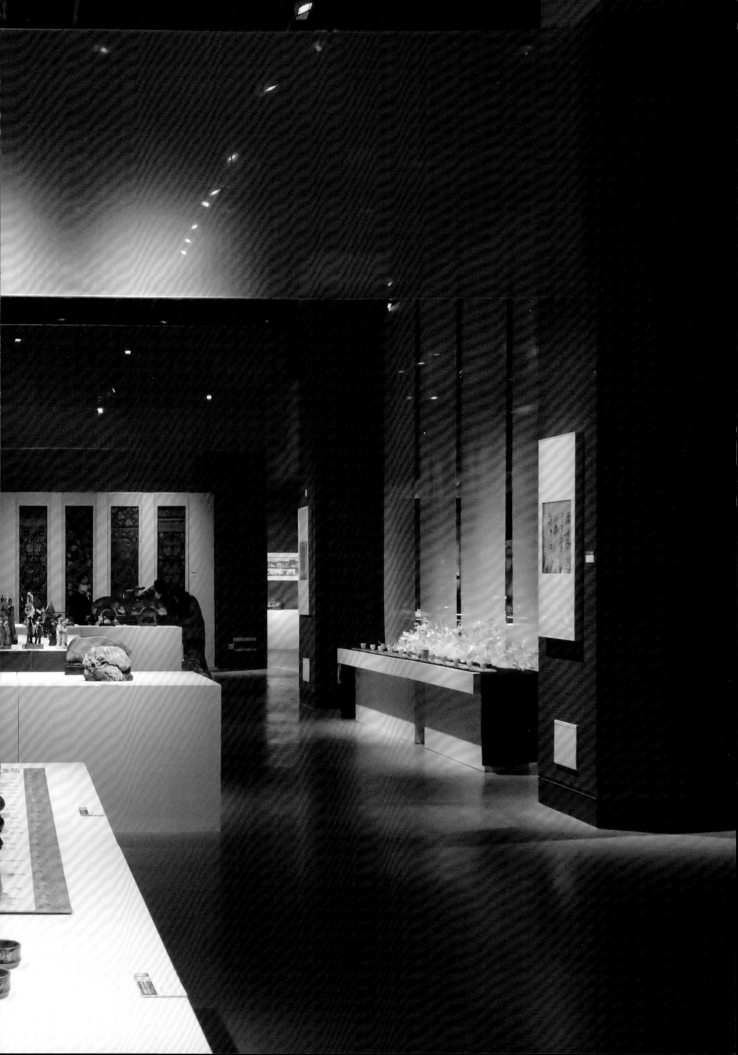

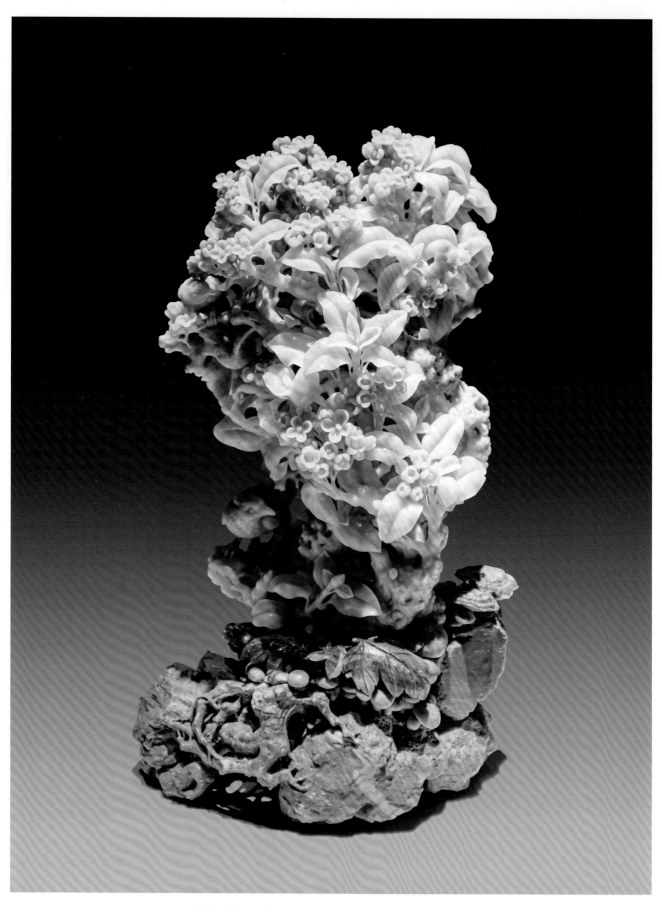

贵在金秋　石雕　25cm×20cm×50cm　周金甫　丽水

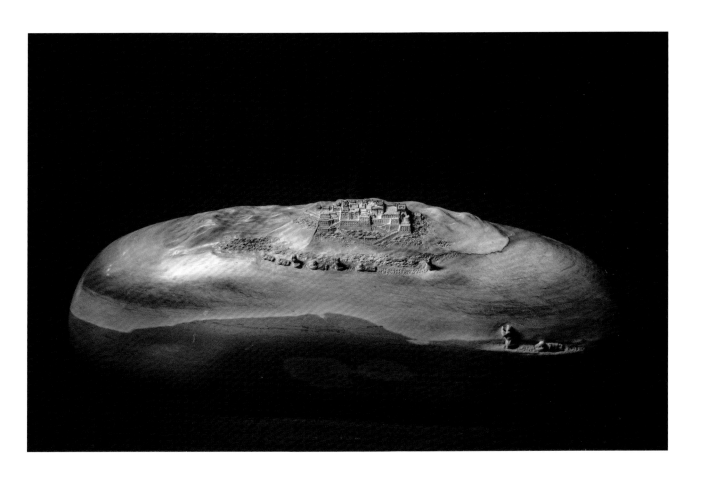

朝圣 石雕 63cm×23cm×20cm 潘成松 温州

庆祝中国共产党成立 100 周年暨第五届浙江工艺美术双年展作品选集

Selected Works from the 5th Zhejiang Arts and Crafts Biennial Exhibition Celebrating the 100th Anniversary of the Founding of the CPC

Stone Carving Craft

石雕工艺

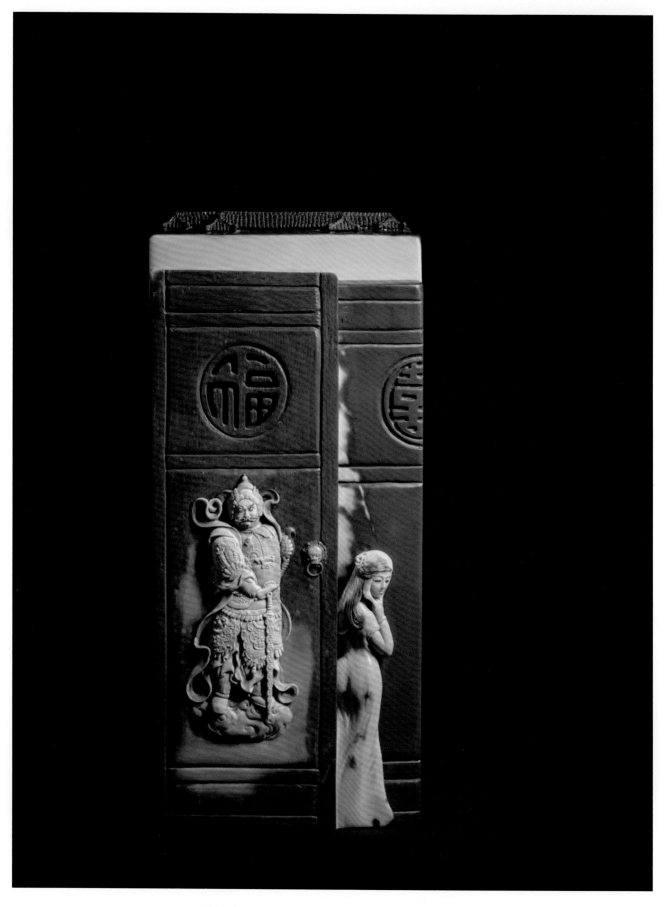

半部唐史　石雕　42cm×23cm×20cm　潘成松　温州

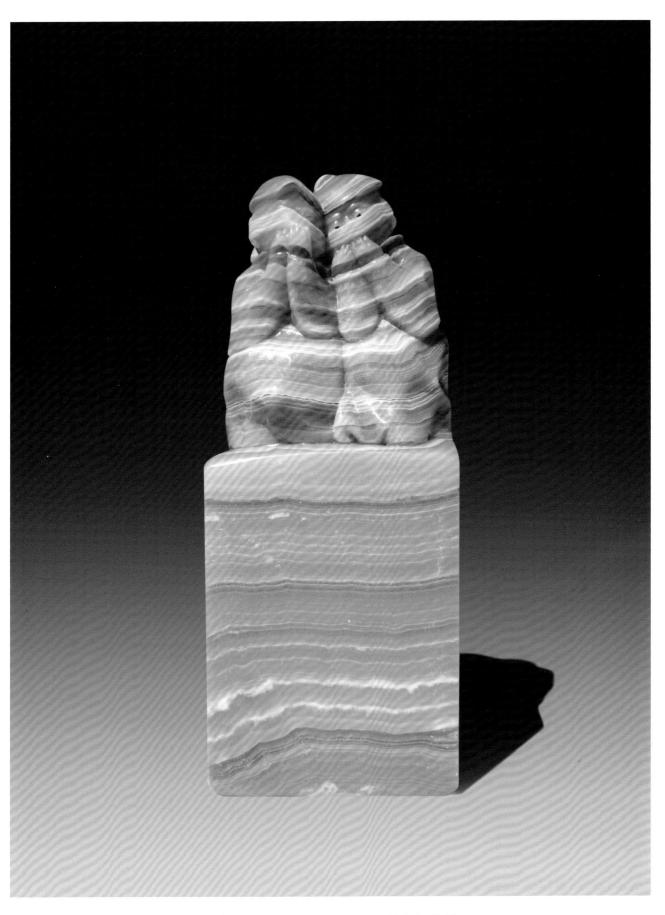

三勿　石雕　45cm×18cm×18cm　潘成松　温州

庆祝中国共产党成立 100 周年暨第五届浙江工艺美术双年展作品选集

Selected Works from the 5th Zhejiang Arts and Crafts Biennial Exhibition Celebrating the 100th Anniversary of the Founding of the CPC

Stone Carving Craft

石雕工艺

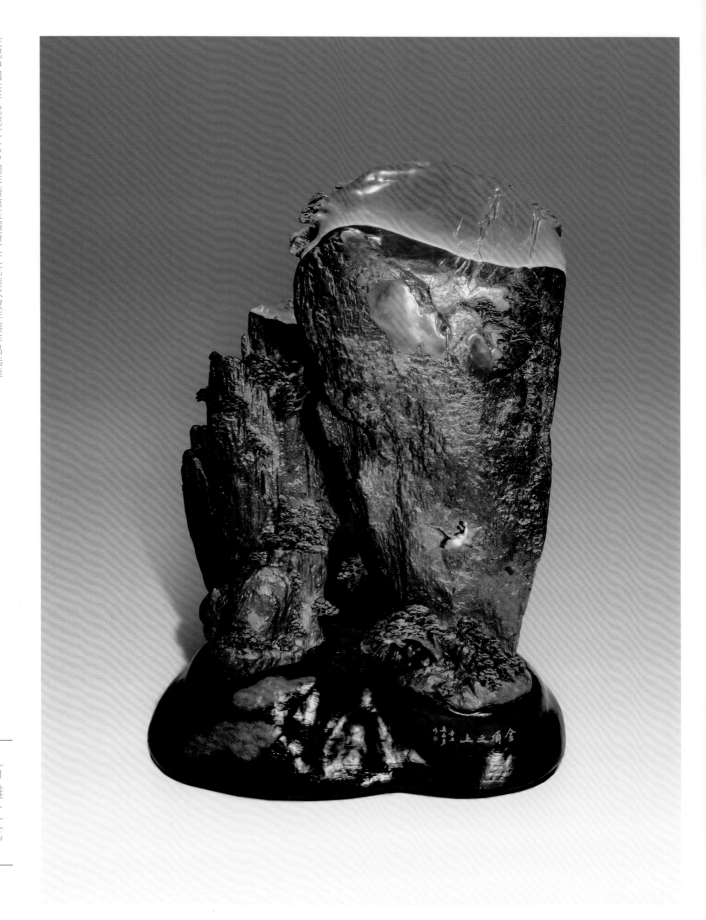

金顶之上 石雕 50cm×20cm×69cm 叶品勇 丽水

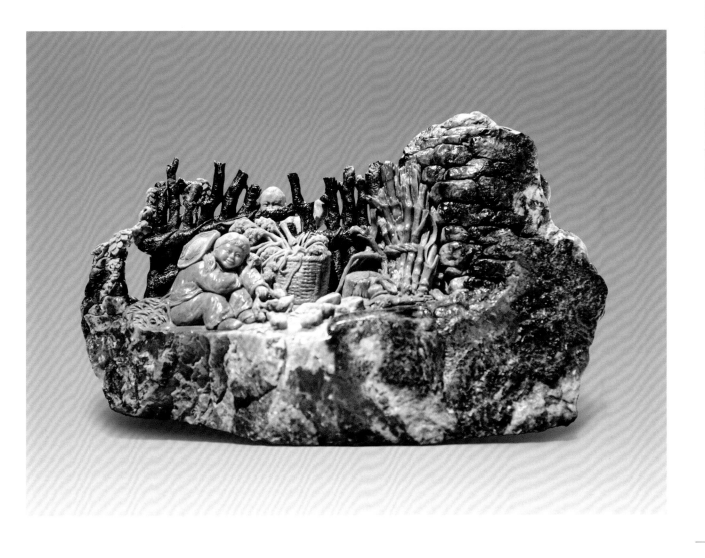

童年时光 石雕 43cm×23cm×23cm 吴松江 杭州

庆祝中国共产党成立 100 周年暨第五届浙江工艺美术双年展作品选集

Selected Works from the 5th Zhejiang Arts and Crafts Biennial Exhibition Celebrating the 100th Anniversary of the Founding of the CPC

Stone Carving Craft

石雕工艺

富春山居　石雕　90cm×40cm×45cm　吴松江　杭州

逆流而上　石雕　80cm×30cm×28cm　李德　丽水

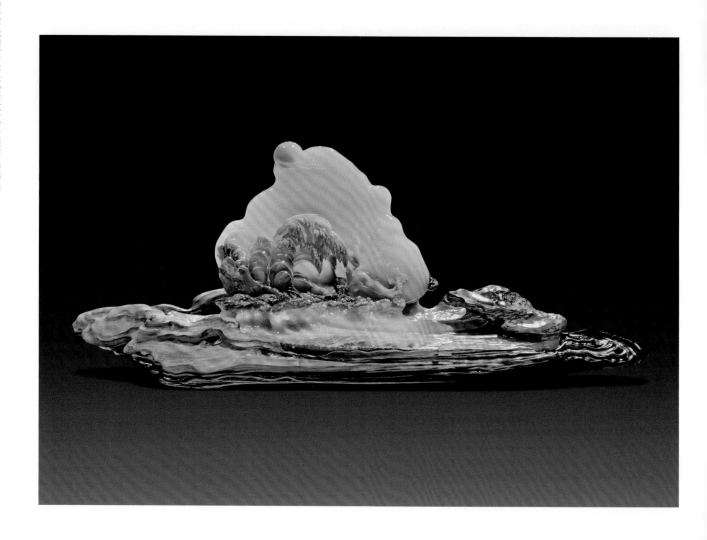

芦花落后鲤鱼肥 石雕 65cm×11cm×33cm 李德 丽水

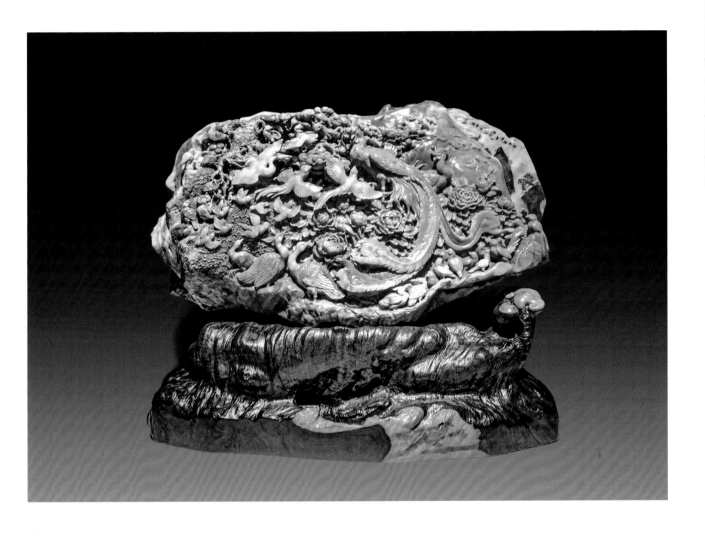

庆祝中国共产党成立 100 周年暨第五届浙江工艺美术双年展作品选集

Selected Works from the 5th Zhejiang Arts and Crafts Biennial Exhibition, Celebrating the 100th Anniversary of the Founding of the CPC

Stone Carving Craft

石雕工艺

百鸟朝凤　石雕　80cm×65cm×30cm　陈顺德　温州

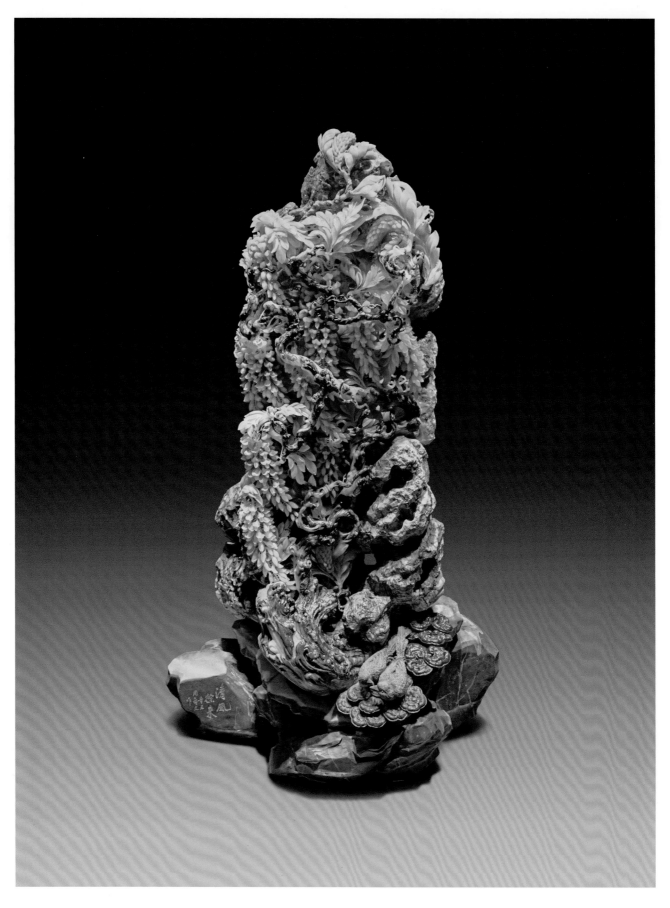

庆祝中国共产党成立 100 周年暨第五届浙江工艺美术双年展作品选集

Selected Works from the 5th Zhejiang Arts and Crafts Biennial Exhibition Celebrating the 100th Anniversary of the Founding of the CPC

Stone Carving Craft

石雕工艺

清风徐来　石雕　50cm×30cm×84cm　周蒋文　丽水

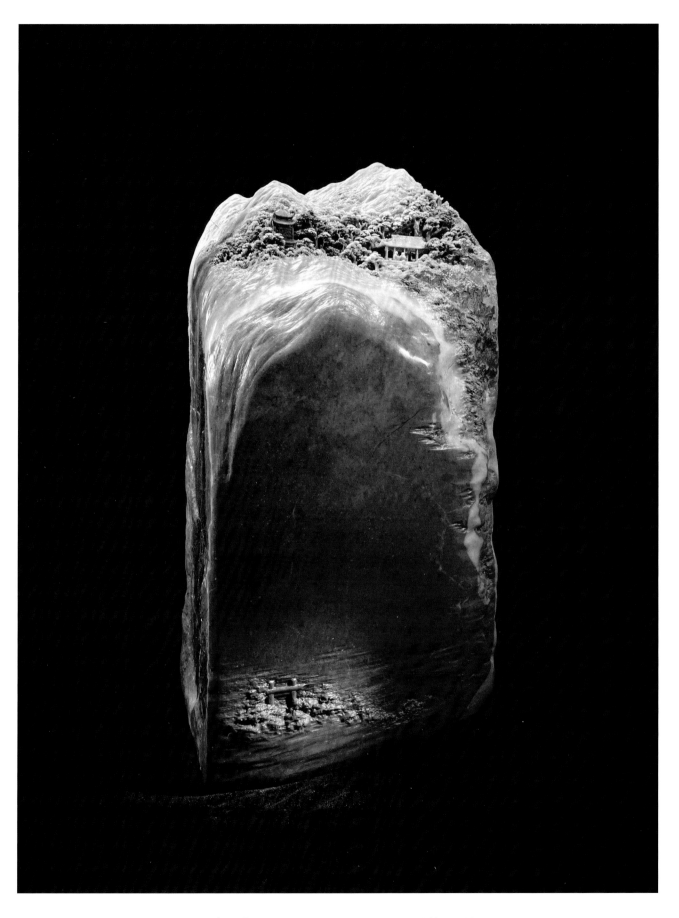

印象西泠 石雕 50cm×30cm×80cm 潘金松 温州

庆祝中国共产党成立 100 周年暨第五届浙江工艺美术双年展作品选集

Selected Works from the 5th Zhejiang Arts and Crafts Biennial Exhibition Celebrating the 100th Anniversary of the Founding of the CPC

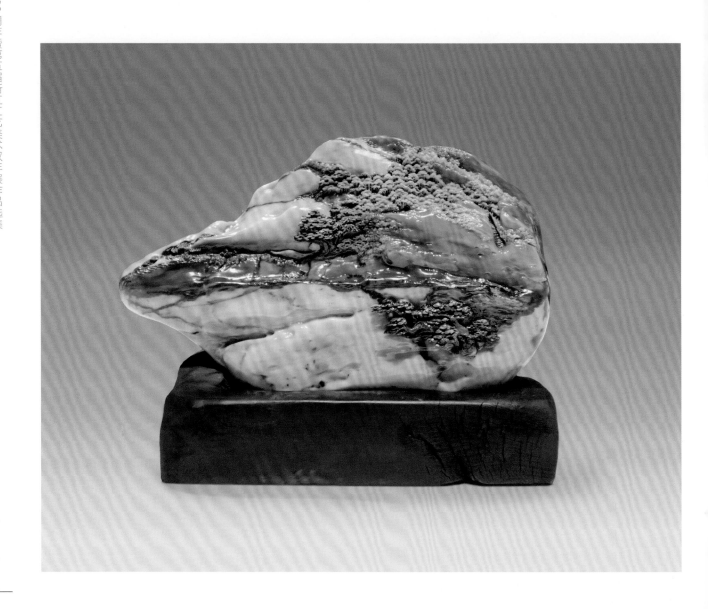

绿水青山　石雕　35cm×10cm×25cm　何细造　温州

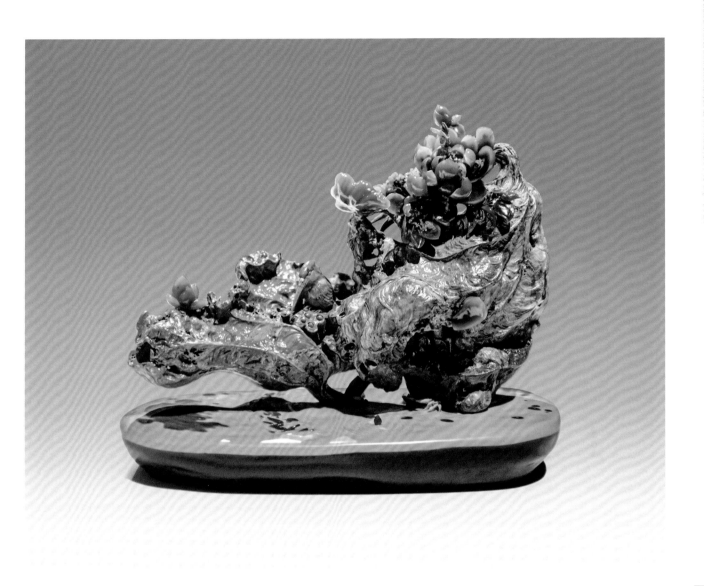

清逸出尘 石雕 48cm×18cm×41cm 王尚可 温州

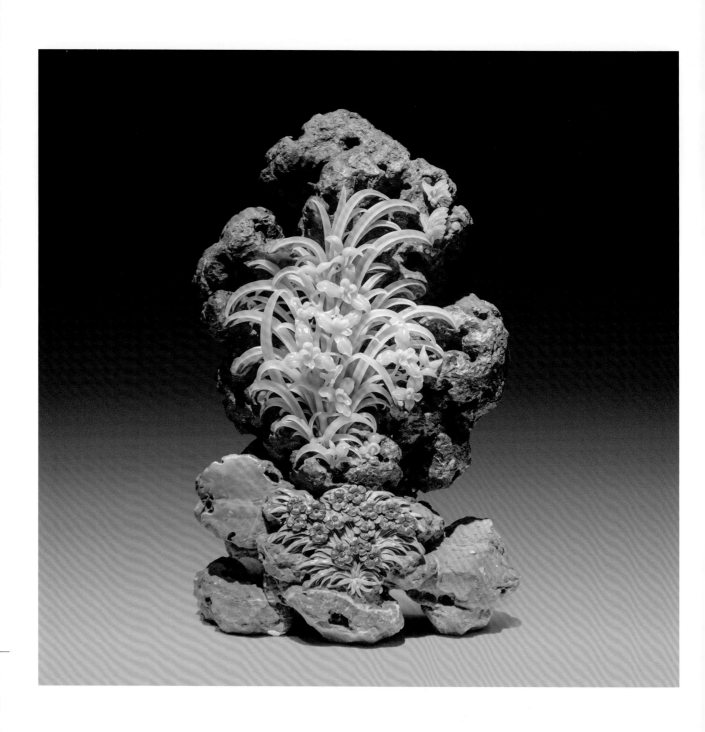

深谷幽兰　石雕　30cm×15cm×50cm　周蒋利　丽水

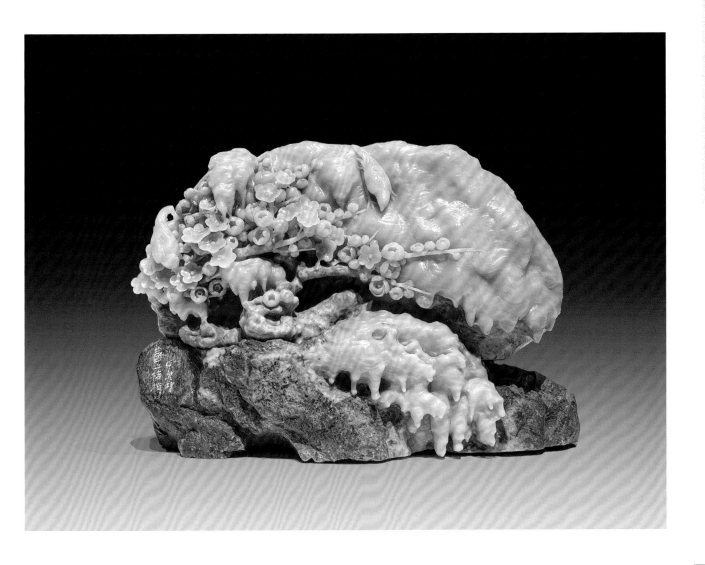

喜上梅梢　石雕　40cm×30cm×20cm　张杏标　丽水

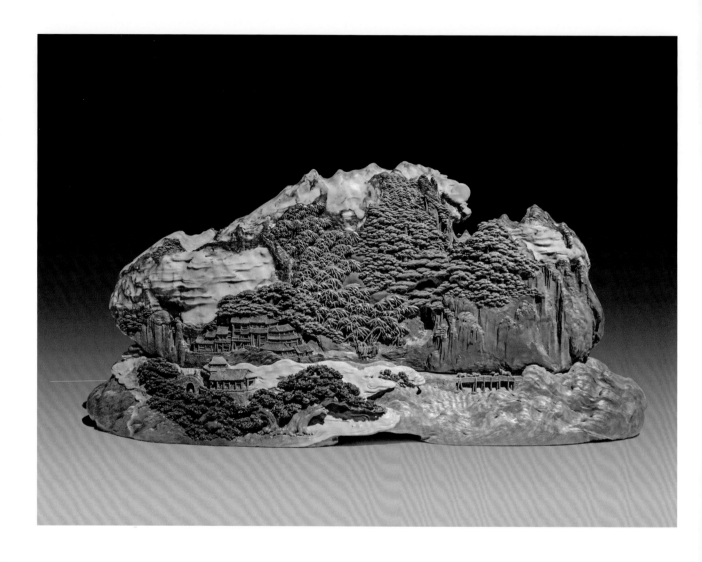

绿水青山就是金山银山　石雕　130cm×33cm×56cm　王银灵　丽水

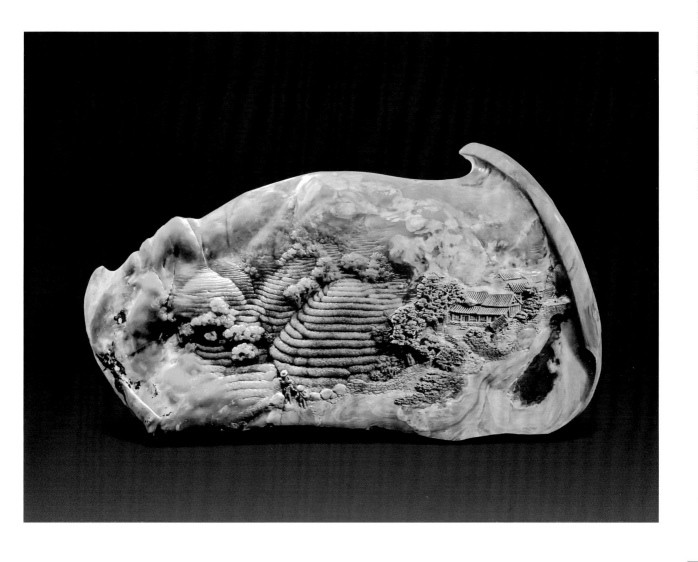

春露 石雕 44cm×15cm×30cm 胡叙令 温州

祥瑞　石雕　20cm×8cm×25cm　胡慧溪　温州

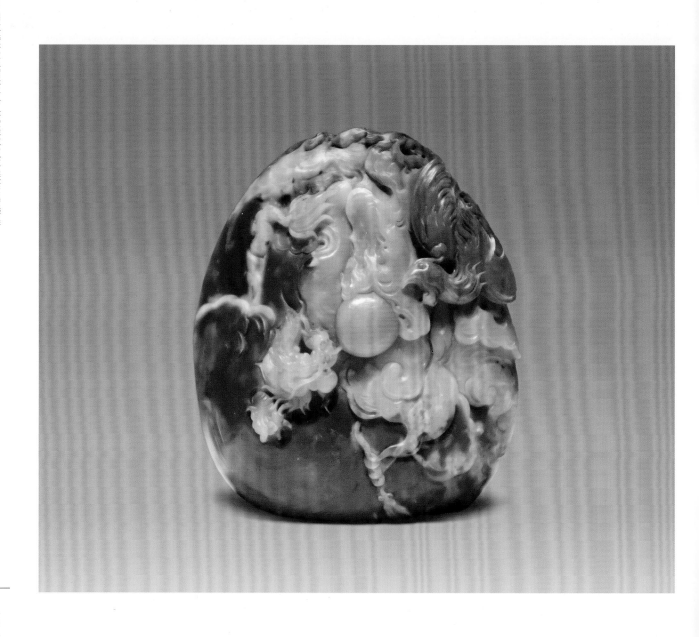

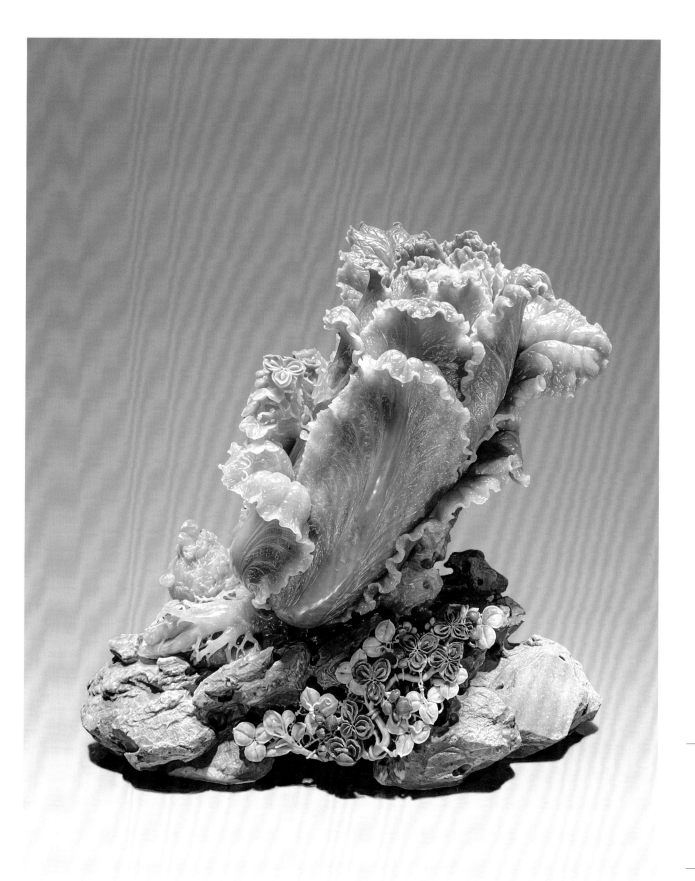

百财聚来 石雕 55cm×50cm×22cm 王爱军 丽水

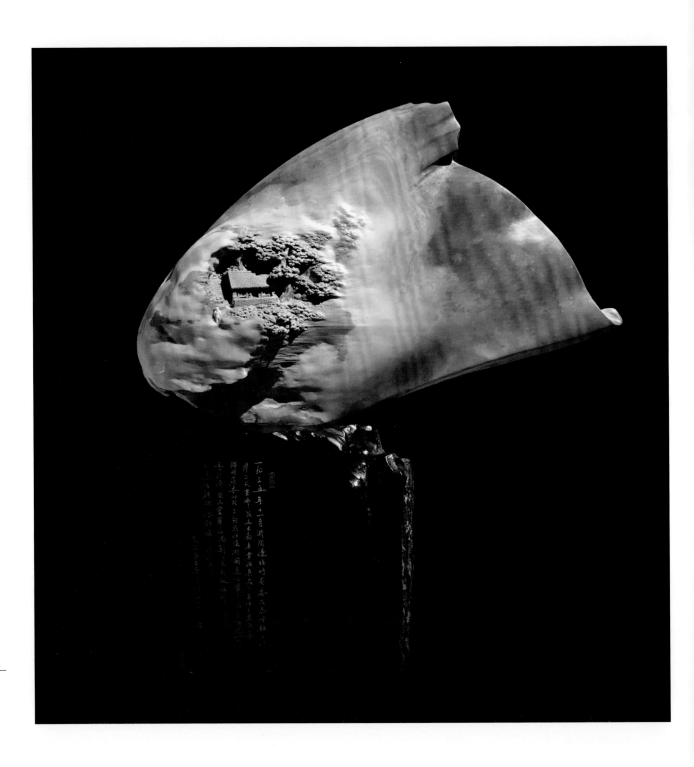

破晓 石雕 39cm×48cm×15cm 胡叙令 温州

庆祝中国共产党成立 100 周年暨第五届浙江工艺美术双年展作品选集

Selected Works from the 5th Zhejiang Arts and Crafts Biennial Exhibition Celebrating the 100th Anniversary of the Founding of the CPC

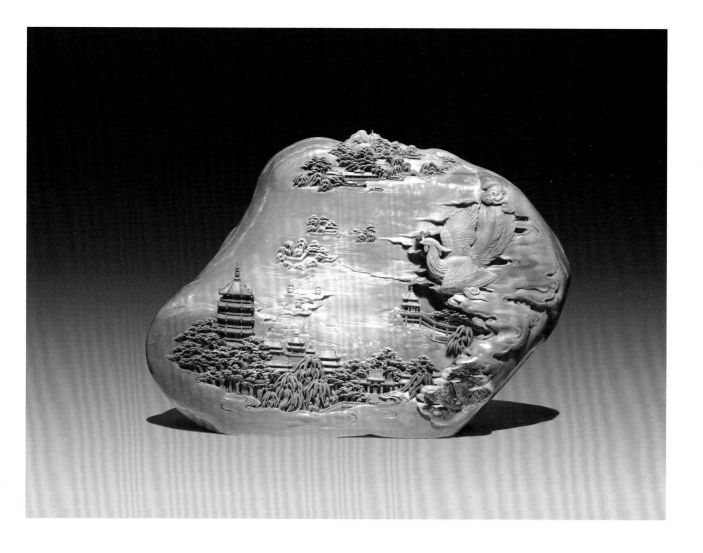

最美西湖　石雕　80cm×28cm×85cm　卓乃枢　温州

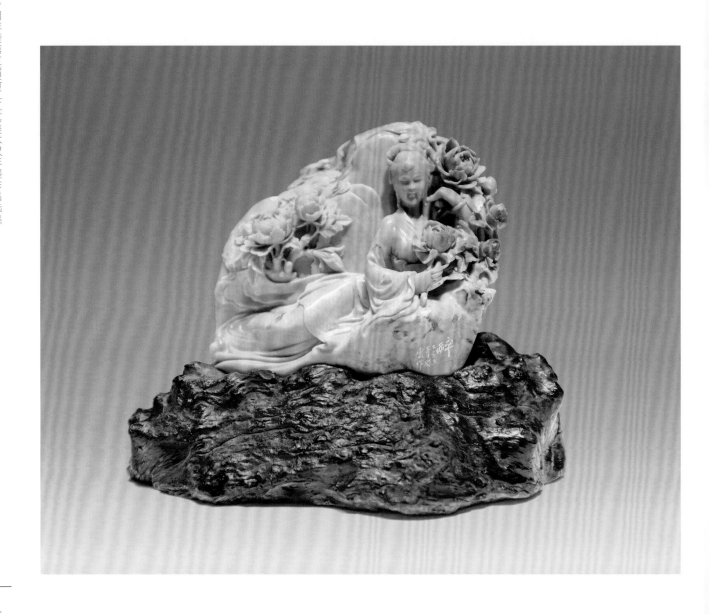

醉 石雕 22cm×18cm×15cm 李彩云 温州

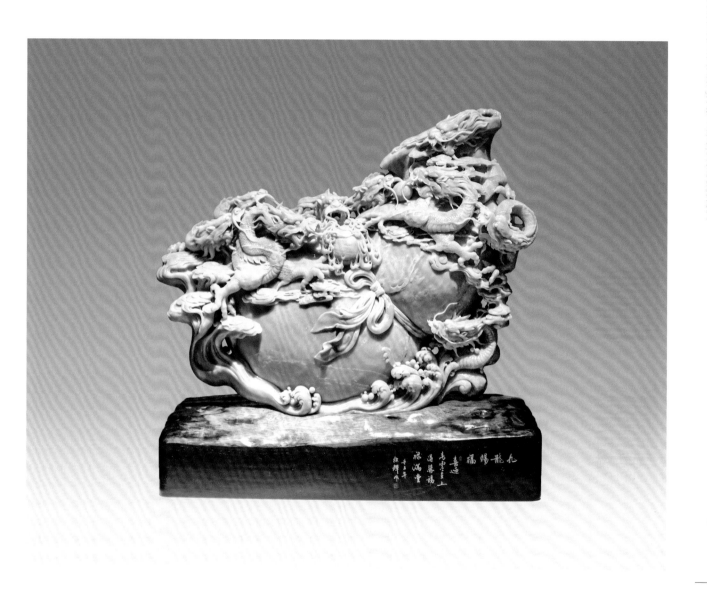

庆祝中国共产党成立100周年暨第五届浙江工艺美术双年展作品选集

Selected Works from the 18th Zhejiang Arts and Crafts Biennial Exhibition Celebrating the 100th Anniversary of the Founding of the CPC

九龙赐福 石雕 62cm×43cm×22cm 徐辉 温州

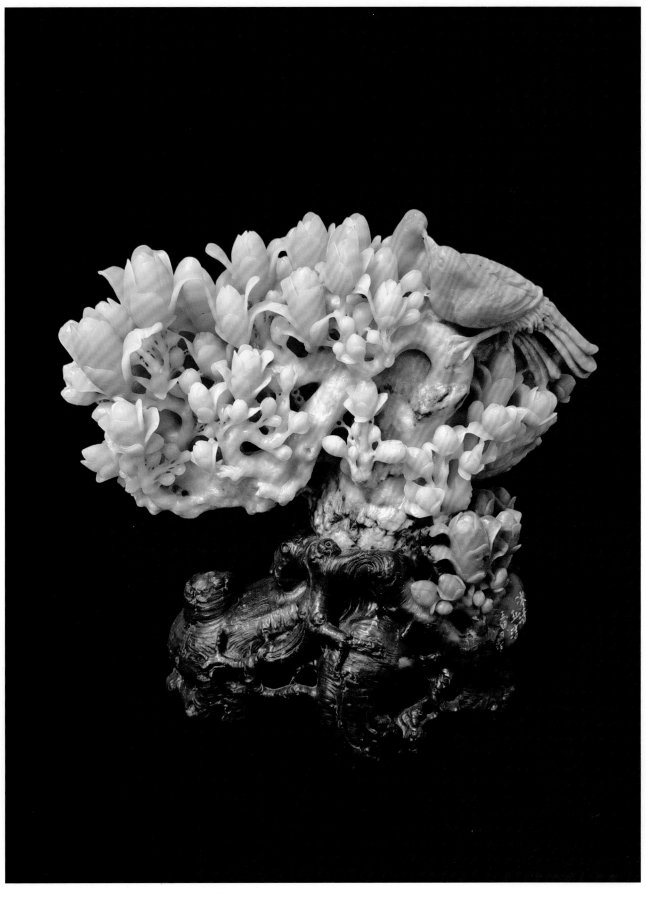

庆祝中国共产党成立 100 周年暨第五届浙江工艺美术双年展作品选集
Selected Works from the 5th Zhejiang Arts and Crafts Biennial Exhibition Celebrating the 100th Anniversary of the Founding of the CPC

Stone Carving Craft

石雕工艺

冰清玉洁　石雕　30cm×12cm×30cm　王细日　温州

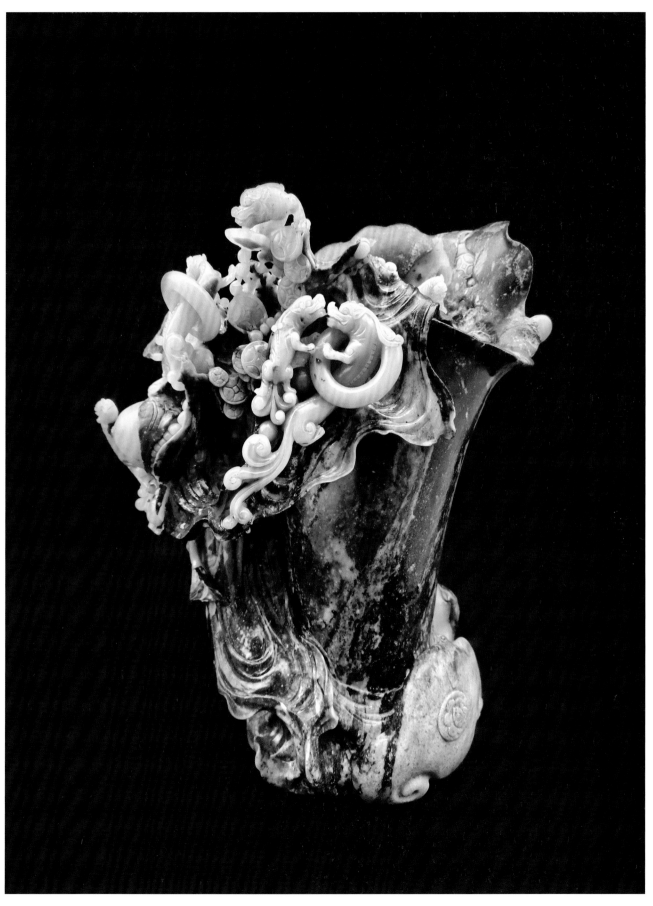

庆祝中国共产党成立100周年暨第五届浙江工艺美术双年展作品选集
Selected Works from the 5th Zhejiang Arts and Crafts Biennial Exhibition Celebrating the 100th Anniversary of the Founding of the CPC

Stone Carving Craft

石雕工艺

福聚财　石雕　20cm×18cm×39cm　林长恩　温州

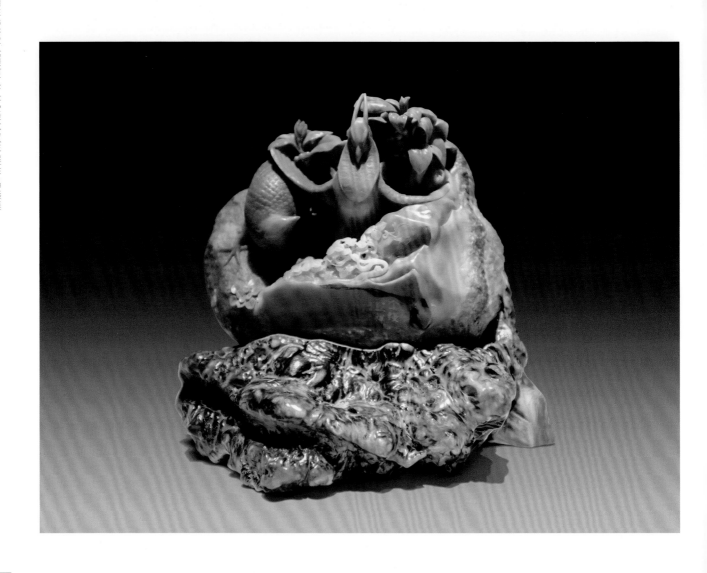

庆祝中国共产党成立 100 周年暨第五届浙江工艺美术双年展作品选集
Selected Works from the 5th Zhejiang Arts and Crafts Biennial Exhibition Celebrating the 100th Anniversary of the Founding of the CPC

Stone Carving Craft

石雕工艺

金绶呈祥 石雕 29cm×30cm×32cm 章汉立 温州

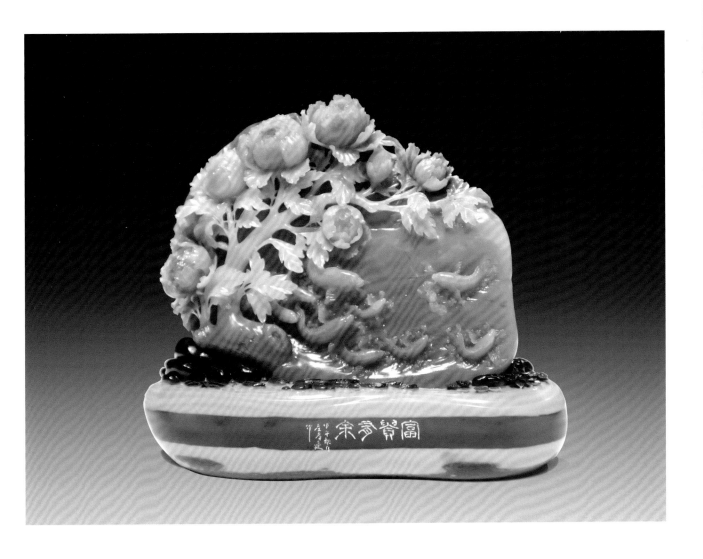

富贵有余　石雕　28cm×11cm×29cm　庄孝通　温州

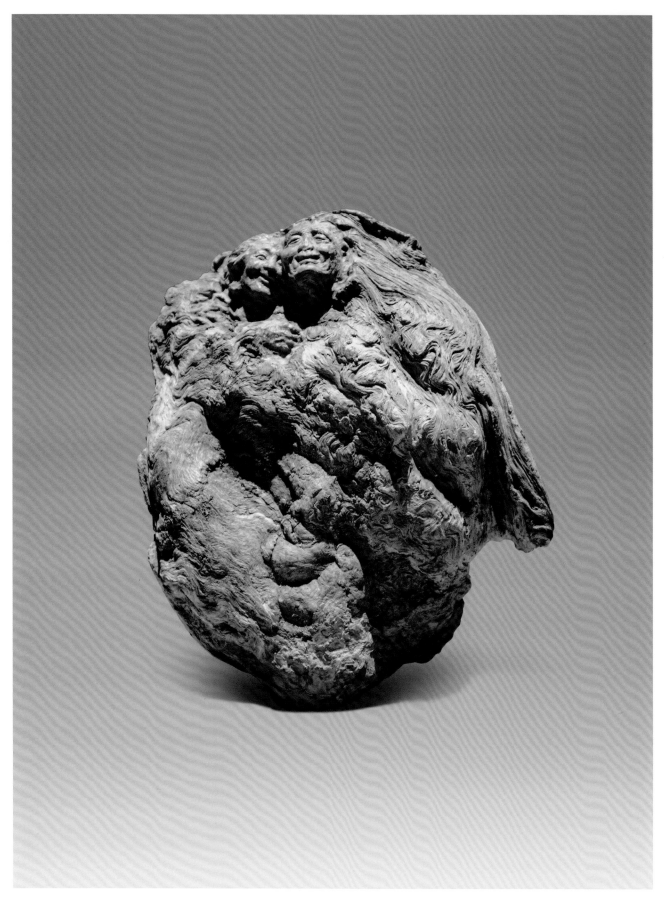

阳光大道　木雕　43cm×30cm　高公博　温州

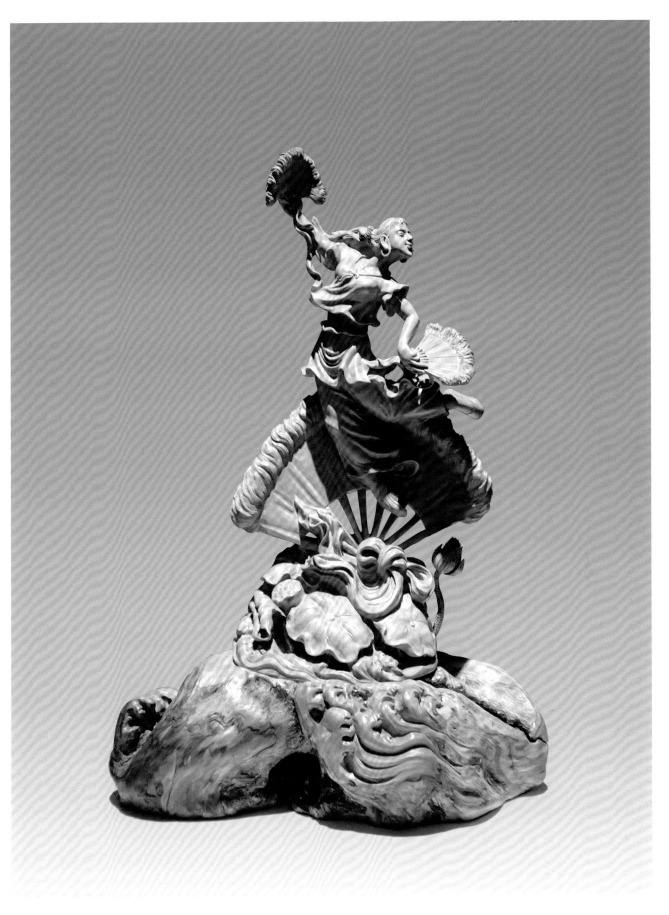

江南美 木雕 52cm×32cm×27cm 虞金顺 温州

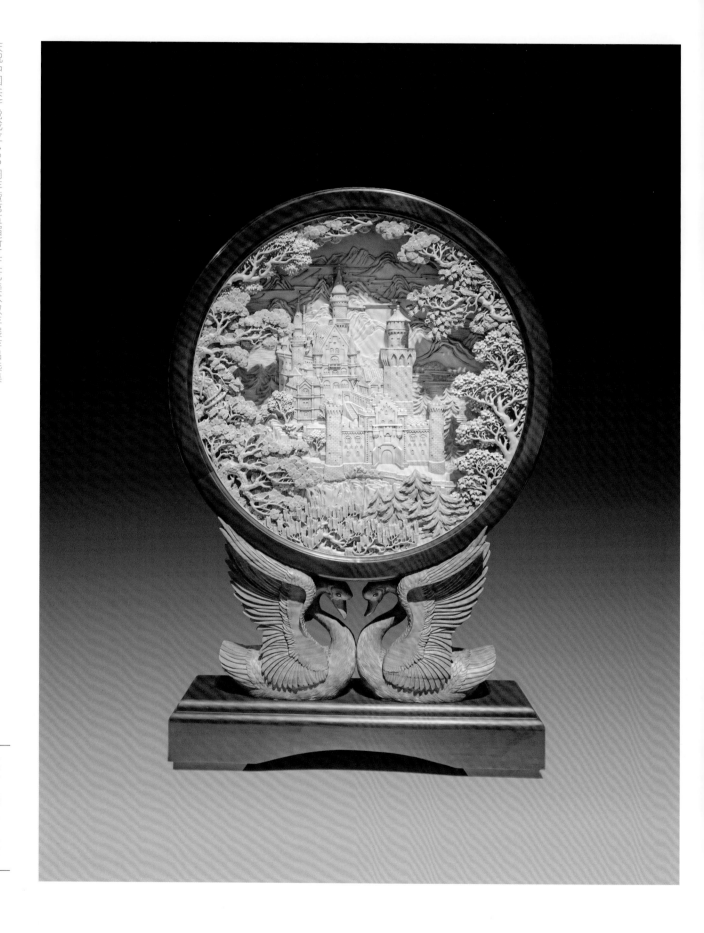

Wood And Bamboo Carving Craft

木竹雕刻工艺

新天鹅堡　木雕　80cm×120cm×10cm　黄小明　金华

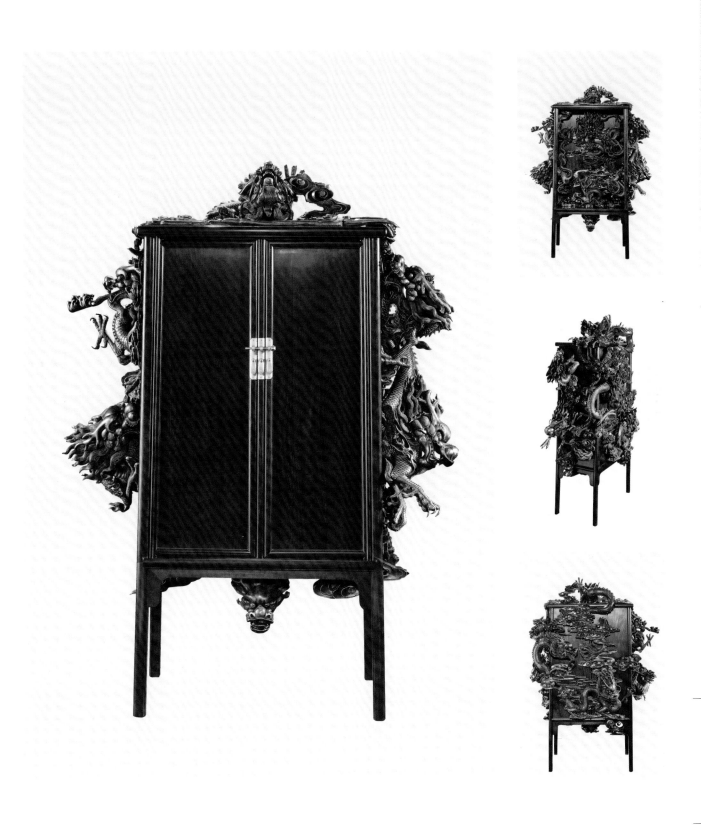

庆祝中国共产党成立 100 周年暨第五届浙江工艺美术双年展作品选集

Selected Works from the Zhejiang Arts and Crafts Biennial Exhibition Celebrating the 100th Anniversary of the Founding of the CPC

WUQI ARTS BUYOU'S ONYHZ OOI

木竹雕刻工艺

天微星·龙柜　木雕　130cm×60cm×163cm　黄小明、李鹏、吴奇荣、楼瑞阳　金华

Wood And Bamboo Carving Craft

木竹雕刻工艺

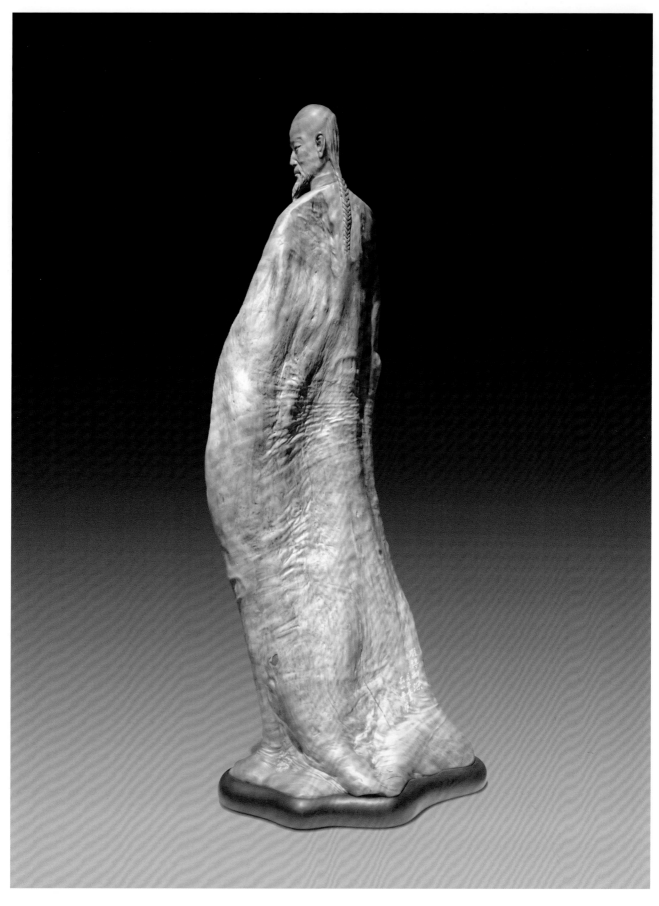

郑板桥 木雕 50cm×30cm×120cm 刘小平 杭州

庆祝中国共产党成立100周年暨第五届浙江工艺美术双年展作品选集

Selected Works That the 100 Zhejiang Arts and Crafts Biennial Exhibition Celebrating the 100th Anniversary of the Founding of the C.P.C.

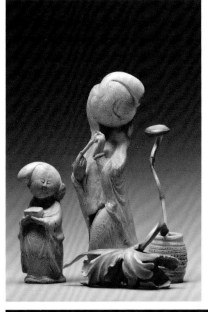
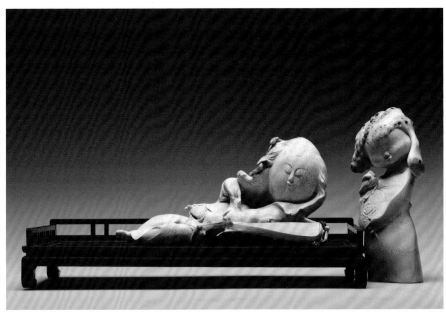
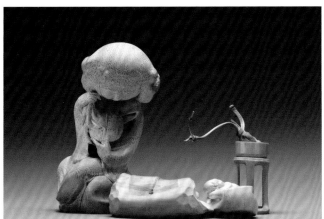
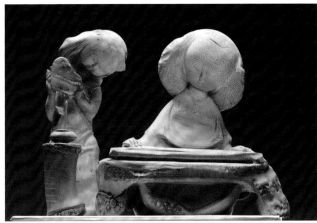

琴棋书画 竹根雕 150cm×25cm×18cm（展示尺寸） 俞田 绍兴

Wood And Bamboo Carving Craft

木竹雕刻工艺

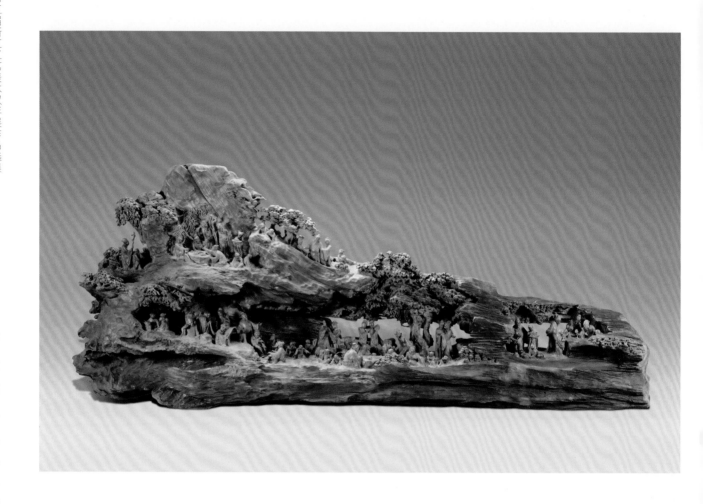

金庭洞天　木雕　238cm×75cm×98cm　郑兴国　绍兴

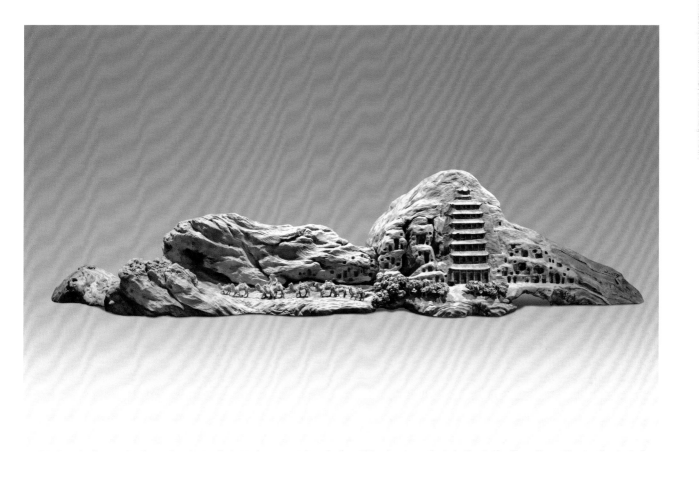

庆祝中国共产党成立 100 周年暨第五届浙江工艺美术双年展作品选集

Selected Work Honoring the 100th Anniversary of the Founding of the CPC and the 5th Zhejiang Arts and Crafts Biennial Celebration Exhibition

木竹雕刻工艺

丝路记忆之敦煌　木雕　168cm×32cm×35cm　俞柏青　绍兴

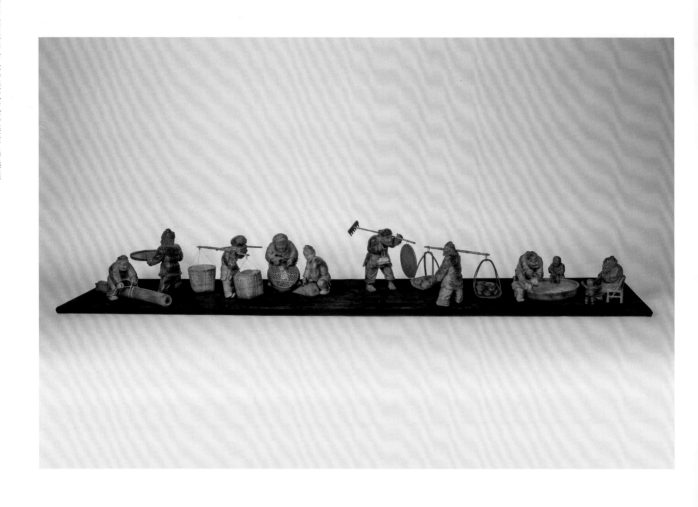

大丰收　竹根雕　180cm×45cm×40cm　周桂新　金华

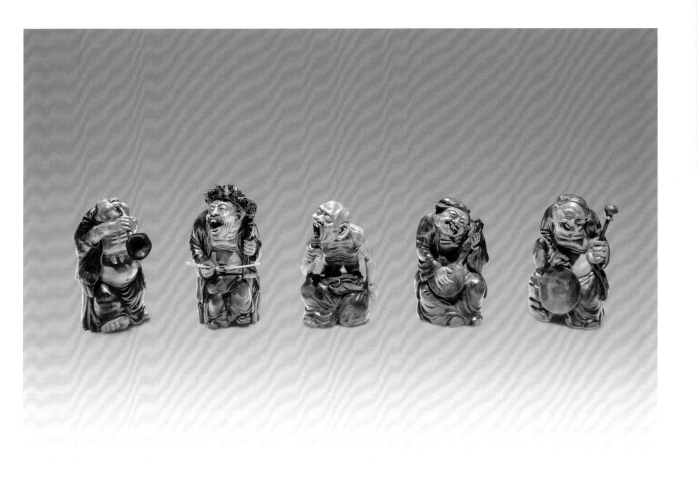

非遗之音　竹根雕　15cm×15cm×30cm×5　朱利勇　宁波

Wood And Bamboo Carving Craft

木竹雕刻工艺

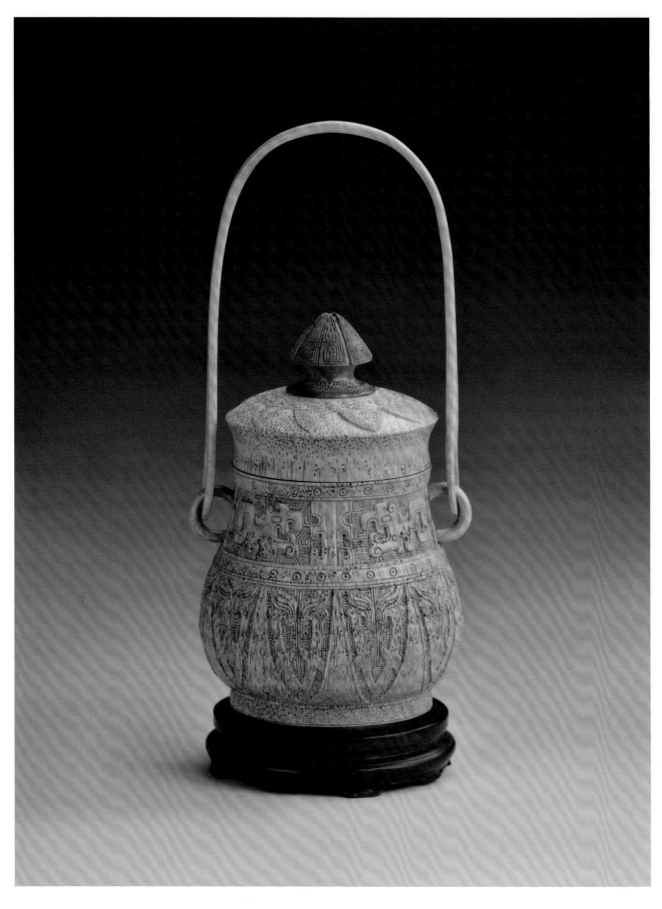

竹制提梁卣　竹刻　10cm×10cm×24cm　王昕　宁波

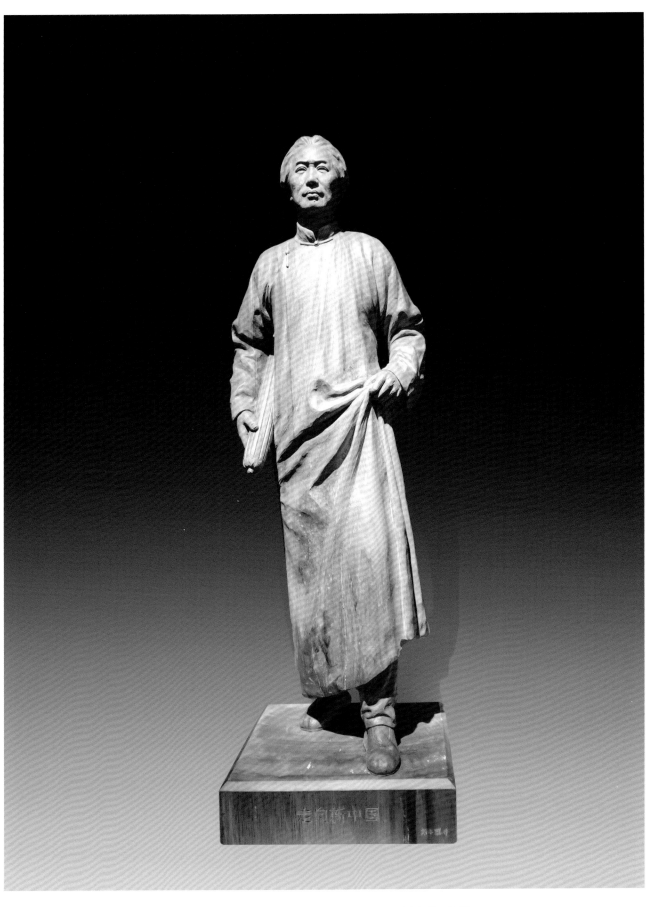

庆祝中国共产党成立 100 周年暨第五届浙江工艺美术双年展作品选集
Selected Works from the 5th Zhejiang Arts and Crafts Biennial Exhibition Celebrating the 100th Anniversary of the Founding of the CPC

木竹雕刻工艺

走向新中国　木雕　40cm×40cm×110cm　刘小聪　杭州

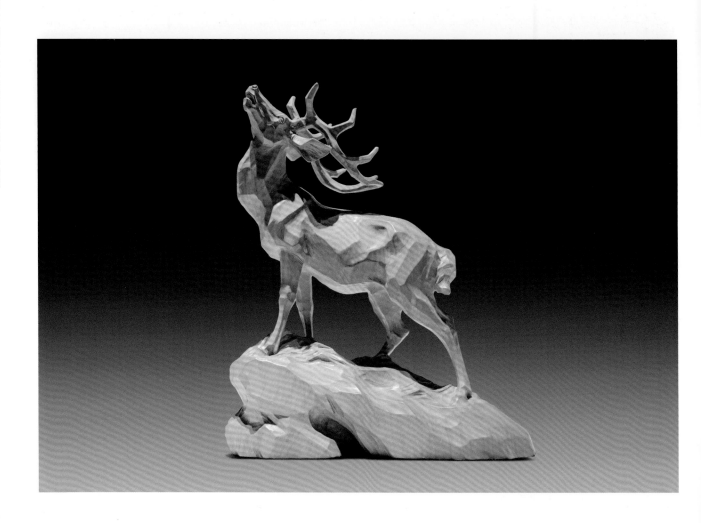

庆祝中国共产党成立 100 周年暨第五届浙江工艺美术双年展作品选集

Selected Works from the 5th Zhejiang Arts and Crafts Biennial Exhibition Celebrating the 100th Anniversary of the Founding of the CPC

Wood And Bamboo Carving Craft

木竹雕刻工艺

一路高歌　木雕　35cm×20cm×55cm　郑国地　温州

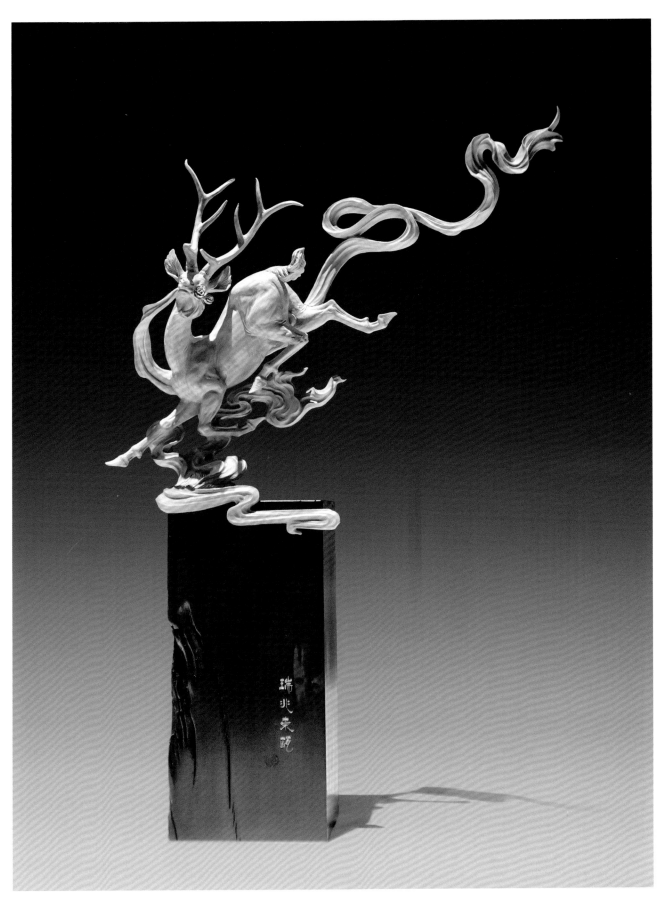

庆祝中国共产党成立100周年暨第五届浙江工艺美术双年展作品选集

Selected Works from the 5th Zhejiang Arts and Crafts Biennial Exhibition Celebrating the 100th Anniversary of the Founding of the CPC

Wood And Lacquer Carving Craft

木竹雕刻工艺

瑞兆东瓯　木雕　15cm×43cm×59cm　夏伯连　温州

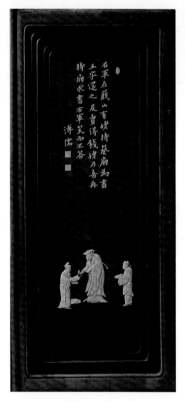
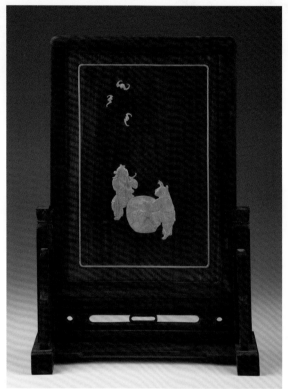
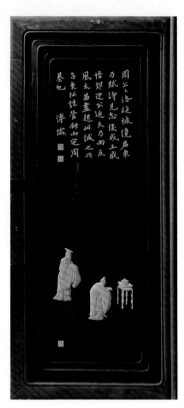

周公吐哺与羲之写扇　木雕　120cm×110cm×6cm（展示尺寸）　章雄辉　宁波

雷　黄杨木雕　83cm×30cm×60cm　董欣珅　杭州

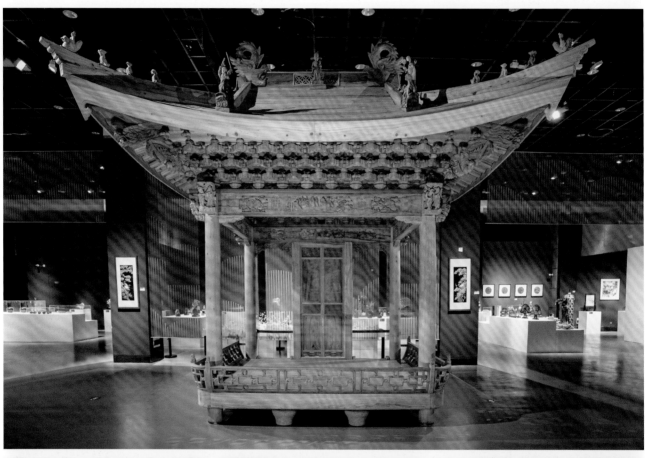

人生·戏台 藻井工艺　560cm×560cm×580cm　葛招龙　宁波

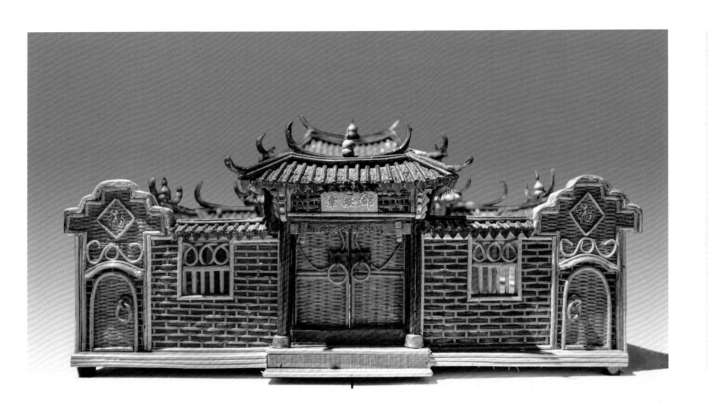

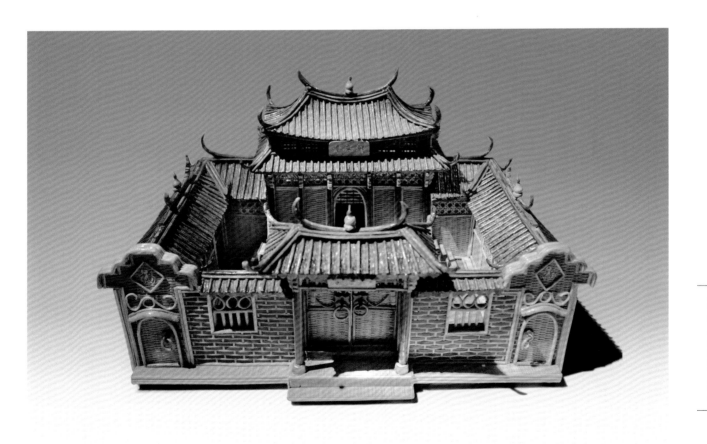

竹编章安郡 竹编 68cm×50cm×48cm 郑米华 台州

庆祝中国共产党成立 100 周年暨第五届浙江工艺美术双年展作品选集

Selected Works from the 5th Zhejiang Arts and Crafts Biennial Exhibition Celebrating the 100th Anniversary of the Founding of the CPC

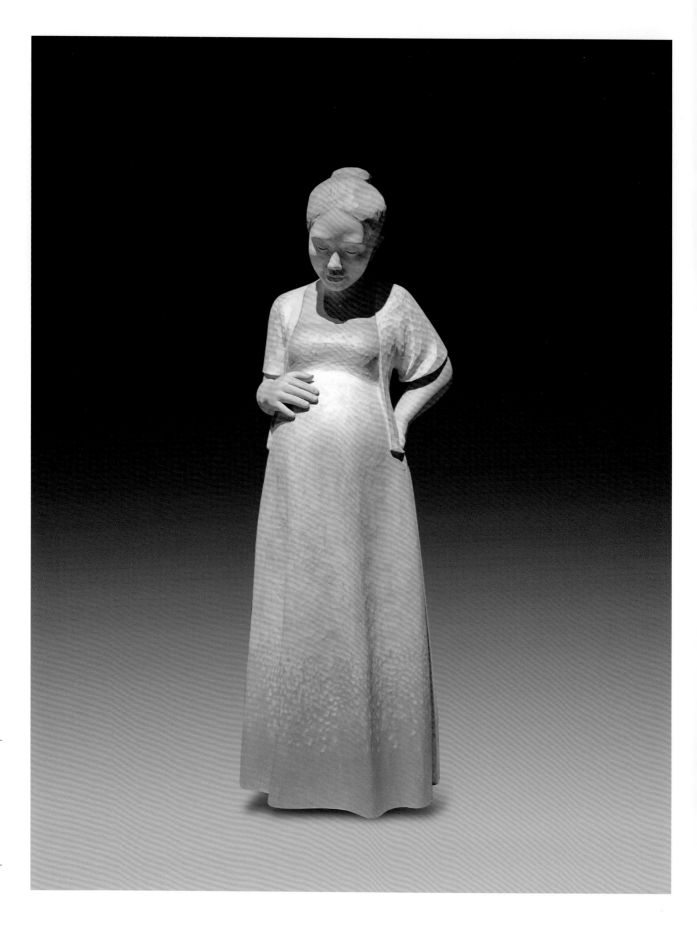

幸福生活　木雕　45cm×40cm×147.5cm　陈德鸿　金华

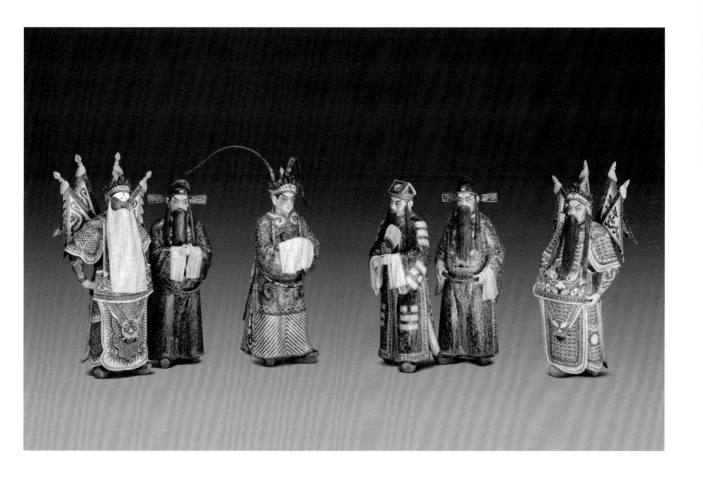

群英荟萃　竹雕　128cm×30cm×50cm　吴涛林　温州

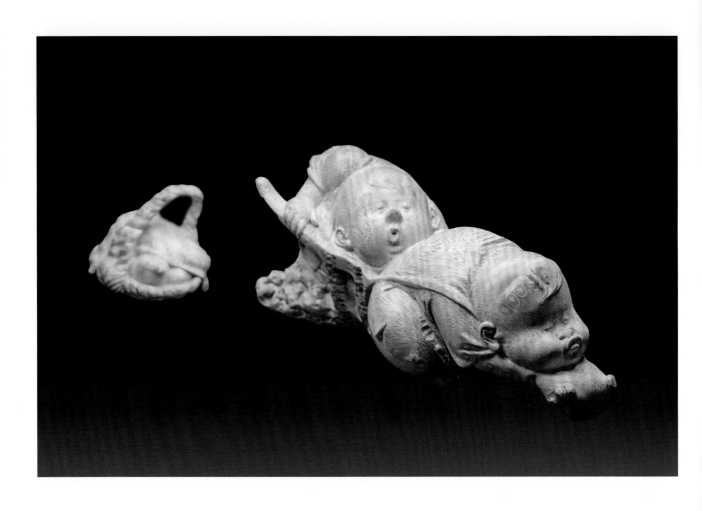

Wood And Bamboo Carving Craft

耕耘 竹根雕 30cm×60cm×15cm 王旭东 绍兴

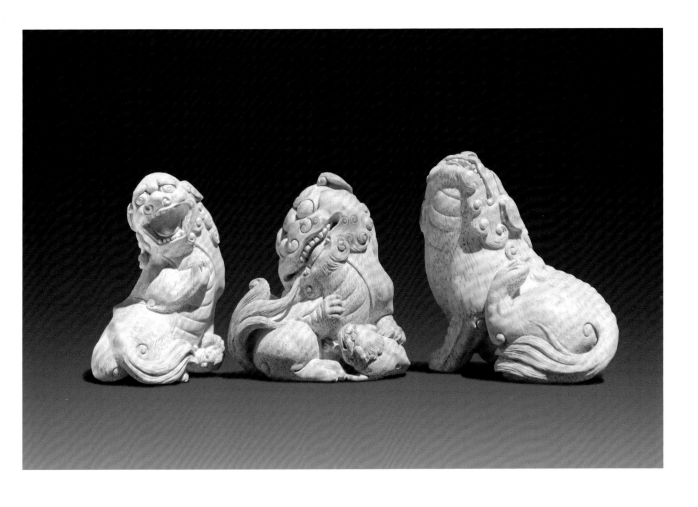

吉祥三宝 竹雕 25cm×30cm×15cm 王金平 台州

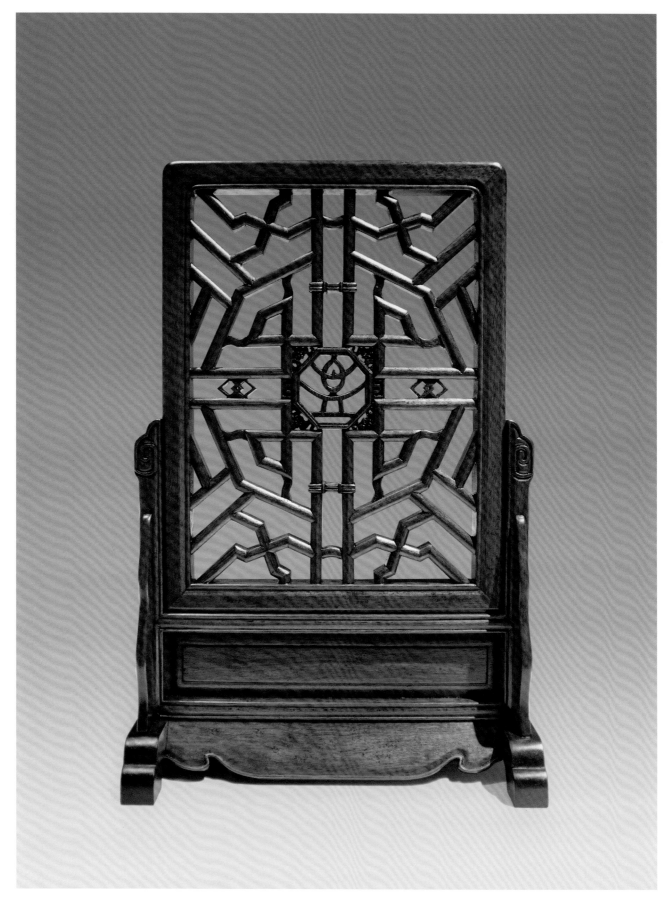

Wood And Bamboo Carving Craft

木竹雕刻工艺

台屏 木工艺 61cm×18cm×41cm 葛兆国 台州

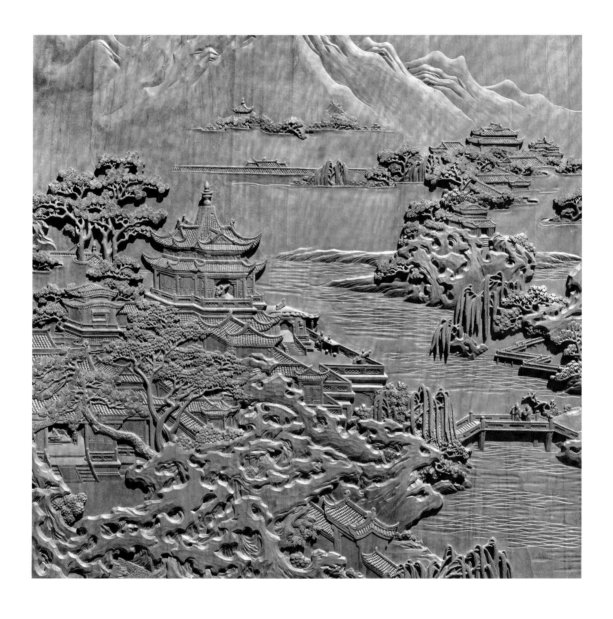

江南好　木雕　75cm×75cm×4cm　蒋武进　金华

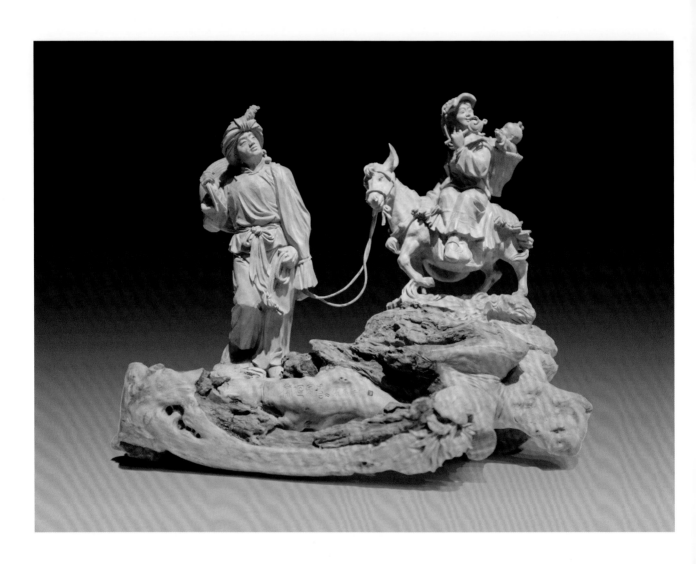

Wood And Bamboo Carving Craft

木竹雕刻工艺

常回家看看　木雕　45cm×35cm×45cm　张燕萍　温州

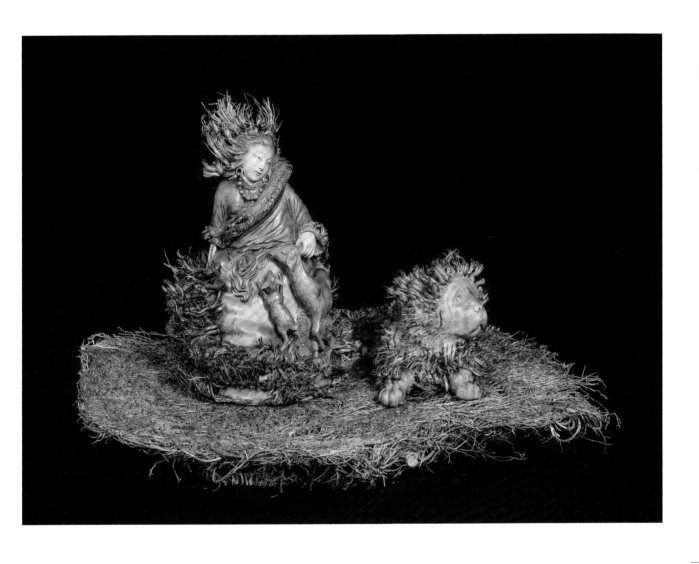

草原情　竹根雕　78cm×60cm×50cm　徐洁　宁波

庆祝中国共产党成立 100 周年暨第五届浙江工艺美术双年展作品选集

Selected Works from the 5th Zhejiang Arts and Crafts Biennial Exhibition Celebrating the 100th Anniversary of the Founding of the CPC

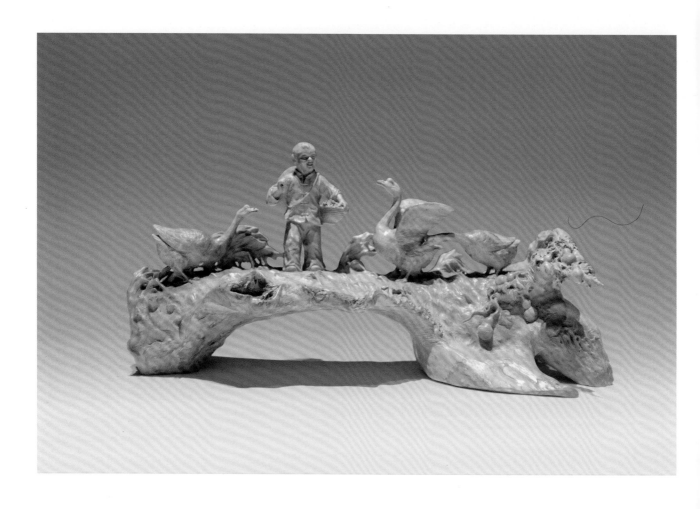

假日 根雕 55cm×22cm×26cm 郭贤姆 温州

和天下　木雕　70cm×33cm×28cm　方江鸿　温州

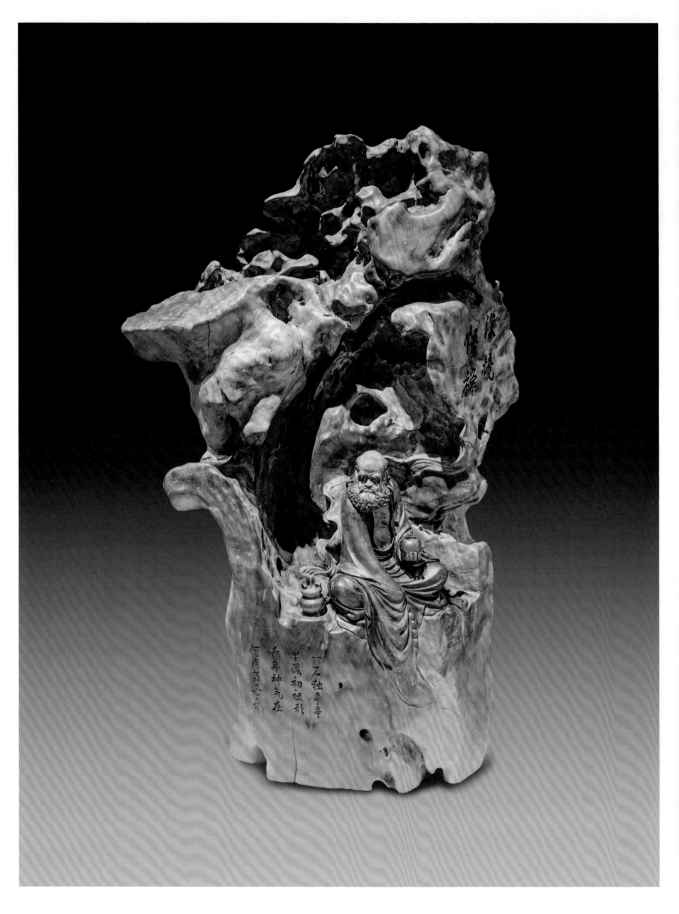

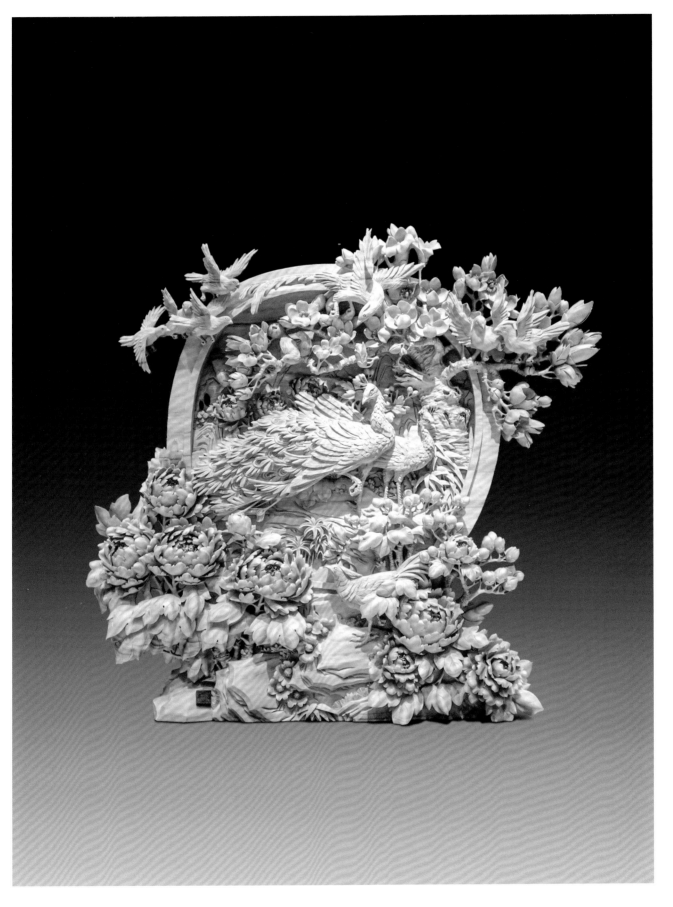

庆祝中国共产党成立 100 周年暨第五届浙江工艺美术双年展作品选集　Selected Works from the 5th Zhejiang Arts and Crafts Biennial Exhibition, celebrating the 100th Anniversary of the Founding of the CPC

木竹雕刻工艺　Wood And Bamboo Carving Craft

含香带露情无限　木雕　98cm×20cm×110cm　杨松华　金华

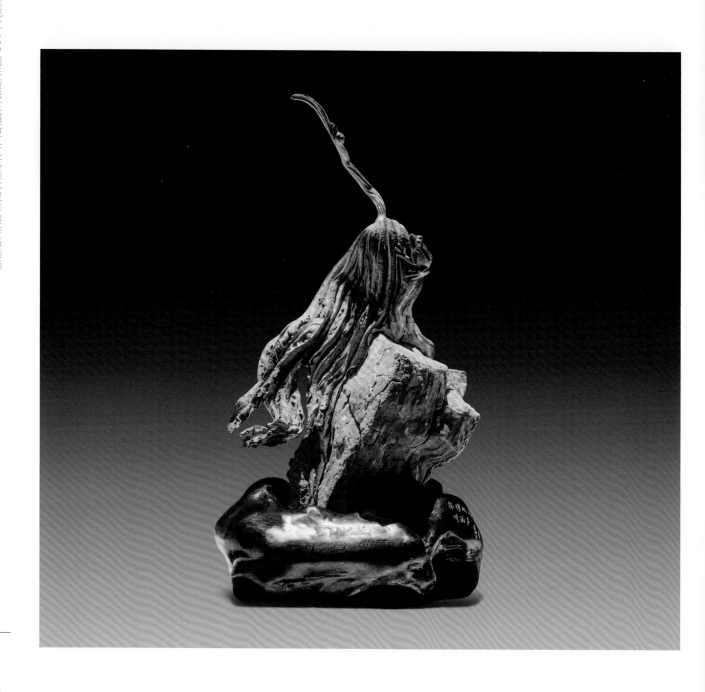

Wood And Bamboo Carving Craft

木竹雕刻工艺

留得残荷听雨声 木根雕 60cm×40cm×65cm 徐惠东 杭州

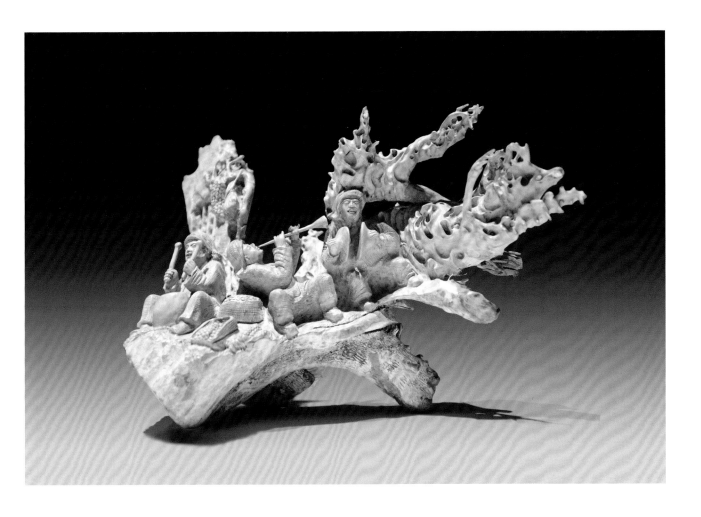

陕北的好江南　木雕　45cm×28cm×48cm　马利洋　嘉兴

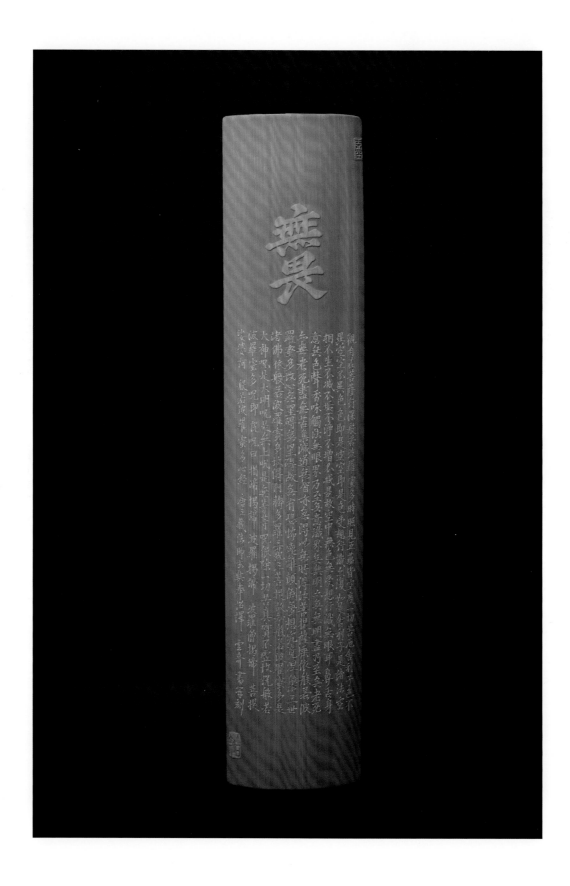

庆祝中国共产党成立 100 周年暨第五届浙江工艺美术双年展作品选集
Selected Works from the 5th Zhejiang Arts and Crafts Biennial Exhibition Celebrating the 100th Anniversary of the Founding of the CPC

Wood And Bamboo Carving Craft

木竹雕刻工艺

无畏心经　竹刻　36cm×8cm×0.6cm　徐云奇　嘉兴

庆祝中国共产党成立 100 周年暨第五届浙江工艺美术双年展作品选集

Selected Works from the 100 Anniversary of the Found of the Communist Party of China and Celent Biennial Exhibition Celebrating the 100th Anniversary of the Communist Party of China PRC

咏兰　竹刻　30cm×11cm　沈晓红　嘉兴

庆祝中国共产党成立 100 周年暨第五届浙江工艺美术双年展作品选集

Selected Works from the 5th Zhejiang Arts and Crafts Biennial Exhibition Celebrating the 100th Anniversary of the Founding of the CPC

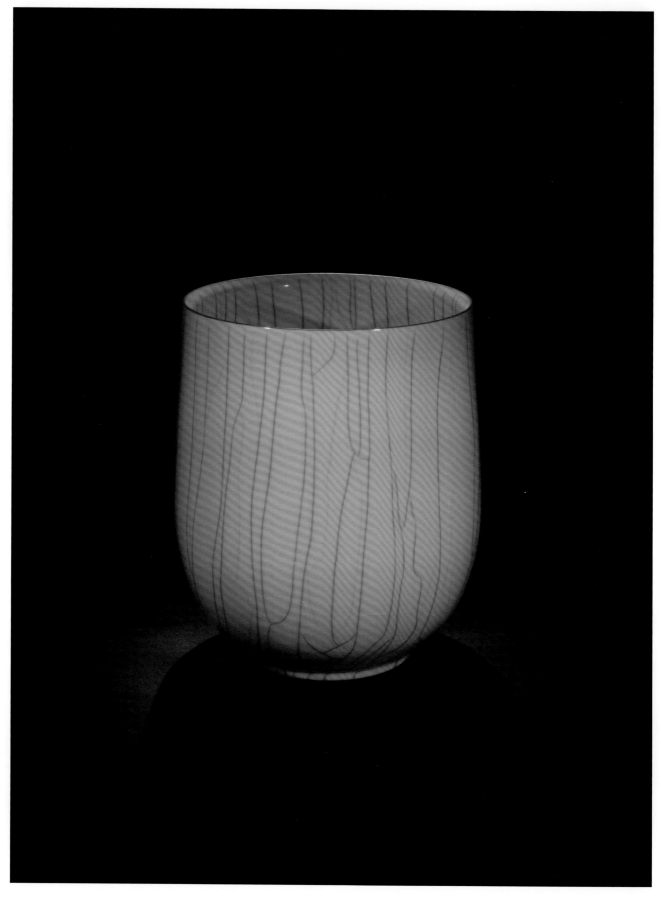

情丝系日　青瓷　17cm×17cm×31cm　卢伟孙　丽水

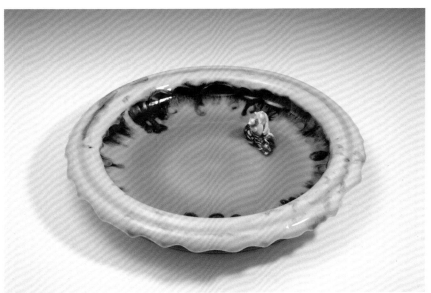

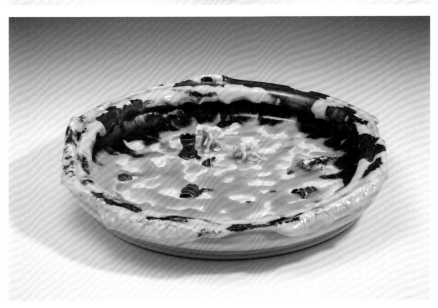

昨天·今天·明天　青瓷　50cm×50cm×15cm×3　李震　丽水

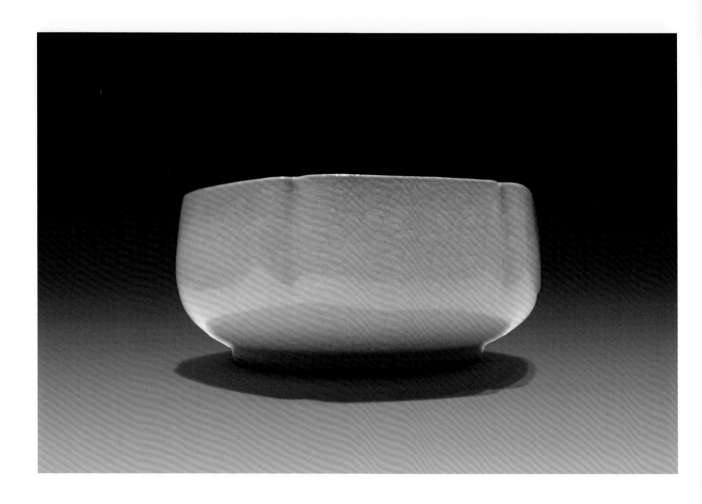

Ceramic Craft

陶瓷工艺

官窑冰裂葵瓣洗　陶瓷　23cm×23cm×8cm　金国荣　杭州

庆祝中国共产党成立 100 周年暨第五届浙江工艺美术双年展作品选集
Selected Works from the 5th Zhejiang Arts and Crafts Biennial Exhibition Celebrating the 10th Anniversary of the Fourth Bing of the CPC

陶瓷工艺

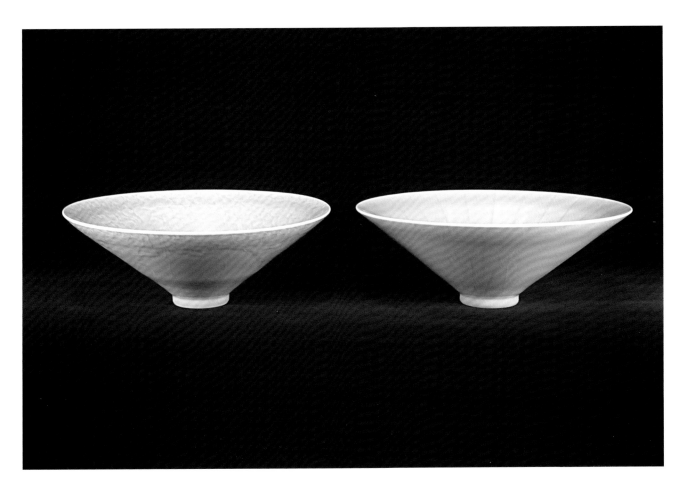

坐定乾坤　青瓷　39cm×39cm×14cm×2　杨小秋　丽水

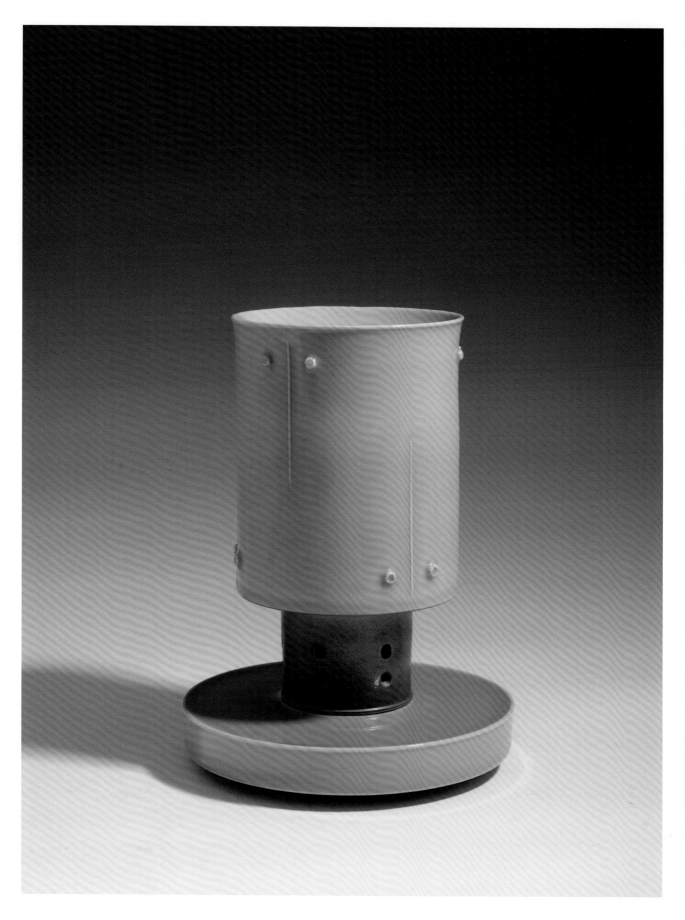

大雪·断虹霁雨　青瓷　22cm×22cm×30cm　支持　丽水

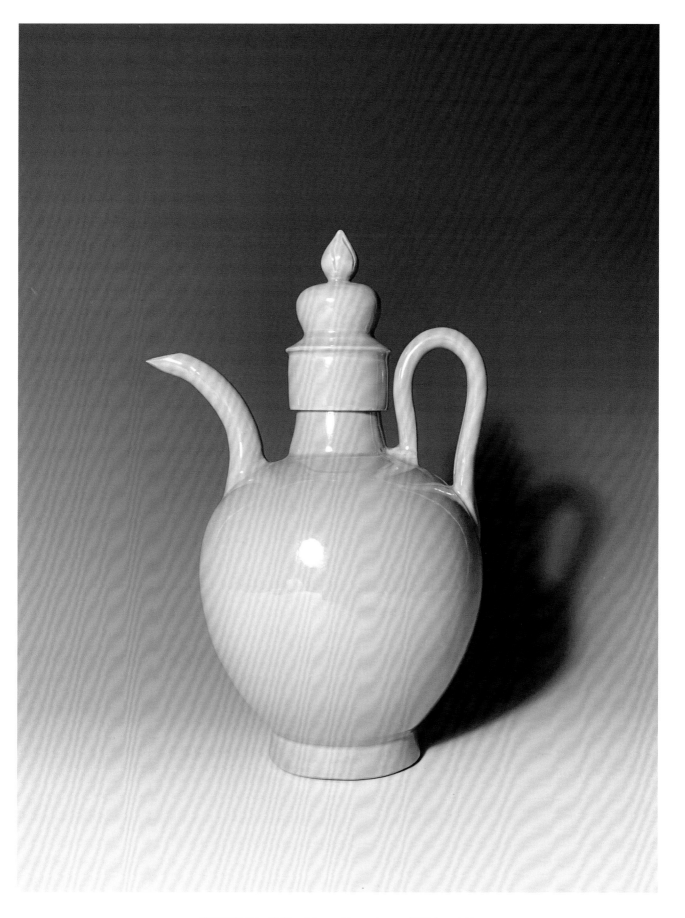

秘色瓷执壶　陶瓷　26cm×14cm×8cm　闻果立　宁波

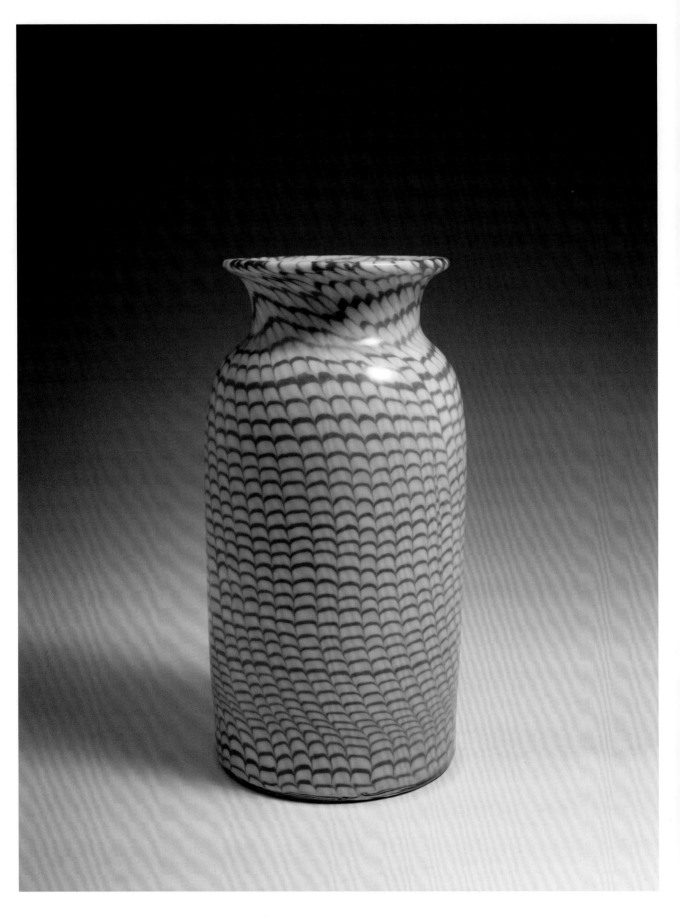

乡愁　青瓷　16cm×16cm×32cm　王法根　丽水

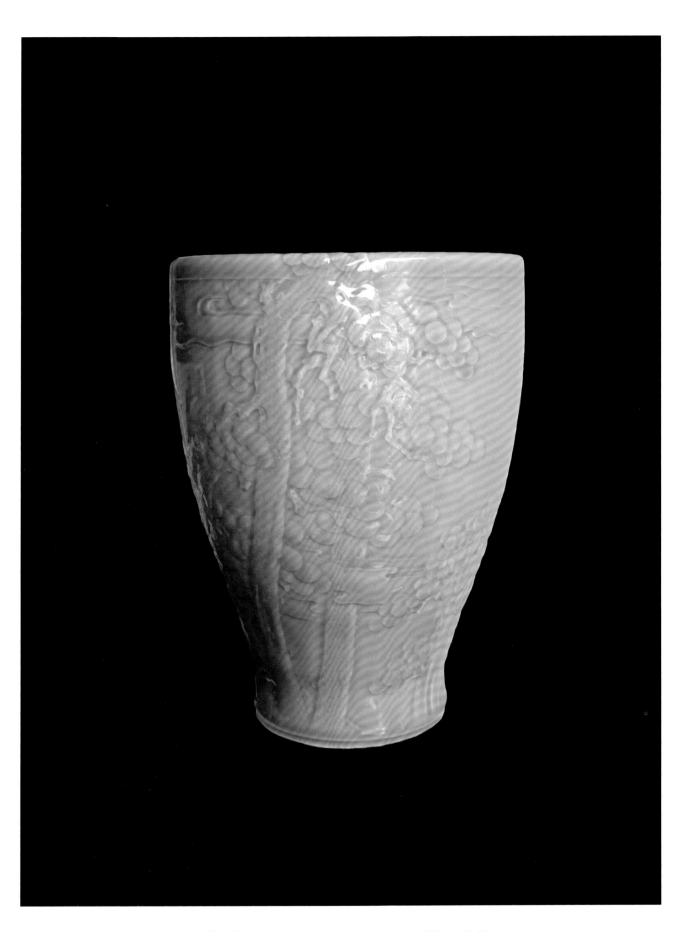

风华正茂　青瓷　30.5cm×30.5cm×43cm　罗洪文　杭州

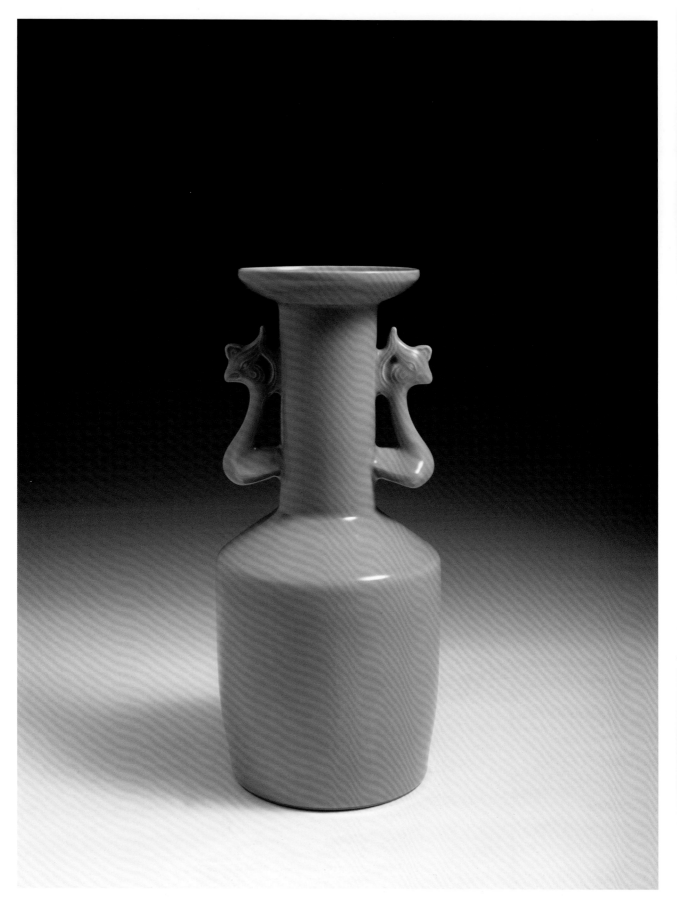

凤耳瓶　青瓷　15.5cm×15.5cm×38cm　徐建新　丽水

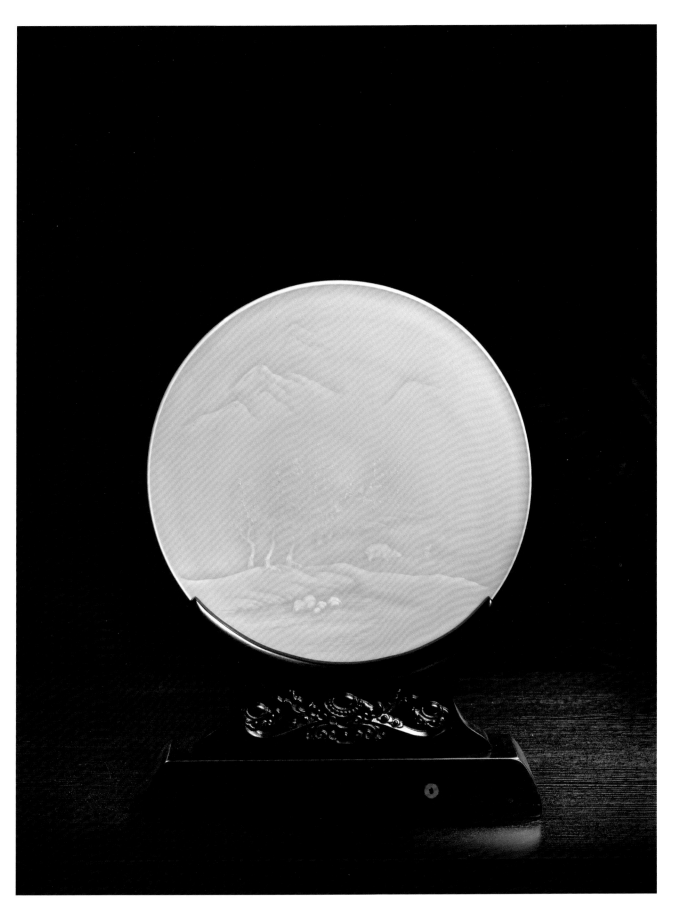

庆祝中国共产党成立 100 周年暨第五届浙江工艺美术双年展作品选集

Selected Works from the 5th Zhejiang Arts and Crafts Biennial Exhibition Celebrating the 100th Anniversary of the Founding of the CPC

牧牛　青瓷　35cm×35cm　胡少芬　丽水

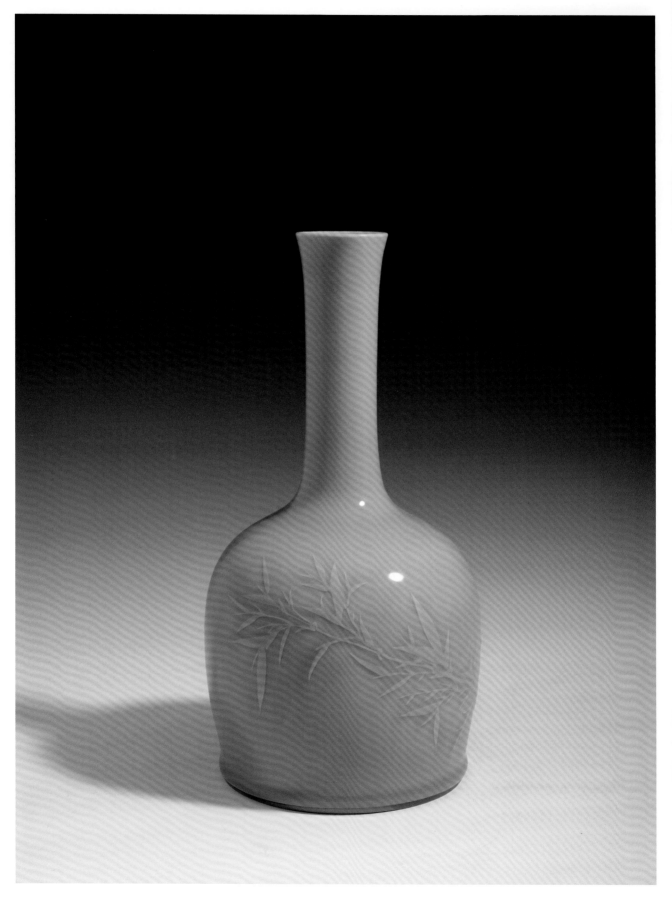

禅竹纸槌瓶　青瓷　14.4cm×14.4cm×31.4cm　吴维清　丽水

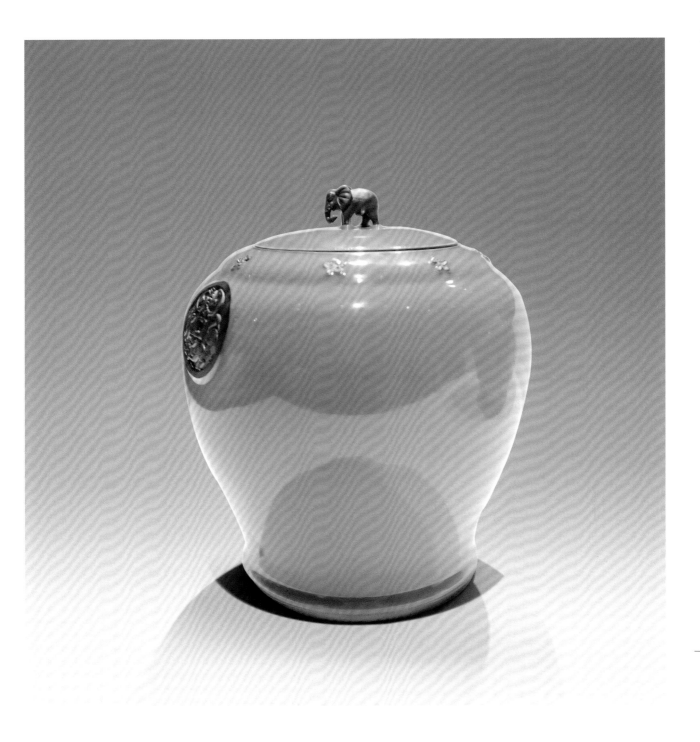

圆融盖罐　青瓷　14.2cm×14.2cm×22cm　吴维清　丽水

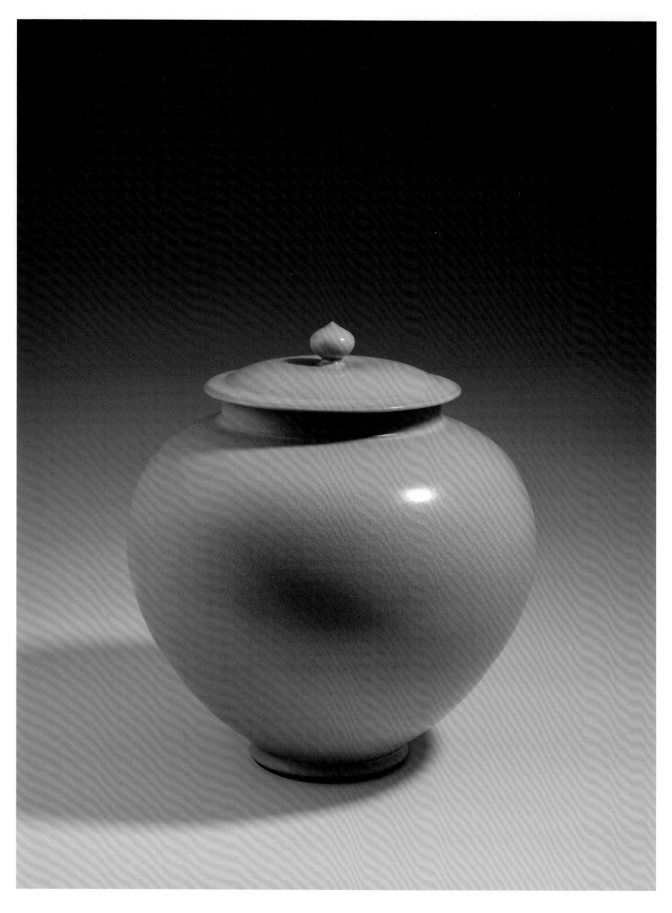

庆祝中国共产党成立 100 周年暨第五届浙江工艺美术双年展作品选集

Selected Works from the 5th Zhejiang Arts and Crafts Biennial Exhibition Celebrating the 100th Anniversary of the Founding of the CPC

Ceramic Craft

陶瓷工艺

唐风宋韵　青瓷　33cm×33cm×37cm　徐俊杰　丽水

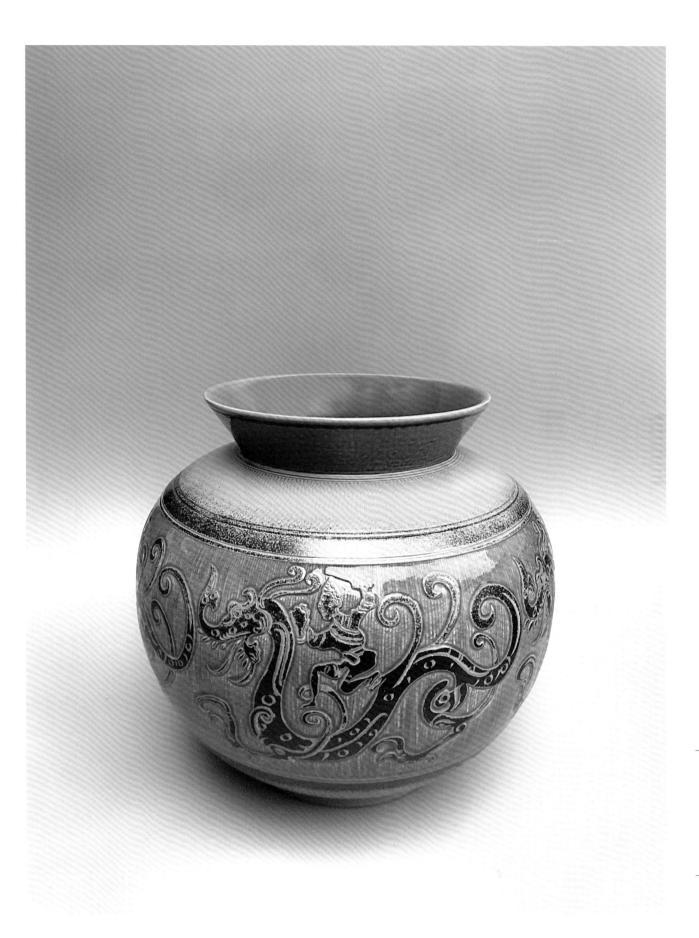

龙腾 　陶瓷　32cm×32cm×36cm　邵杭平　金华

庆祝中国共产党成立 100 周年暨第五届浙江工艺美术双年展作品选集

Selected Works from the 5th Zhejiang Arts and Crafts Biennial Exhibition Celebrating the 100th Anniversary of the Founding of the CPC

Ceramic Craft

陶瓷工艺

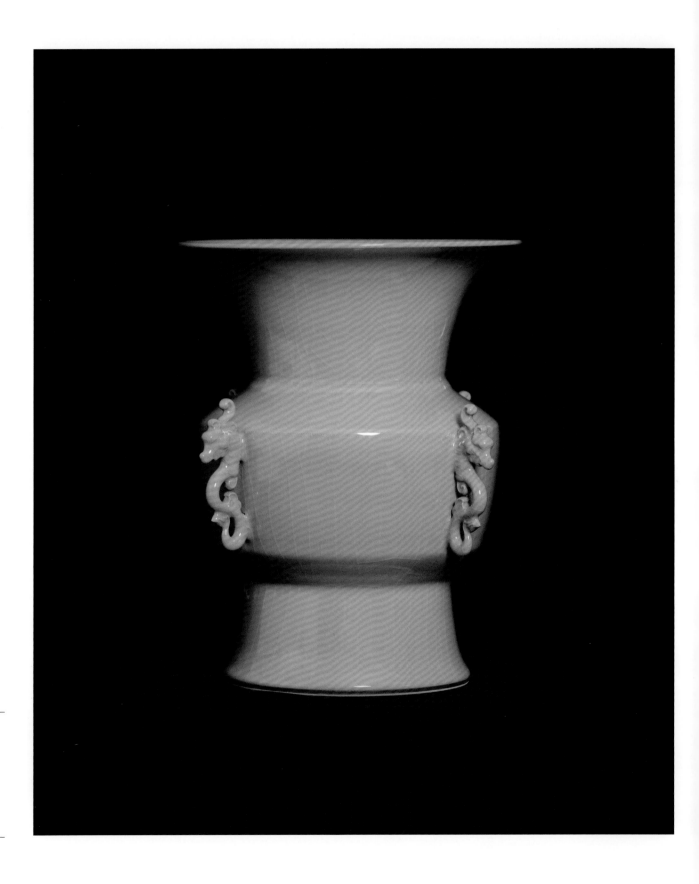

盛世尊　青瓷　27.5cm×27.5cm×34.5cm　叶传应　丽水

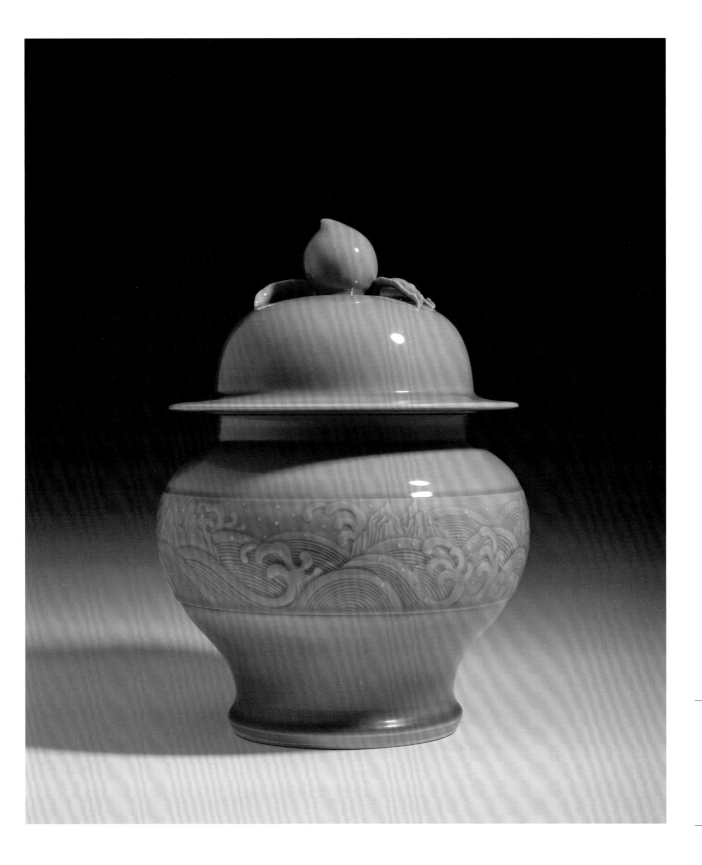

福寿贺诞·清韵山河　青瓷　28cm×28cm×48cm　兰宁莉　丽水

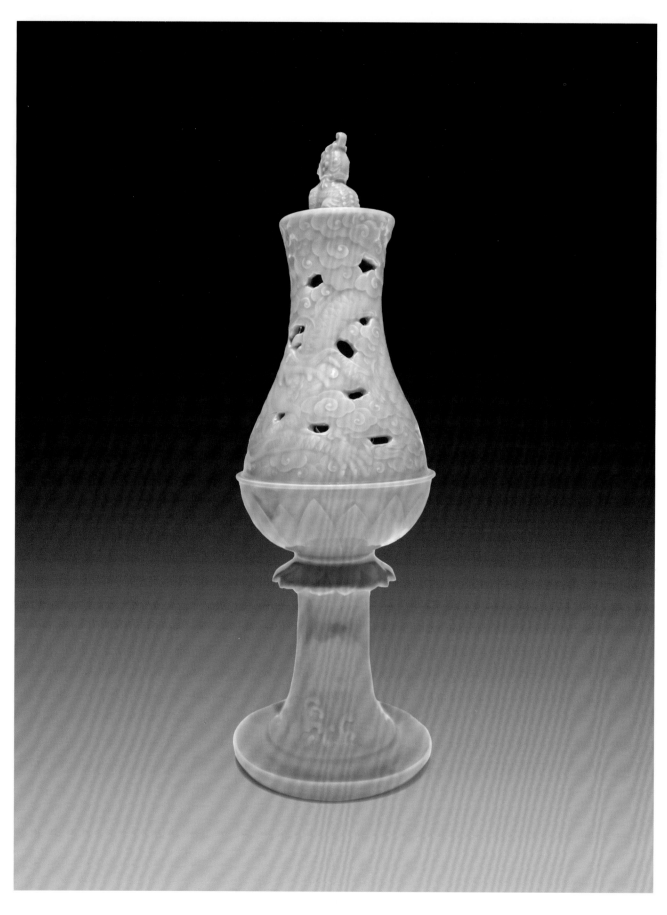

龙渊记　青瓷　20cm×20cm×50cm　曾志女　丽水

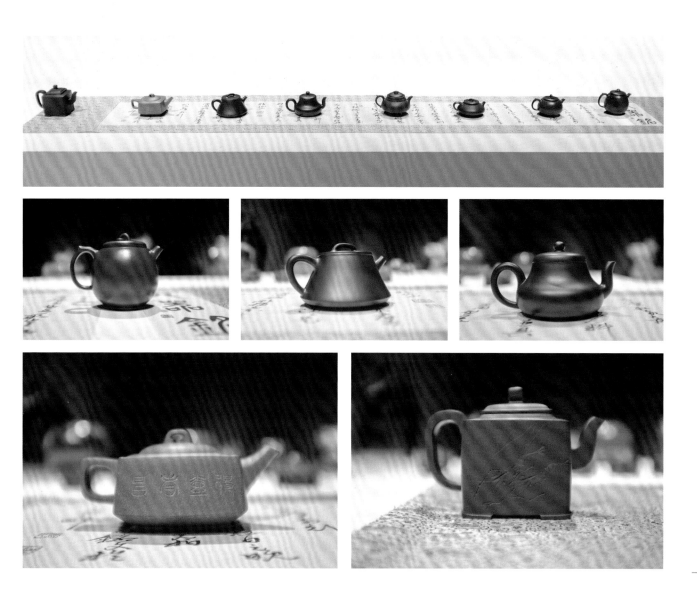

元柏十八式　紫砂　160cm×38cm（展示尺寸）　吴煜敏　杭州

庆祝中国共产党成立 100 周年暨第五届浙江工艺美术双年展作品选集

Selected Works from the 5th Zhejiang Arts and Crafts Biennial Exhibition Celebrating the 100th Anniversary of the Founding of the CPC

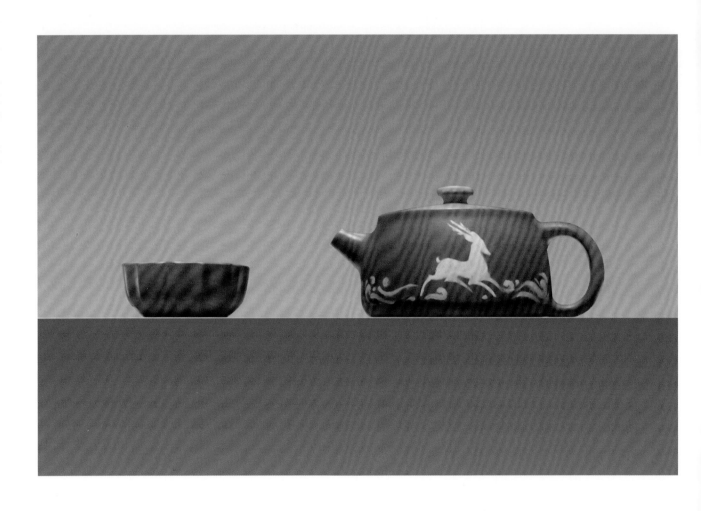

白鹿游　紫砂　16cm×10.6cm×8.7cm　陈曦　湖州

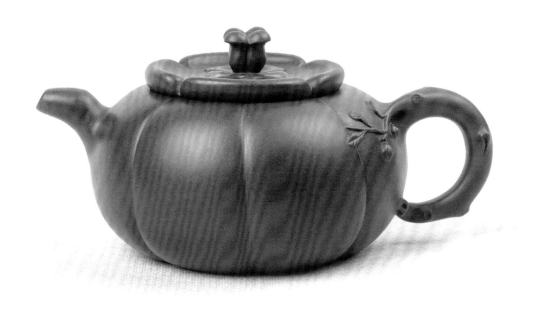

事事如意　紫砂　17cm×11cm×15cm　蒋燕　湖州

庆祝中国共产党成立 100 周年暨第五届浙江工艺美术双年展作品选集

Selected Works from the 5th Zhejiang Arts and Crafts Biennial Exhibition Celebrating the 100th Anniversary of the Founding of the CPC

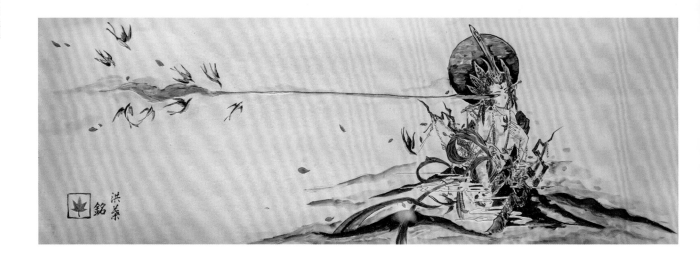

乾闼婆　陶瓷　110cm×55cm×5cm　洪叶　湖州

丝路锦绣　刺绣　40cm×100cm×4　金家虹　杭州

庆祝中国共产党成立 100 周年暨第五届浙江工艺美术双年展作品选集

Selected Works from the 5th Zhejiang Arts and Crafts Biennial Exhibition Celebrating the 100th Anniversary of the Founding of the CPC

Embroidery Craft

刺绣工艺

似水　台绣　14.5cm×20cm×12　王沁、潘小英　台州

庆祝中国共产党成立100周年暨第五届浙江工艺美术双年展作品选集

Selected Works from the 5th Zhejiang Arts and Crafts Biennial Exhibition Celebrating the 100th Anniversary of the Founding of the CPC

草木本心　发绣　45cm×45cm×2　蔡淑明　温州

庆祝中国共产党成立 100 周年暨第五届浙江工艺美术双年展作品选集

Selected Works from the 5th Zhejiang Arts and Crafts Biennial Exhibition Celebrating the 100th Anniversary of the Founding of the CPC

千丝万缕 棉纱抽丝 180cm×260cm 王丽华 杭州

庆祝中国共产党成立 100 周年暨第五届浙江工艺美术双年展作品选集

Selected Works from the 5th Zhejiang Arts and Crafts Biennial Exhibition Celebrating the 100th Anniversary of the Founding of the CPC

昆虫·标本盒子　发绣　32cm×23cm×5cm　林纤宁　温州

庆祝中国共产党成立 100 周年暨第五届浙江工艺美术双年展作品选集

Selected Works from the 5th Zhejiang Arts and Crafts Biennial Exhibition Celebrating the 100th Anniversary of the Founding of the CPC

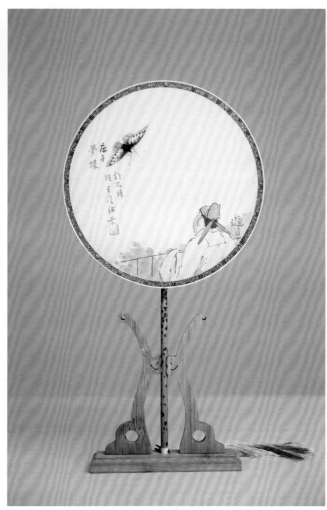

梦蝶·蝉　发绣　32cm×26cm×2　王欢儿　宁波

庆祝中国共产党成立 100 周年暨第五届浙江工艺美术双年展作品选集

Selected Works from the 8th Zhejiang Arts and Crafts Biennial Exhibition Celebrating the 100th Anniversary of the Founding of the JPC

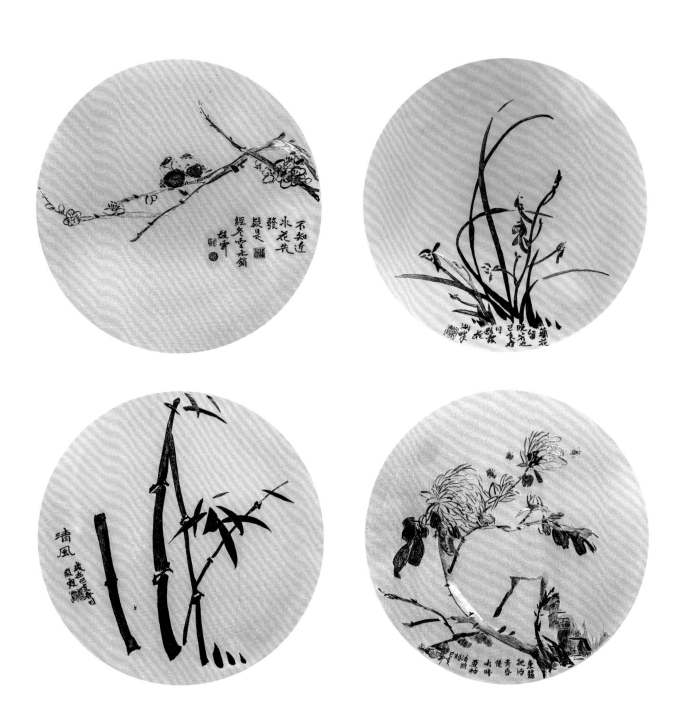

四季君子　杭绣　60cm×60cm×4　邵毅霞、陆蕾　杭州

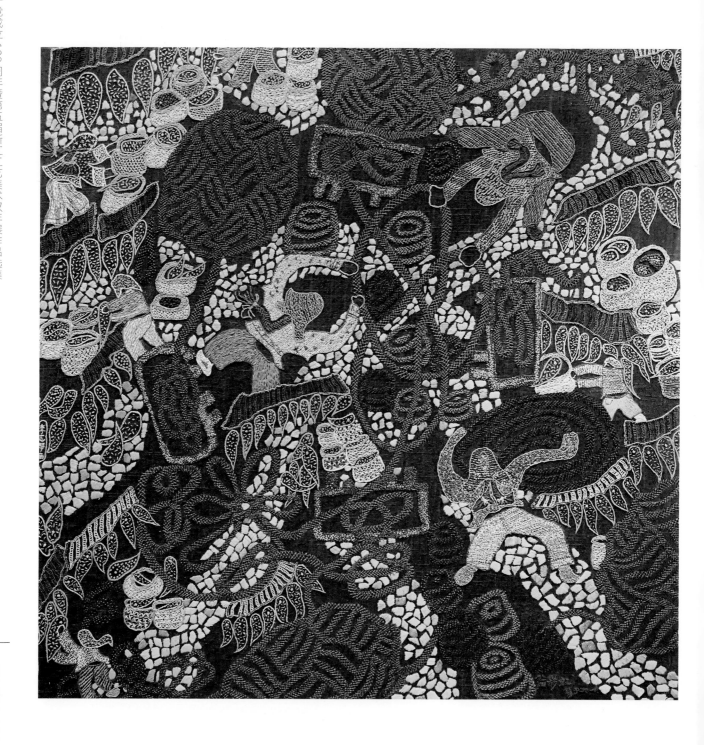

渔绳呈祥图　刺绣　85cm×85cm　陆彩红　舟山

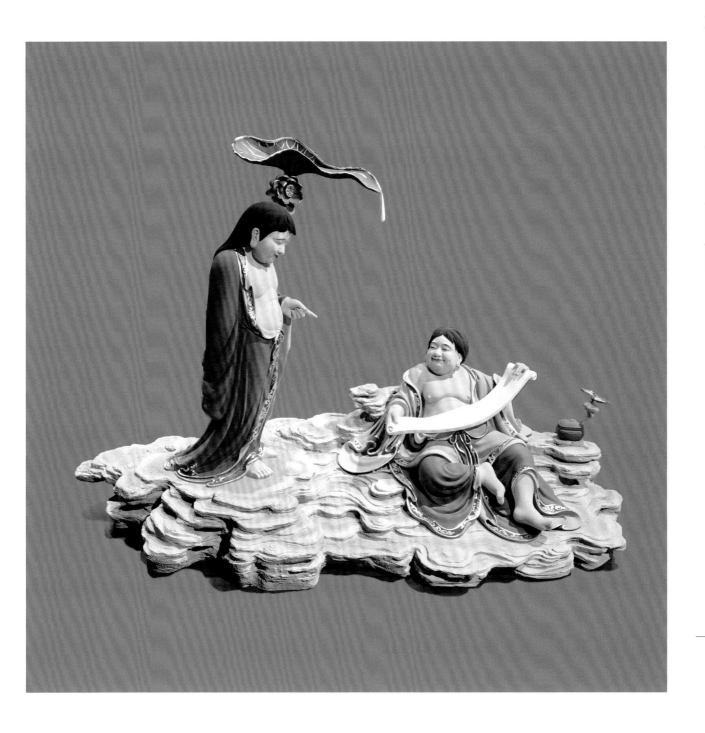

和合系列·和而不同　夹苎脱胎漆艺　146cm×78cm×99cm　李善土、李浩凯　台州

庆祝中国共产党成立100周年暨第五届浙江工艺美术双年展作品选集

Selected Works from the 5th Zhejiang Arts and Crafts Biennial Exhibition Celebrating the 100th Anniversary of the Founding of the CPC

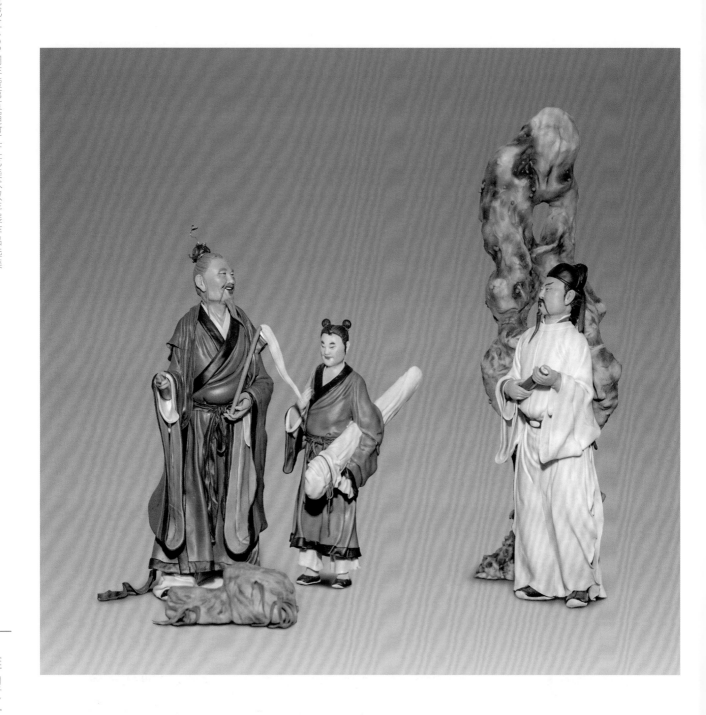

诗路文化·李白与司马承祯　面塑　60cm×40cm×50cm（展示尺寸）　刘存昶　台州

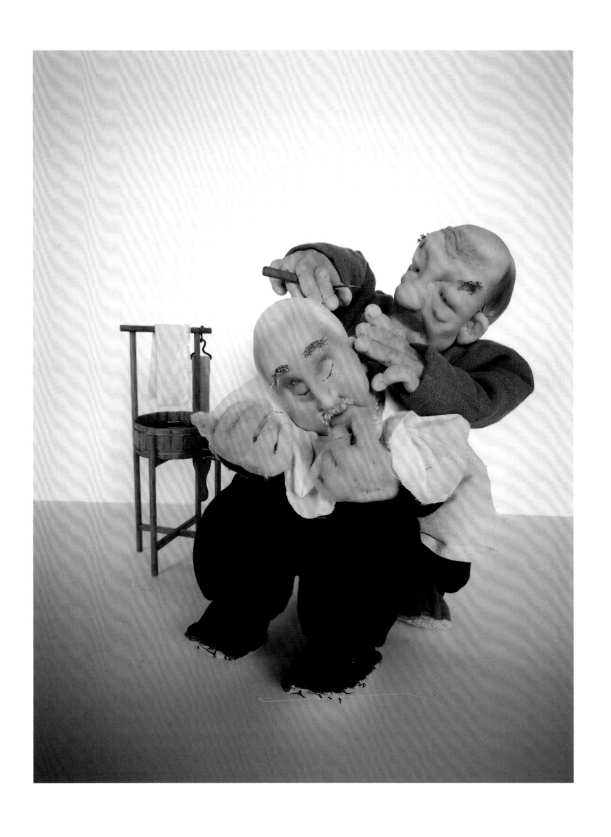

守艺人·剃头师傅 绣塑 30cm×20cm×30cm 朱雪芬 嘉兴

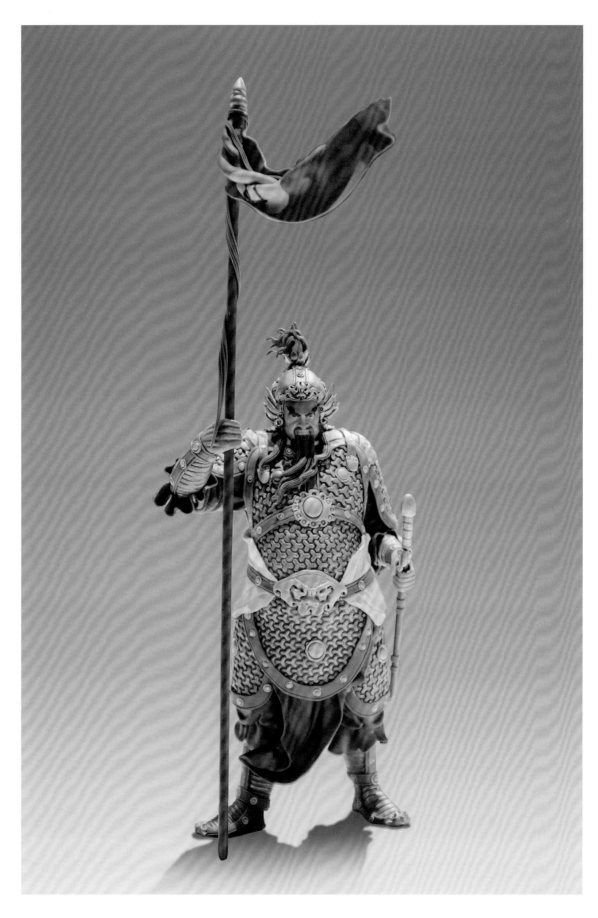

精忠报国　粉塑　20cm×15cm×60cm　孙文聪　宁波

谦受益·满招损 现代刻字 35cm×45cm×5cm 周敬林 衢州

庆祝中国共产党成立100周年暨第五届浙江工艺美术双年展作品选集

Selected Works from the 5th Zhejiang Arts and Crafts Biennial Exhibition Celebrating the 100th Anniversary of the Founding of the CPC

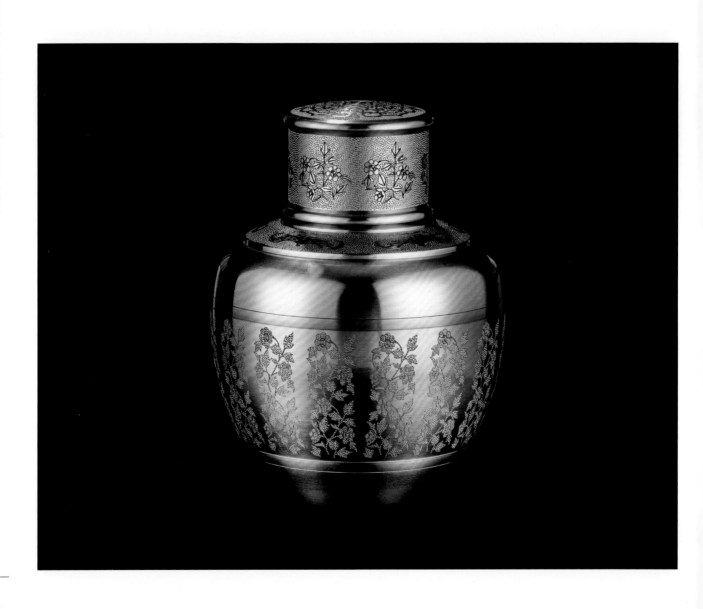

五福临门锡罐　锡雕　13cm×13cm×16cm　盛一原、盛世民　金华

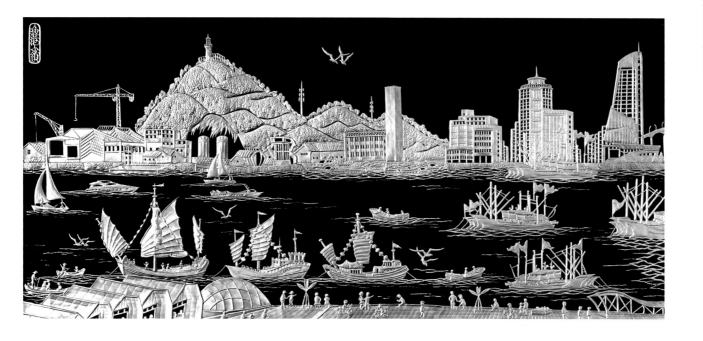

渔港小镇　金属工艺　130cm×70cm　谢惠儿　舟山

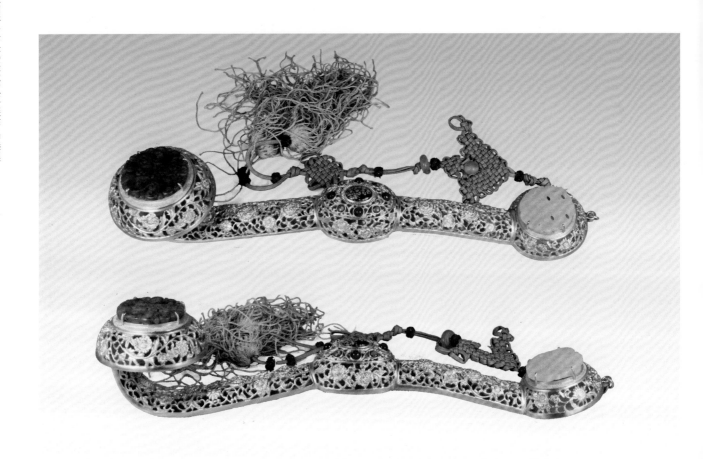

金镶玉富贵如意　金银细工　48cm×18cm×11cm　张震港　杭州

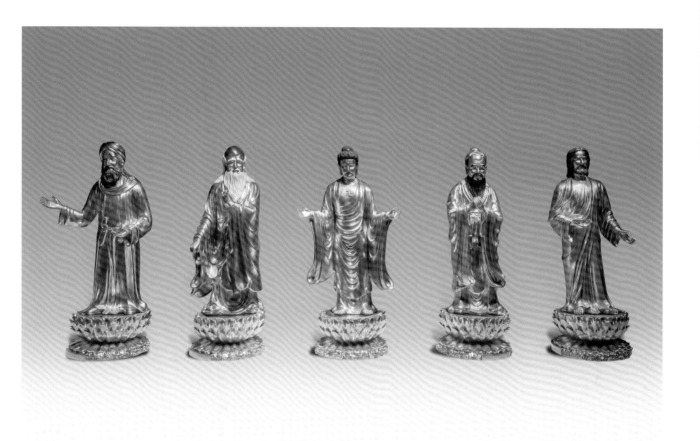

和谐世界　漆器　40cm×40cm×108cm×5　汤江洁　台州

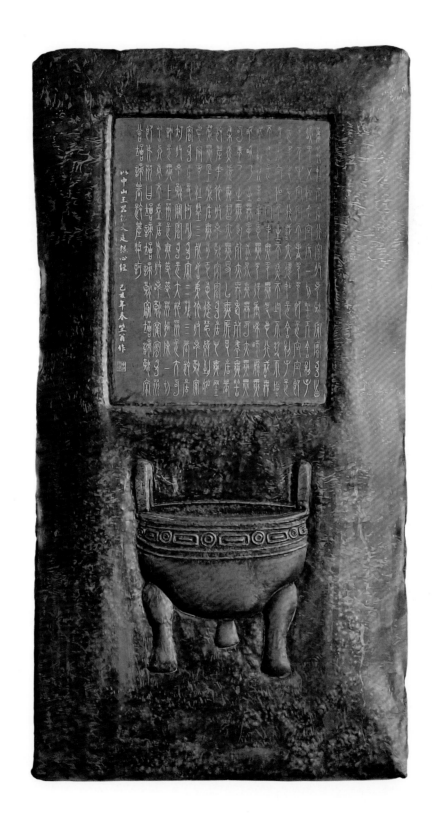

中山王鼎铭文之《心经》　金属工艺　160cm×75cm×7cm　翁海星　舟山

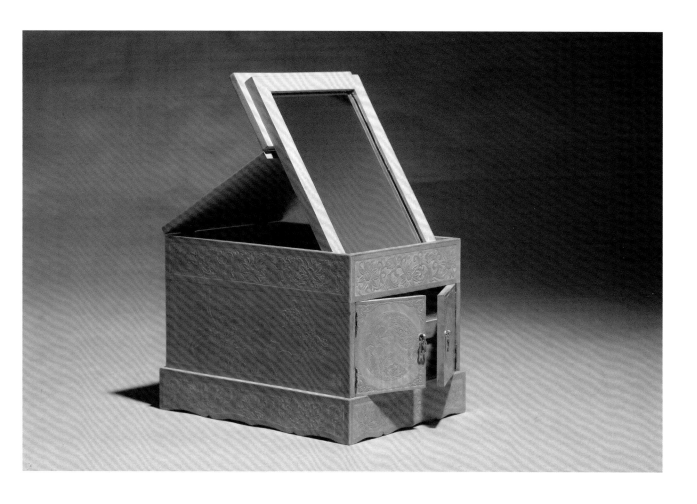

黄岩翻簧竹雕镜奁　翻簧竹刻　24.5cm×18.5cm×19cm　罗文弛　台州

庆祝中国共产党成立 100 周年暨第五届浙江工艺美术双年展作品选集

Selected Works from the 5th Zhejiang Arts and Crafts Biennial Exhibition Celebrating the 100th Anniversary of the Founding of the CPC

一带一路　竹编　90cm×25cm×80cm　何红兵　金华

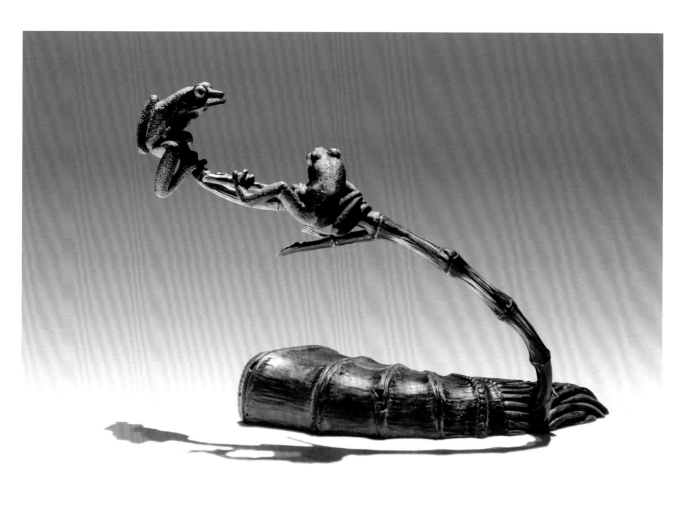

庆祝中国共产党成立 100 周年暨第五届浙江工艺美术双年展作品选集

Selected Works from the 5th Zhejiang Arts and Crafts Biennial Exhibition - Celebrating the 100th Anniversary of the Founding of the CPC

情话 角雕 28cm×13cm×18cm 柴春福 衢州

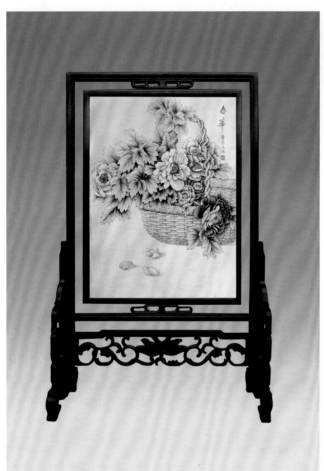
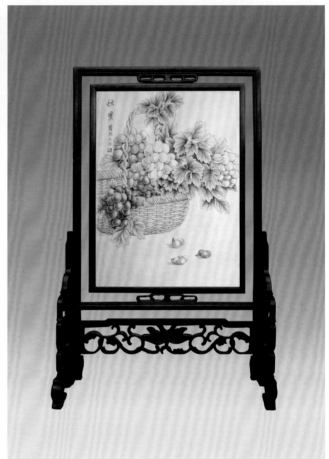

春华秋实　烙画　20cm×48cm×72cm　王永祥　杭州

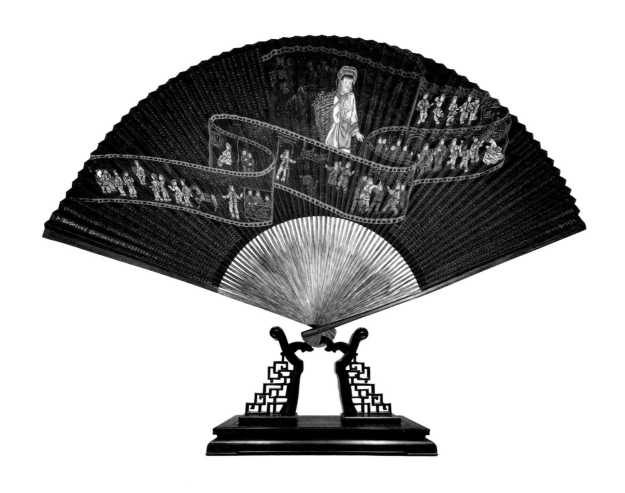

庆祝中国共产党成立100周年暨第五届浙江工艺美术双年展作品选集

Selected Works from the Mo Zhejiang Arts and Crafts Biennial Exhibition Celebrating the 100th Anniversary of the Founding of the CPC

阿诗玛　扇艺　110cm×30cm×80cm　俞备红　杭州

庆祝中国共产党成立 100 周年暨第五届浙江工艺美术双年展作品选集

Selected Works from the 5th Zhejiang Arts and Crafts Biennial Exhibition Celebrating the 100th Anniversary of the Founding of the CPC

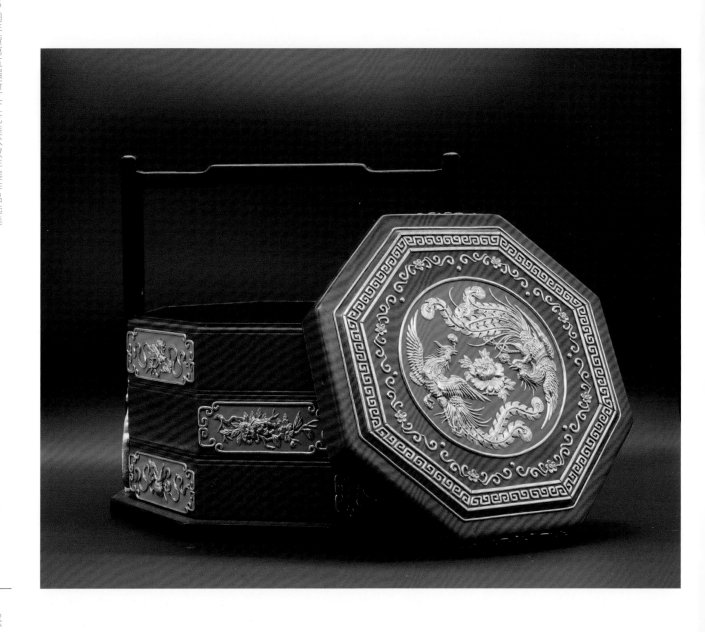

泥金彩漆八角提篮　泥金彩漆　29cm×26cm×27cm　胡亮亮、王琼、王占奎　宁波

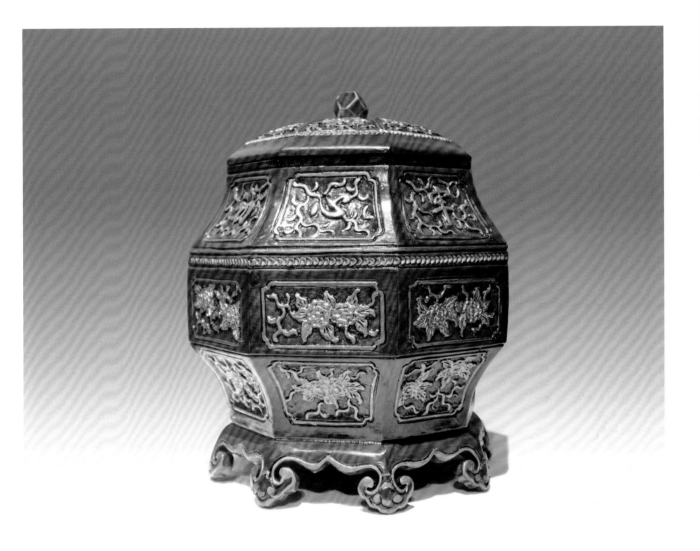

不忘初心 木工艺 40cm×40cm×55cm 姚祖观 嘉兴

大好河山 艺术铜版画 50cm×200cm×5cm 刘华 杭州

生如夏花 手工挂毯 70cm×200cm 郑丹 嘉兴

庆祝中国共产党成立 100 周年暨第五届浙江工艺美术双年展作品选集

Selected Works from the 5th Zhejiang Arts and Crafts Biennial Exhibition Celebrating the 100th Anniversary of the Founding of the CPC

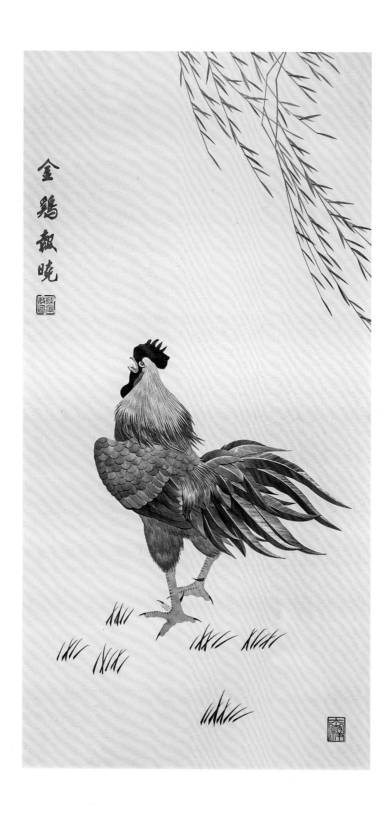

金鸡报晓　稻草画　50cm×85cm　陈军敏　台州

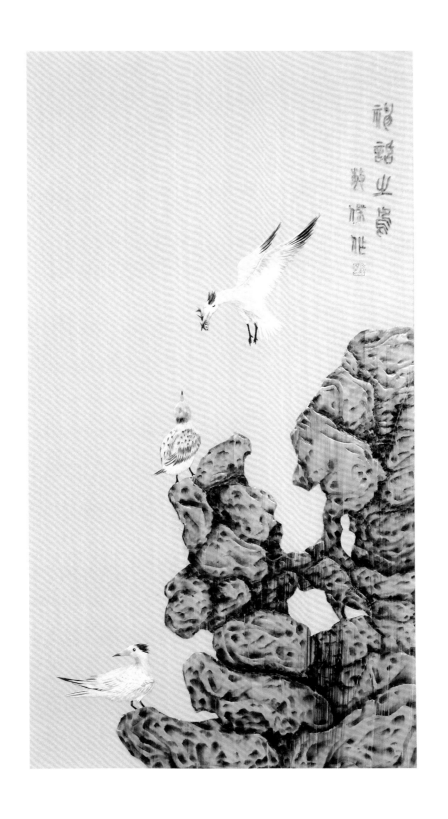

神话之鸟 麦秸画 60cm×105cm 徐敏杰 宁波

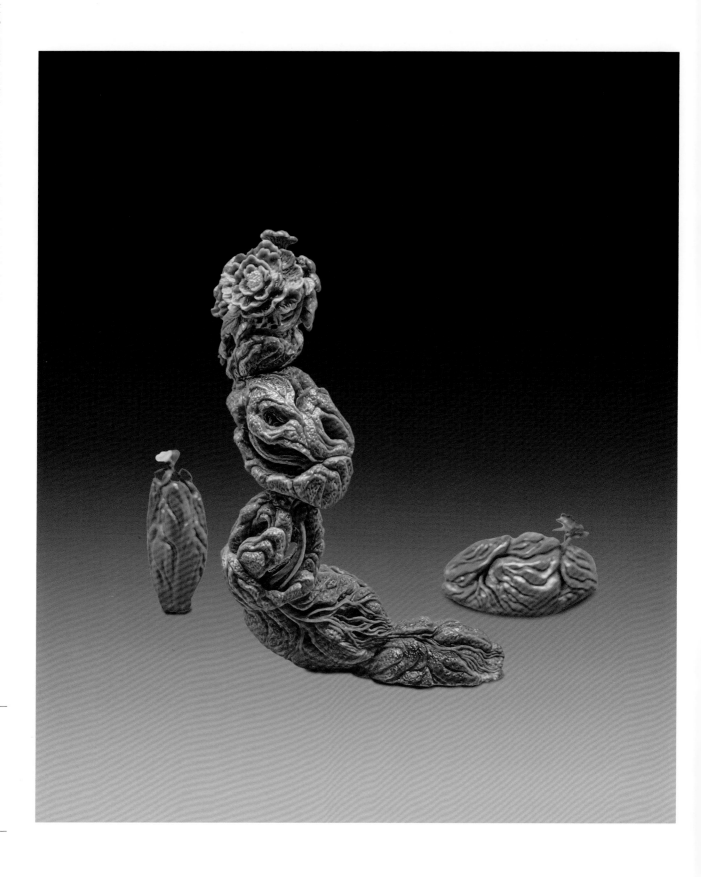

梦想之花　橄榄核雕　17cm×14cm×12cm（展示尺寸）　夏云龙　湖州

庆祝中国共产党成立 100 周年暨第五届浙江工艺美术双年展作品选集

Selected Works from the 5th Zhejiang Arts and Crafts biennial Exhibition Celebrating the 100th Anniversary of the Founding of the CPC

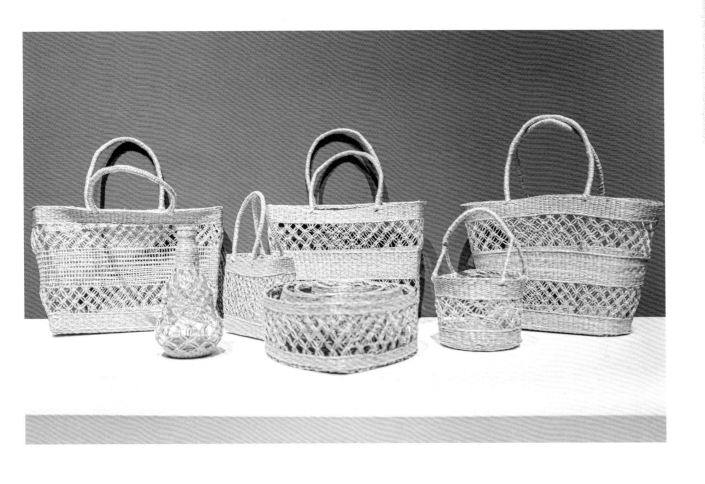

百年梦圆 草编 80cm×100cm（展示尺寸） 沈晓君 杭州

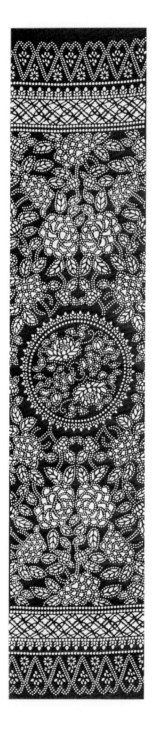
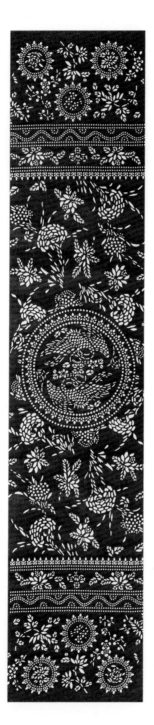

芳华 蓝印花布 235cm×50cm×4 哀警卫 嘉兴

农忙时节 蓝印花布 120cm×90cm 钱诗勋 嘉兴

山光水色　蓝印花布　115cm×80cm　胡耀飞　嘉兴

果熟 蓝印花布 90cm×70cm 虞燕燕 嘉兴

礼赞红帮　蓝印花布　100cm×150cm　张剑峰　宁波

松鹤长春 泥金彩漆 52cm×112cm×2 沈黎军 宁波

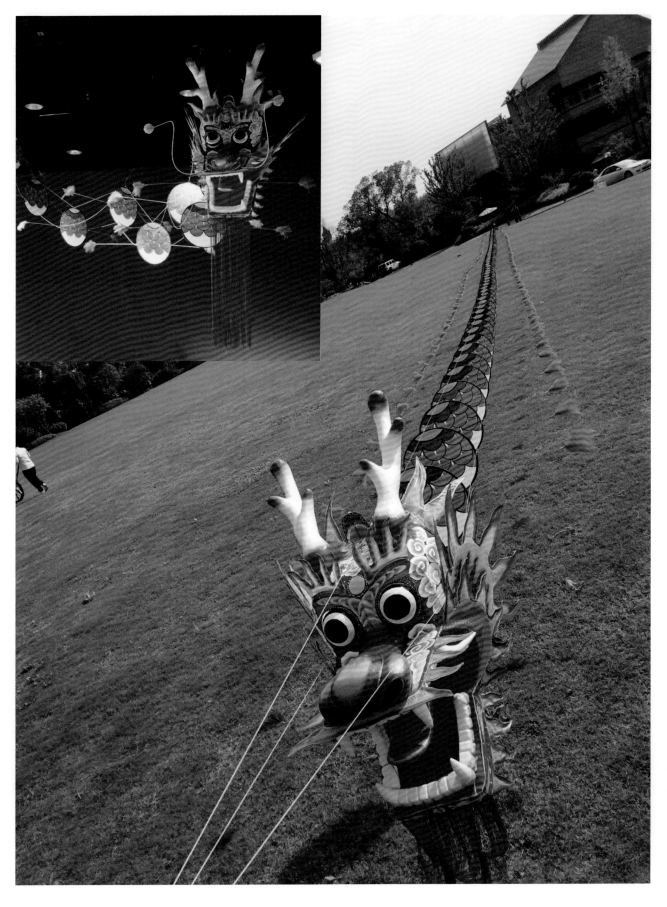

百米长龙　风筝　1000cm×150cm×150cm　程迪申　杭州

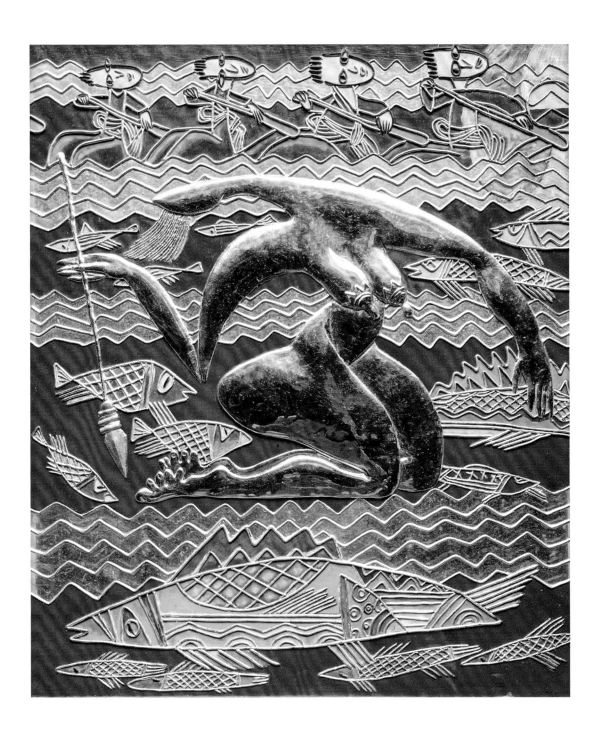

渔船　泥金彩漆　51cm×56cm　李明霁　宁波

漆杯　漆艺　5cm×8cm　朱金玲　台州

大肚漆杯 漆艺 8cm×30cm×7.5cm 黄晨 台州

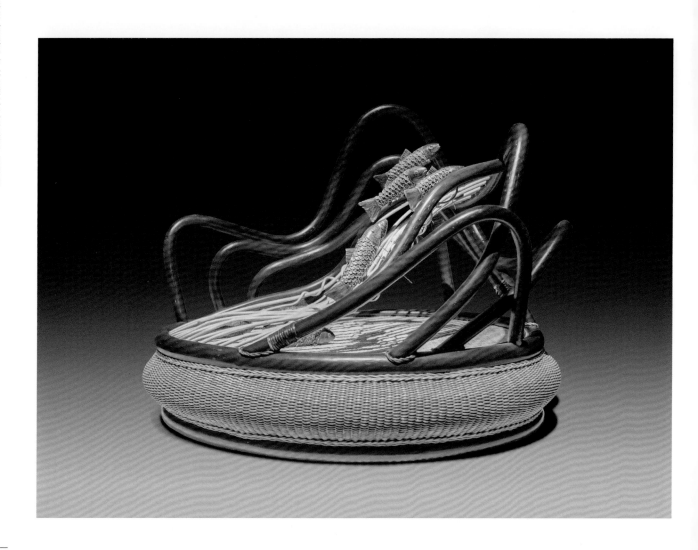

逆行　藤编　70cm×48cm×35cm　张焕宝　嘉兴

庆祝中国共产党成立100周年暨第五届浙江工艺美术双年展作品选集

(Qing Zhu Zhong Guo Gong Chan Dang Cheng Li 100 Zhou Nian Ji Di Wu Jie Zhe Jiang Gong Yi Mei Shu Shuang Nian Zhan Zuo Pin Xuan Ji)

综合工艺

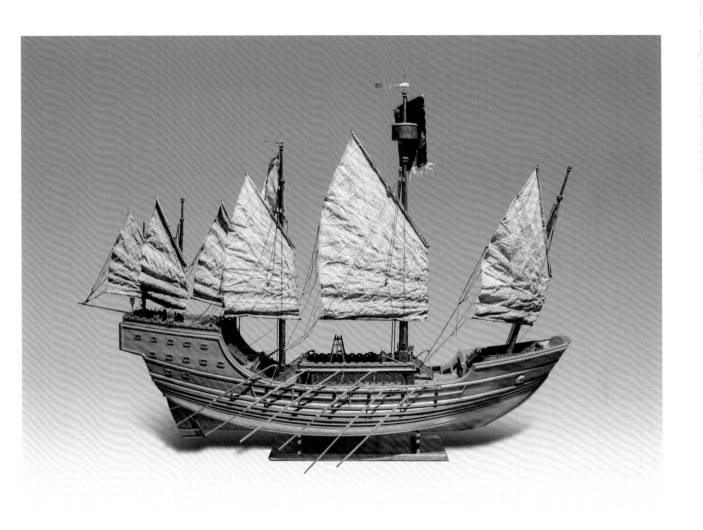

船模·郑和宝船 船模 130cm×40cm×110cm 岑国和 舟山

庆祝中国共产党成立 100 周年暨第五届浙江工艺美术双年展作品选集

Selected Works from the 5th Zhejiang Arts and Crafts Biennial Exhibition Celebrating the 100th Anniversary of the Founding of the CPC

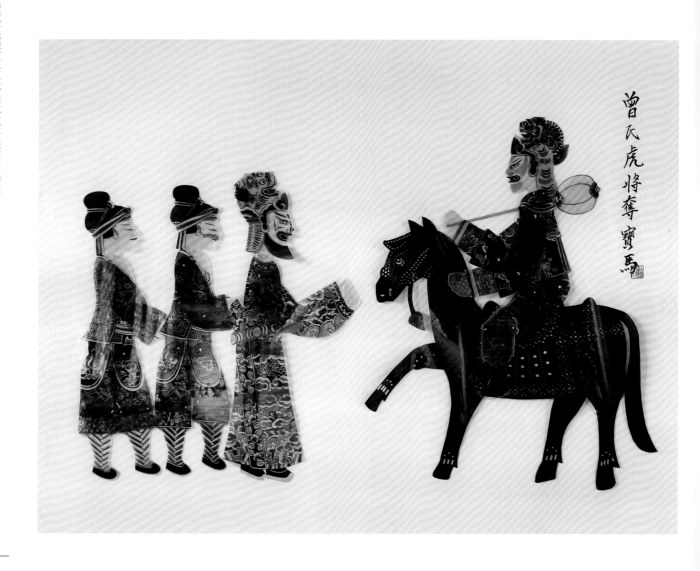

曾氏虎将夺宝马　皮影画　92cm×72cm　徐迪文　嘉兴

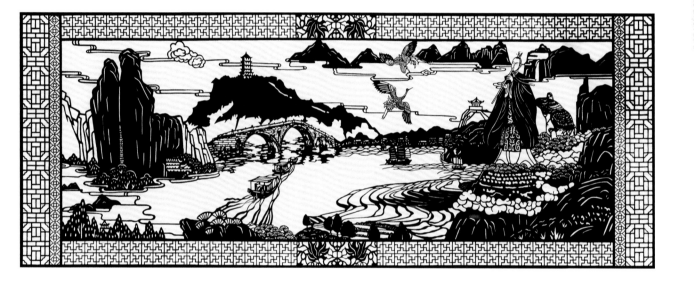

雁山瓯水　细纹刻纸　140cm×60cm　余林敏　温州

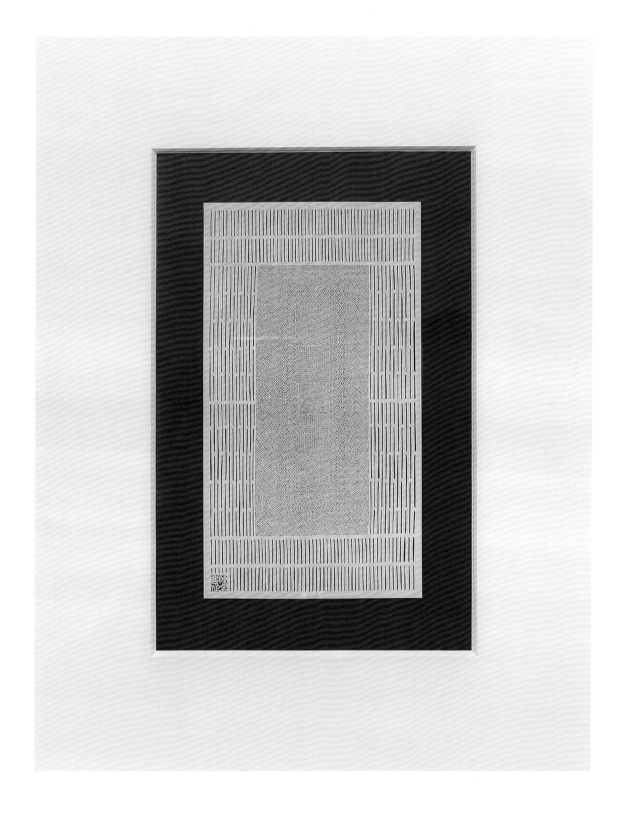

龙船花　细纹刻纸　19cm×11cm　陈余华　温州

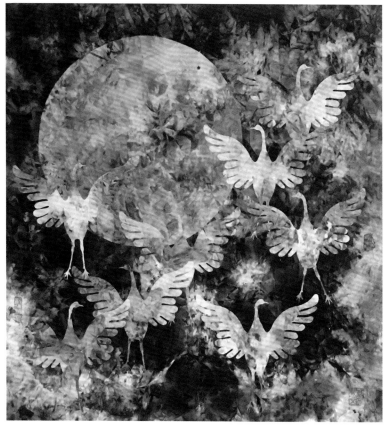

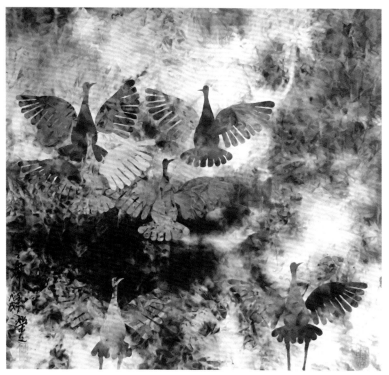

鹤之舞 剪纸　60cm×63cm×2　林荣文　台州

塘栖水北街 剪纸　260cm×44cm　宋胜林　杭州

万年上山文化印象　剪纸　300cm×75cm　方灵莉　金华

乡村振兴·稻丰人欢　剪纸　95cm×79cm　董志华　衢州

麒麟送喜　剪纸　135cm×40cm　方侃源　杭州

Chinese Paper Cutting Craft

剪纸工艺

瓯窑小镇　剪纸　62cm×49.7cm　王温洪　温州

港湾　农民画　100cm×80cm　蒋德叶　舟山

农民画

乡村党课　农民画　76cm×76cm　毛华琴　杭州

庆祝中国共产党成立 100 周年暨第五届浙江工艺美术双年展作品选集

Selected Works from the 5th Zhejiang Arts and Crafts Biennial Exhibition celebrating the 100th Anniversary of the Founding of the CPC

Farmers' Paintings

农民画

丰收宴 农民画 76cm×76cm 周焕琴 杭州

南瓜丰收了 农民画 76cm×76cm 王珏 杭州

庆祝中国共产党成立 100 周年暨第五届浙江工艺美术双年展作品选集

Selected Works from the 5th Zhejiang Arts and Crafts Biennial Exhibition, Held Along with the Celebration for the 100th Anniversary of the Founding of the CPC

农民画

柿子红了　农民画　76cm×76cm　王青　杭州

腾龙舞狮　农民画　68cm×68cm　刘巧云　杭州

山海福地·古韵郭巨　农民画　108cm×75cm　顾常春　宁波

庆祝中国共产党成立 100 周年暨第五届浙江工艺美术双年展作品选集
Selected Works from the 5th Zhejiang Arts and Crafts Biennial Exhibition Celebrating the 100th Anniversary of the Founding of the CPC

Farmers' Paintings

农民画

年年夺丰收　渔民画　65cm×65cm　杨素亚　舟山

庆祝中国共产党成立100周年暨第五届浙江工艺美术双年展作品选集

Selected Works from the Zhejiang 5th annual Crafts Biennial Exhibition Celebrating the 100th Anniversary of the founding of the CPC

又是一个丰收季　渔民画　80cm×80cm　张斌恒　舟山

庆祝中国共产党成立 100 周年暨第五届浙江工艺美术双年展作品选集

Selected Works from the 5th Zhejiang Arts and Crafts Biennial Exhibition Celebrating the 100th Anniversary of the Founding of the CPC

喜气洋洋小康村　农民画　76cm×76cm　项红红　杭州

四月乌贼肥又多 农民画　120cm×80cm　李芝琴　舟山

富美生活
The Optimal Living

　　一缕清香在断桥残雪氤氲缭绕，青瓷、紫砂、刺绣、石雕、木雕、湖笔、蓝印花布、螺钿在这里会聚，从一件件技艺精湛的艺术品到融入现今小康社会的日用品，传统的民艺正大踏步地走入当代生活。

　　民间工艺既是生产的技艺，又是生活的艺术。坚持创造性转化、创新性发展，让文化走出博物馆，文创走进大众视野，民艺飞入寻常百姓家，用文创衍生品讲述传统故事，链接当代生活。文化自信留住老手艺，编织新梦想。

　　让民艺、非遗"活"起来，富裕一方百姓，增强传承后劲，凝聚起民族复兴的精神伟力。

刺
绣
mbroigery

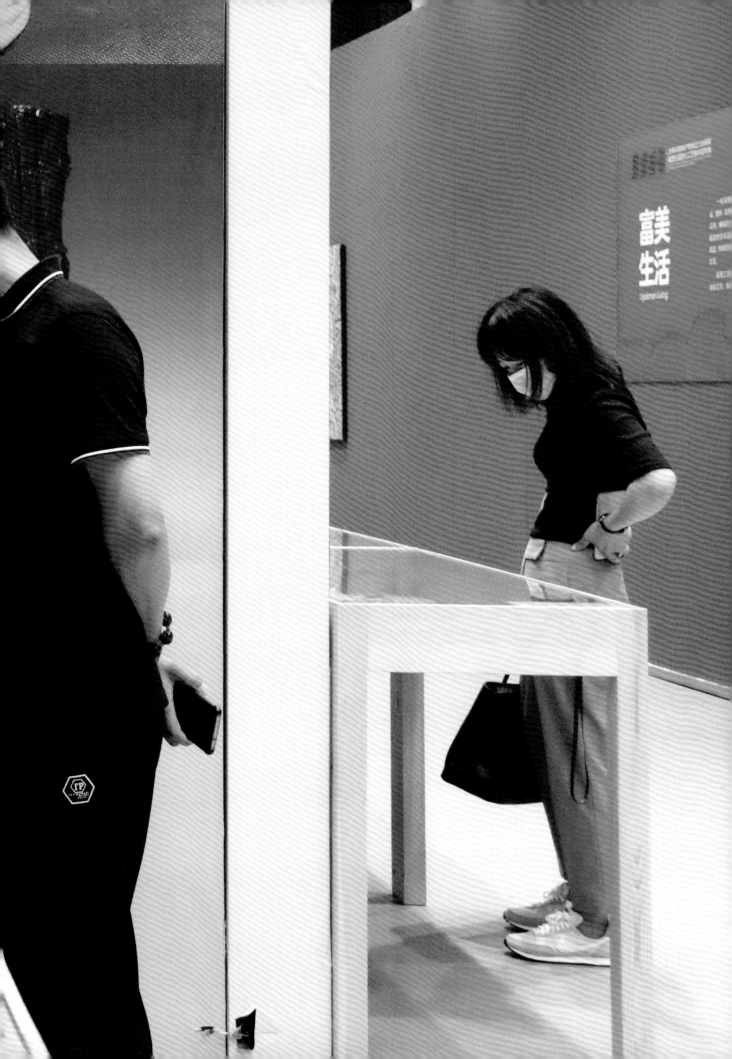

石雕

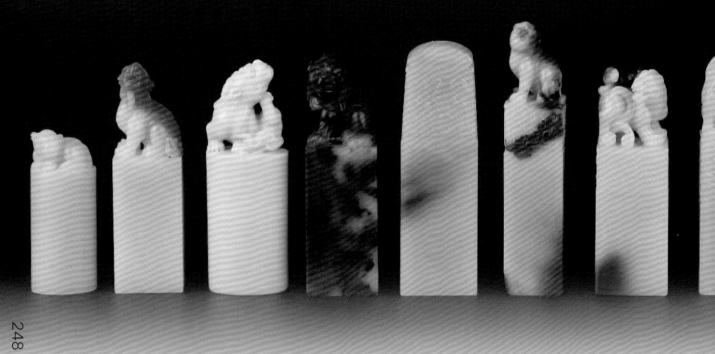

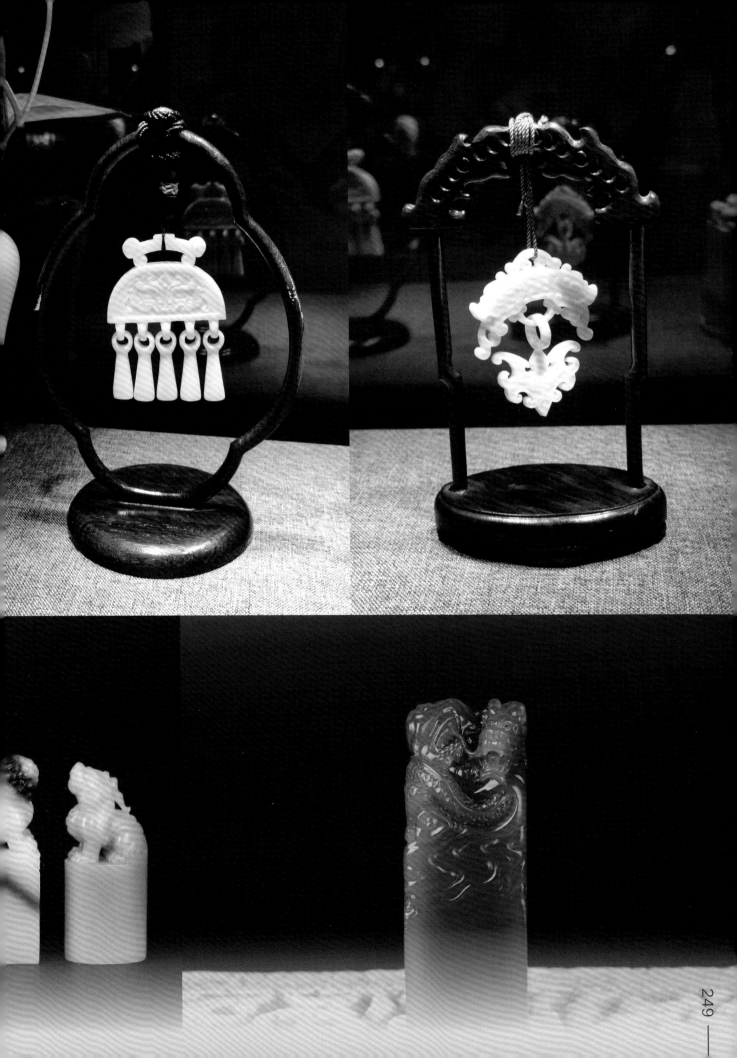

木雕

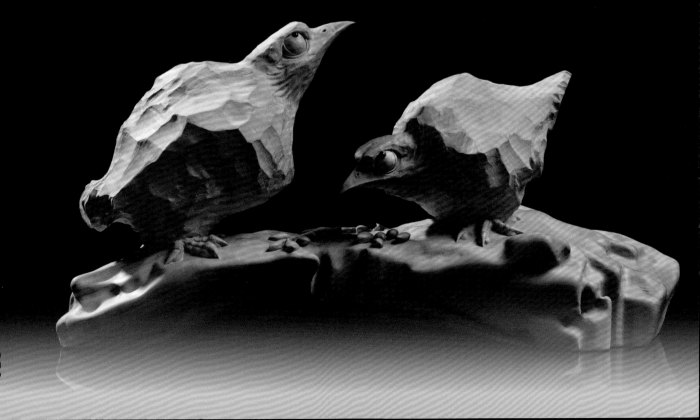

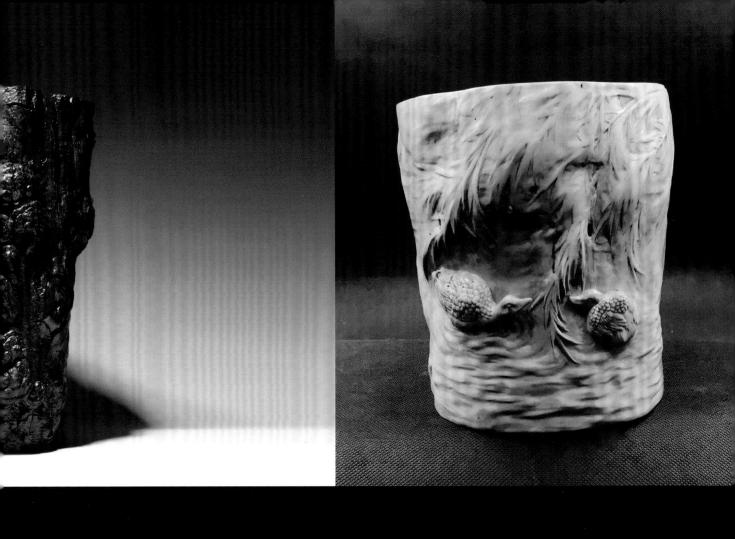

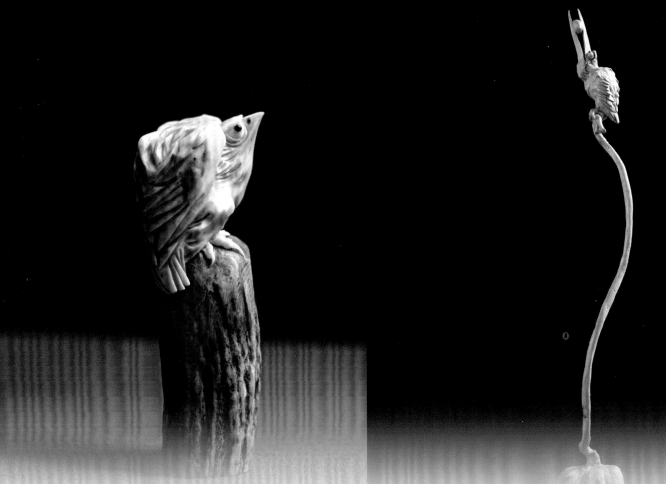

青瓷
Celadon

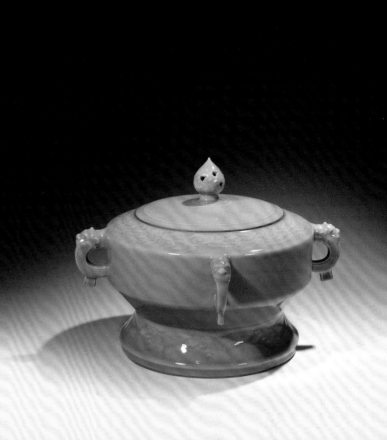

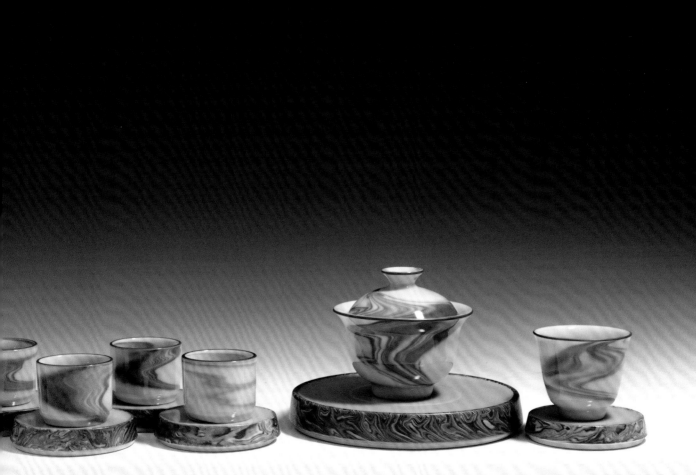

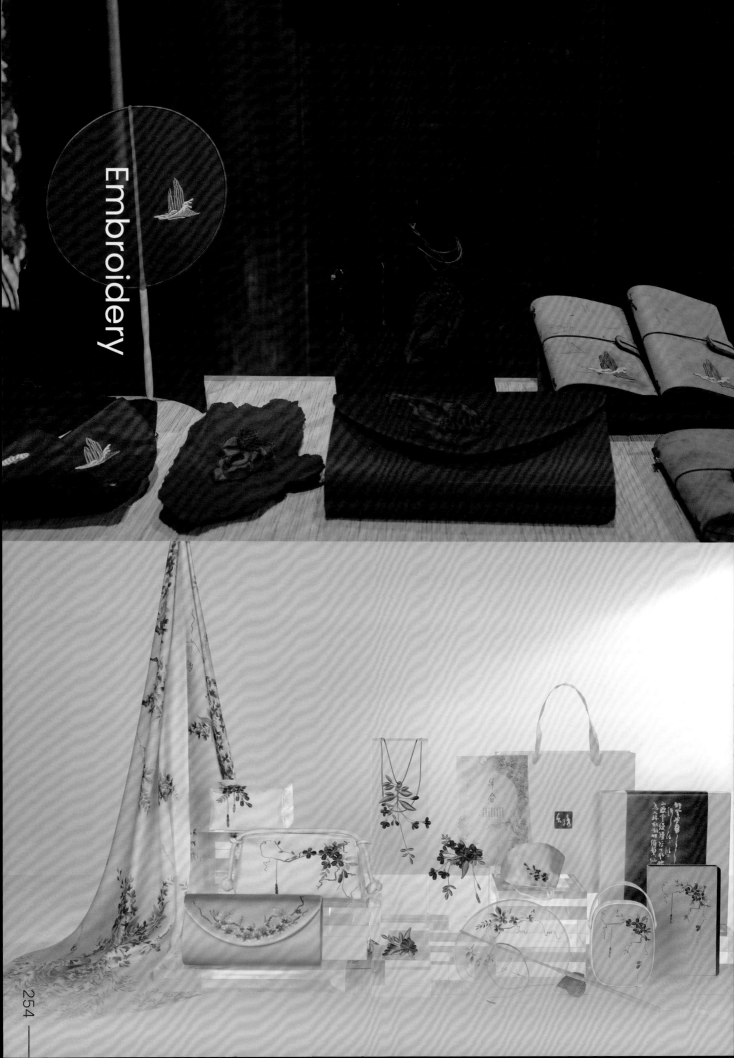

Embroidery

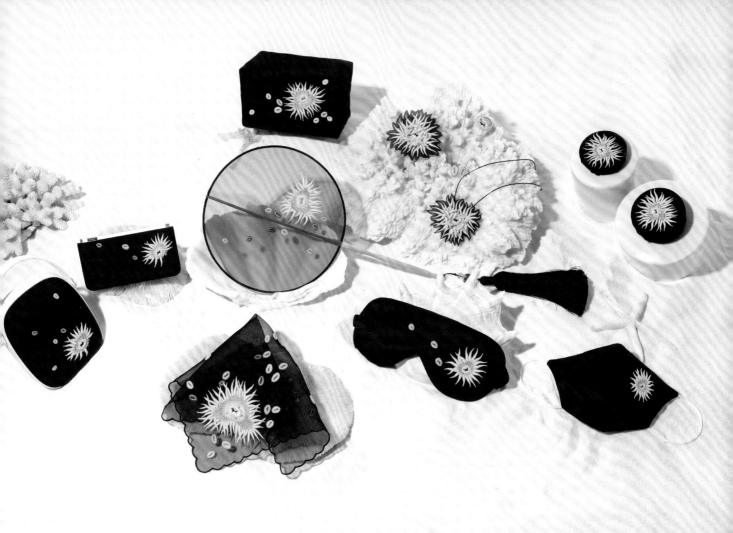

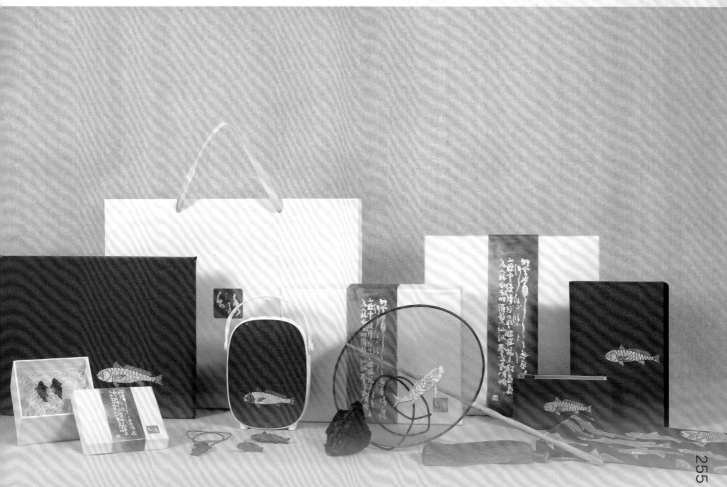

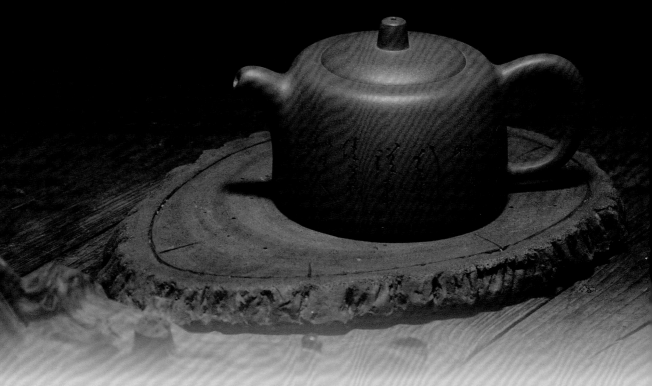

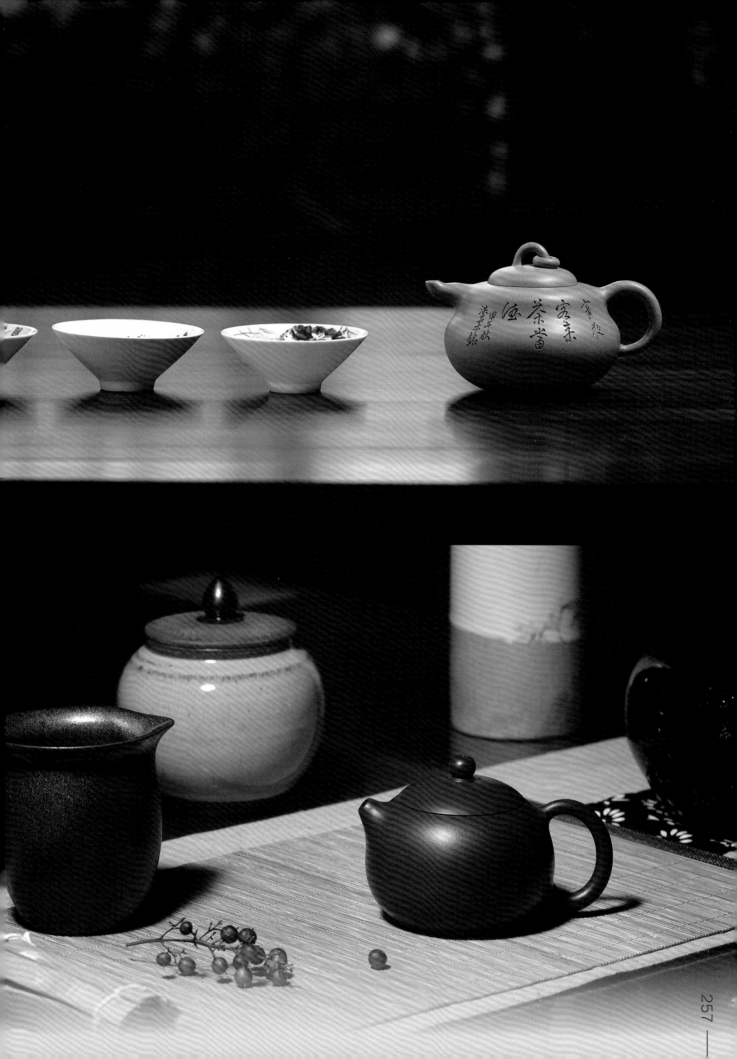

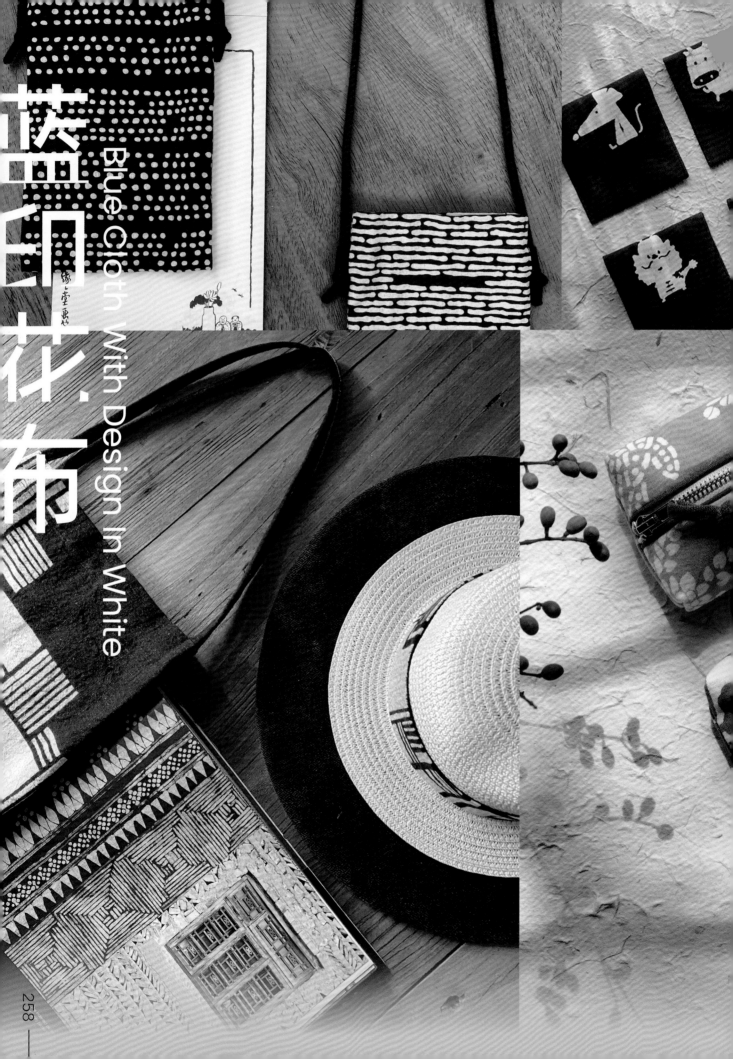

蓝印花布

缘·堂画坊

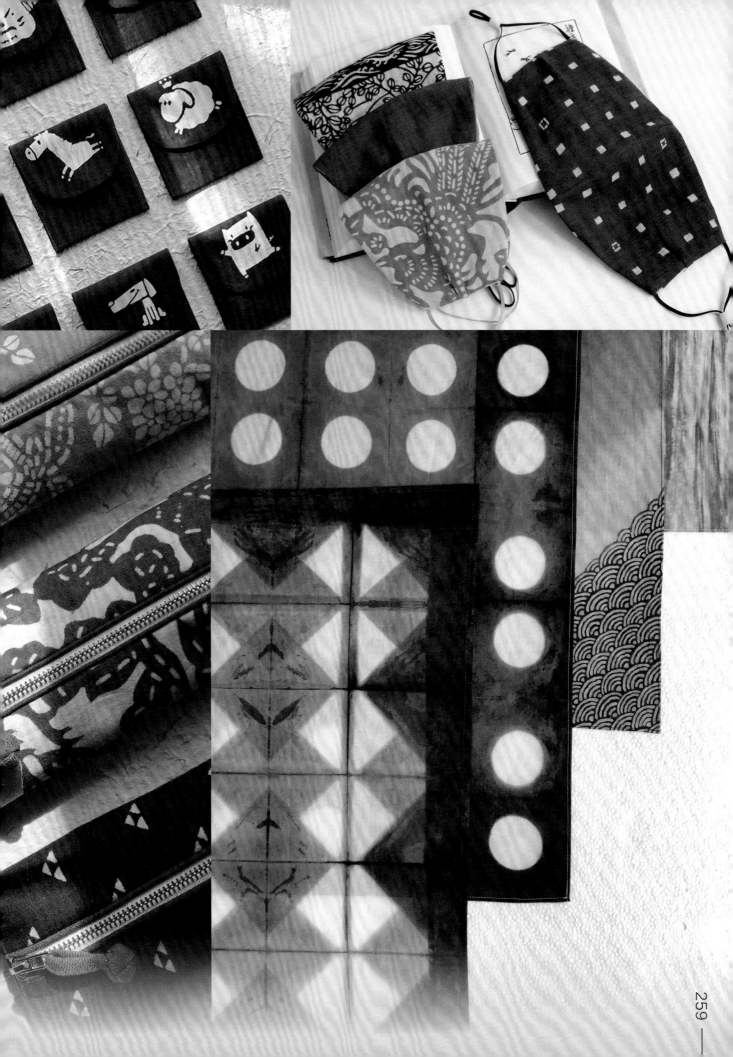

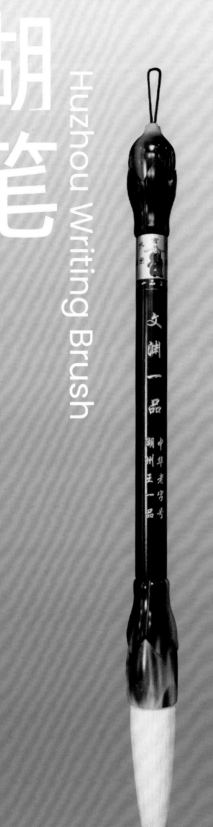

湖笔

ONE BRUSH

品

ONE WORLD

世界

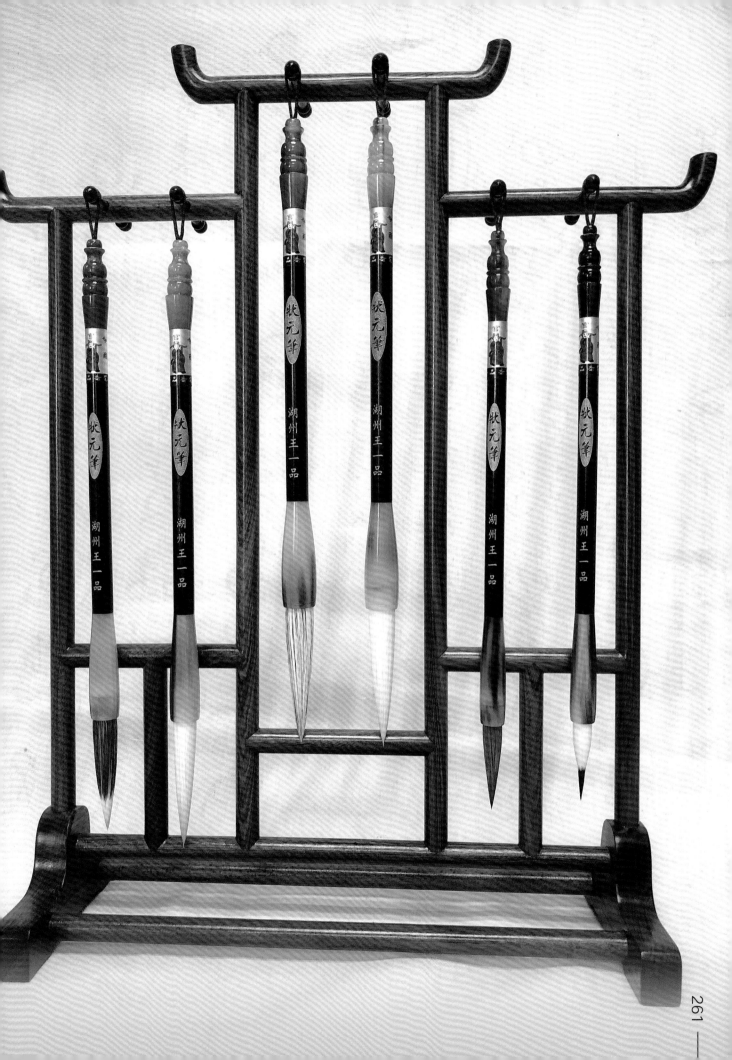

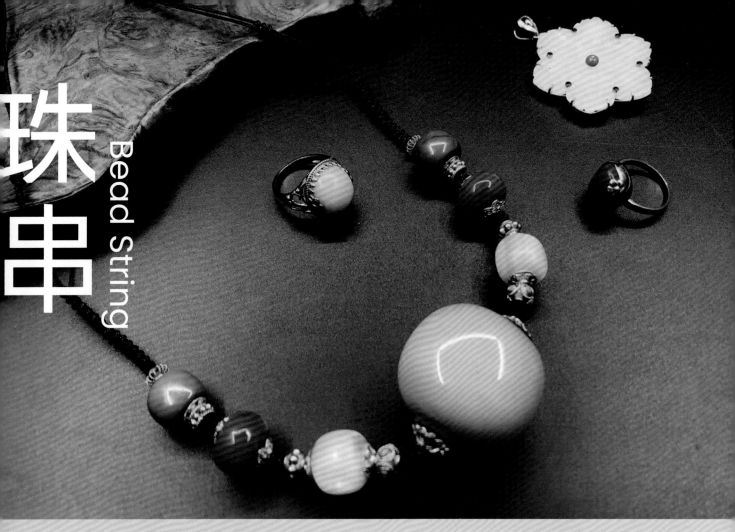

珠串

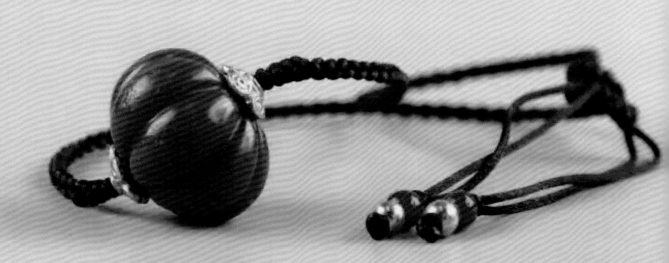

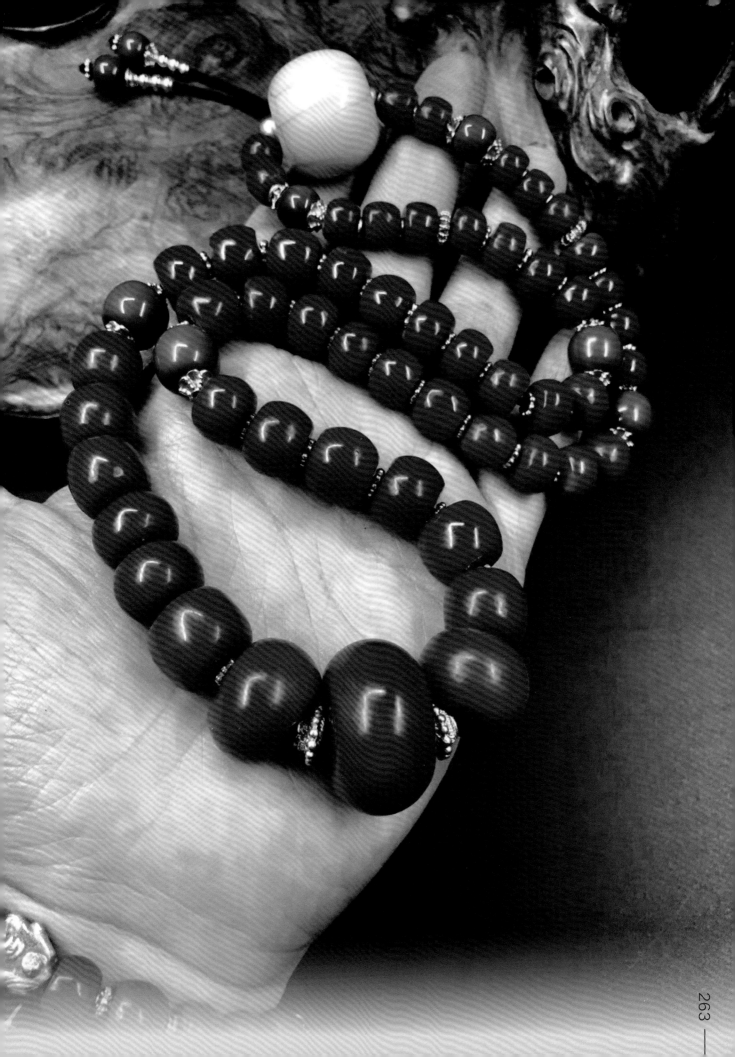

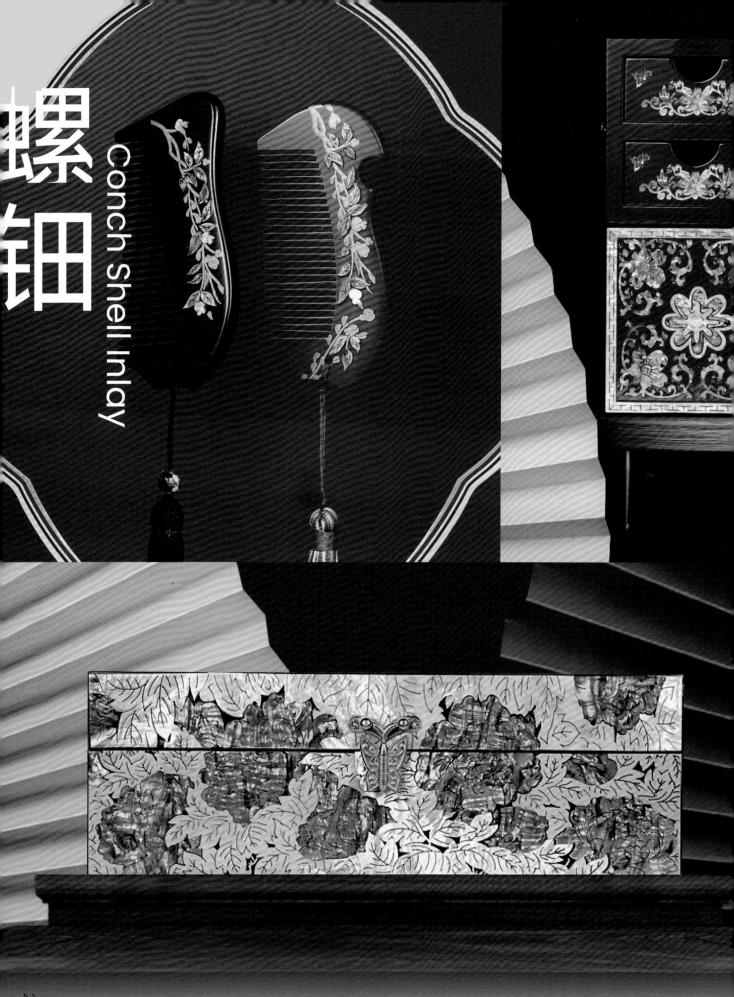

螺钿

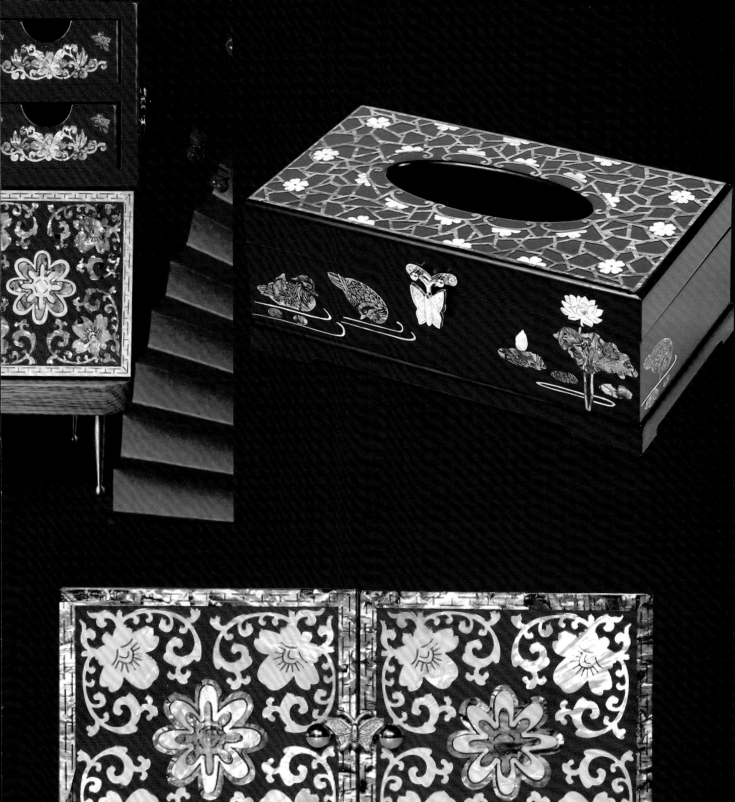

敦煌

中華遺產
敦煌

敦煌

敦煌莫高窟三窟窟大图

敦煌装饰图案考

敦煌艺术

咖

螺钿
Mother-Of-Pearl

高而颐

郑　蓉

潘金松

蒋建云

《庆祝中国共产党成立100周年暨第五届浙江工艺美术双年展作品选集》编委会

主　　任：张均林

主　　编：郑　蓉

编　　委：黄小明　孟永国　林　霞　卢伟孙　朱军岷　施　珍　蒋建云　郑九燕

图书在版编目（CIP）数据

庆祝中国共产党成立100周年暨第五届浙江工艺美术双年展作品选集/ 郑蓉主编. -- 杭州：浙江文艺出版社，2022.1
ISBN 978-7-5339-6767-3

Ⅰ. ①庆… Ⅱ. ①郑… Ⅲ. ①工艺美术－作品综合集－浙江－现代 Ⅳ. ①J521.55

中国版本图书馆CIP数据核字(2022)第001572号

责任编辑　金荣良
责任校对　陈　玲
装帧设计　杭州全仝品牌设计有限公司

庆祝中国共产党成立100周年
暨第五届浙江工艺美术双年展作品选集

郑　蓉　主编

出版发行　浙江文艺出版社
地　　址　杭州市体育场路347号
邮　　编　310006
电　　话　0571-85176953（总编办）
　　　　　0571-85152727（市场部）
制　　版　浙江影天印业有限公司
印　　刷　浙江影天印业有限公司
开　　本　889毫米×1194毫米　1/16
印　　张　18.25
版　　次　2022年1月第1版
印　　次　2022年1月第1次印刷
书　　号　ISBN 978-7-5339-6767-3
定　　价　168.00元